LOST BADENOCH
AND STRATHSPEY

LOST BADENOCH AND STRATHSPEY

Bruce B. Bishop

BIRLINN

First published in 2011 by
Birlinn Ltd
West Newington House
10 Newington Road
Edinburgh
EH9 1QS

www.birlinn.co.uk

ISBN 978 1 84158 963 3

British Library Cataloguing-in-Publication Data
A catalogue record for this book is available
from the British Library

Series design by Mark Blackadder

Typeset by Brinnoven, Livingston
Printed and bound by Gutenberg Press Ltd, Malta

To
My Wife

CONTENTS

ACKNOWLEDGEMENTS

Acknowledgements are due to many individuals and organisations. Thanks go to Mr Graeme Wilson and his staff at the Moray Heritage Centre, and to the staff of the Historical Search Room at the National Archives of Scotland in Edinburgh. The Church of Scotland has kindly allowed the transcriptions of extracts from the Kirk Session Minutes. Acknowledgements for photographs and other illustrations are due to the Moray Council Libraries and Museums Manager Alistair Campbell for his kindness in granting unlimited access to the Moray Council Library Service photographic collection, and to Molly Duckett at the Grantown on Spey Museum for giving access to the museum's collection of photographs.

INTRODUCTION

The intrepid traveller on their journey to the north, whether it is by road or on the train, emerges from the Pass of Drumochter into what may seem to be a different world. Passing between Drumochter Lodge on the right and the peak of Creagan Mor on the left, very soon, just a little further to the north, the expanse of Loch Ericht becomes visible to the west. This is the wild mountainous country of the Scottish Highlands but, just before reaching Dalwhinnie, a different, a new, landscape opens up ahead.

Gone is the feeling of being hemmed in by the closeness of the hills and coming in to view is a vista of mountain, moorland and space. Loch Laggan and a road to the Isles lie hidden away beyond the hills to the west; ahead we see the purple summits of the Monadhliath Mountains and a little further on, away to the right, are the towering peaks of the Cairngorms, patches of snow lying deep in the corries here until the late summer and often even longer. Glen Truim is now taking our route northeastwards to join the fledgling River Spey, flowing down from its source at Loch Spey in the shadow of Creag Meagaidh, high in the moorland wastes of Badenoch.

Badenoch – what thoughts this name invokes. High mountains, expanses of moorland and peat, pathless, treeless wastes untrodden by few except the deer and the other creatures of these wild parts. A perfect setting for stories of the exploits of Alexander Stuart, the aptly named 'Wolf of Badenoch', the wild mountain men and tales of the unexpected.

Where does Badenoch end and Strathspey begin? No arbitrary line on the map ever marked this boundary, if indeed such a distinction was ever made. Somewhere between Newtonmore and Aviemore, though, the character of the land changes and the mountains recede on either side of the route north. The extensive Insh Marshes to the north of Kingussie tell us that it is the river which is now shaping the landscape

so maybe it is here that Strathspey is born. Or perhaps it is at the cliffs of Craigellachie, near Aviemore. It could almost be said that this Craigellachie and the cliffs of the same name just north of Aberlour are the top and tail of Strathspey.

Strathspey – evocations of Scottish fiddle music and dancing, the music of Niel Gow, William Marshall, James Scott Skinner and others, maybe a hospitable evening spent in the inns along the road north. Views of the gentle haughs along the banks of the Spey, quietly grazed by cattle and sheep, a river full of salmon and trout and, of course, the whisky, all wait to welcome both locals and visitors alike.

It seems to me, though, that the most lasting impression of Badenoch and Strathspey is imprinted on the mind, and maybe even the soul, as one drives southwards across the Dava Moor on a clear morning on the road from Ferness to Carrbidge. After passing the crossroads for Dulsie Bridge and the bright orange snow gates, the road climbs to the crest of those barely named hills which form the western shore of Lochindorb. The soft lands of Moray and Nairn, the dark line of the Black Isle and the blue waters of the Moray Firth are fading into the distance in the rear-view mirror, and the whole landscape of Cairngorm and the Monadhliath Mountains is spread before us. The mountains and moorland stretching purple into the distant reaches of Badenoch surely entice the traveller to explore further into this beautiful part of Scotland.

Badenoch and Strathspey, a land of many contrasts – and, in modern times, a land of many uses. Not always was it the playground of winter sports enthusiasts and a Mecca for tourists – these mountains which protected the Province of Moray to the north and the Highland glens to the west were an obstacle to travel and a haven for cattle thieves and reivers. Hut circles, forts, chambered cairns and souterrains in the hills along the banks of the Spey all give us clues to a much earlier civilisation. In more recent times, the northern Picts and the Celtic clansmen may have argued over these lands, indeed they may even have often fought over them – it is certainly on record that two of the claimants to the Scottish throne fought a vicious battle in the upland wastes of Badenoch in the twelfth century. One consolation, though, may be the fact that the area seemed totally uninviting to any occupying Roman forces coming from either the south or the north and indeed to any Vikings with their minds set on an expansion of their territories. They visited the area and even traded with the native

people but it is here that the original culture of the Picts and of even earlier inhabitants is preserved almost untarnished by any permanent presence of these later invaders.

The snow lies here long after spring has come to the rest of the country. The Spey and its tributaries are swollen by the melting snows and the now-thawing Insh Marshes have become almost an inland sea, but the snow is still white in the shaded corries of the Cairngorms and the Monadhliath Mountains. Although the valley of the Spey may be sheltered, the winds can howl across the mountains with an almost unbelievable force and life in the hills can be hard, sometimes impossible, for man and beast alike. The deer which have come down from the hills in the winter retreat to the higher ground as soon as spring eventually makes its appearance, the sheep graze the pastures further up the slopes of the valley and the moors are set alight by the wild flowers which follow the retreating snows. The wild geese leave the marshes and the meadows along the Spey and head back to their summer homes in the arctic north.

Strathspey is a wide valley – the retreating glaciers of the Ice Age and the rivers which followed them have cut their own way through the mountains – but not all of the strath was created by the river. Standing near the small loch at Avielochan it almost feels as though the viewer is in the centre of a great caldera, a massive amphitheatre surrounded by hills and mountains. This vast basin even has its own microclimate and can generate showers and sometimes thunderstorms which then, in the right wind conditions, drift down the valley of the Spey to the sea, surprising the holidaymakers on the beaches of Moray. Was this a result of volcanic activity in millennia past or is it just an impression on the mind? There are still rumbles under the earth in this part of the world – a glance at the British Geological Survey map tells us that there has been earthquake activity here many times over the last century or more. Perhaps the mind isn't playing tricks after all.

How far down the Spey does Strathspey extend? Somewhere it must cease to be a strath and maybe, as has already been suggested, it is near to the cliffs of Craigellachie, just to the north of Aberlour, that our journey should end. Perhaps we could stretch a point and venture just a little further downstream to the mansion house of Arndilly, whose Ford of Ardentol, almost beneath the walls of the old castle at Rothes, was used as a crossing point by King Edward's army over seven hundred years ago.

There were, though, few prominent buildings, apart from the castles and mansion houses, anywhere in Badenoch and Strathspey. Most of those which were ever built are still in existence, some only as a ruin, but many others as comfortable houses. In terms of architecture, without wishing to offend the designers and architects who first thought of the grand castles and mansion houses, and even the shooting lodges, there has never been very much of architectural merit in the area and as a consequence of this many buildings have been modified and adapted but few buildings have become totally lost. What has been lost, though, is a characteristic culture, a way of life defined by the river and the mountains, many of its conflicts and customs now vanished into the mists of time, and it is this which will provide the detail and the interest for this book.

But, before we can even consider any of this, what of Badenoch and Strathspey in more distant times?

CHAPTER 1
EARLY TIMES

FROM THE ICE AGE
TO THE PICTS

The vast expanse of the ice sheet gleamed white in the sun, as far as the eye could see. But no human eyes ever saw it, no one ever walked on the top of that sheet of ice and snow which covered much of the country we now know as Scotland during the Ice Age. Two or three thousand feet below the top of the ice the jagged peaks of the mountains were being eroded, smoothed and rounded by the ice which flowed across the country, scraping rock and gouging out the U-shaped valleys which are so much a feature of the countryside today. The ice weighed heavy on the land, gradually pushing it downward – difficult to imagine when we look at the seemingly solid and immovable mountains that form our modern landscape.

There may well have been people in Scotland before the coming of the last major Ice Age but we will never know who they were as the ice has erased any evidence of human presence before this time. The vast amounts of water tied up in these ice sheets would have reduced the amount of precipitation dramatically and any humans, or indeed animals, would have not only suffered from the extreme cold but also the drought which was associated with it. The deteriorating climate would soon have forced both beasts and people southwards to find pastures new and both the indigenous animals and people may have just died out totally. This was one of a long series of such events that had a hand in shaping the face of our world, this latest episode reaching its peak about 18,000 years ago. Gradually, though, the ice sheets began to thin and retreat westwards, a process of several thousand years but, in the geological timescale, of course, it was little more than the blinking of an eye.

Gradually the landscape as we know it evolved. The eroded rocks formed boulder fields and the finer debris settled in the valleys

formed by the retreating glaciers. These glaciers and, later, the rivers ground down the rocks even further and gave us the soil on which the agriculture of the area is founded. Enormous herds of bison and deer, and the predators which accompanied them, had made their way across the exposed wastes of the marshland bridge which joined Britain to the continent of Europe and these were soon followed by the nomadic tribesmen who hunted them.

These tribes, coming from central Europe, and even further south and east, have left little evidence of their passing. To venture into the wild hills of Scotland, by now covered with the dense woodlands which had sprung up after the ice had retreated, may have seemed a very daunting prospect but the wide rivers, the estuaries of the Forth and the Tay, would have given easy access to the hinterland and would have been inviting to these new settlers. Travel along the coast was relatively easy but any remains of the dugout canoes and flat-bottomed boats they would have used have long since mouldered into the mud of the rivers and the sea.

These were a lost race of people – or were they? Surely these were the ancestors of the tribes so feared by the later Romans, the Picti – the Pictish race who gradually settled first of all the coastal areas and the river valleys but later ventured further into the Highlands. The hunter-gatherer way of life was dying out as they became more settled, the woods and the forest were cleared in places to allow an early form of agriculture and, rather than wandering across the landscape in search of food, they were now growing it on their own doorstep. Beasts were becoming domesticated and the hunting was now becoming as much a sport as a necessity. Look on the map for places whose name starts with 'pit' – the 'clearing in the forest', maybe this is one word which still survives from their long-lost language.

The long valleys of the Tay, the Dee, the Don and, more importantly from our point of view, the Spey would have provided just what these new people were looking for. There were rivers full of fish, there was the level land of the haughs along the edges of the river to grow their crops and there were woods and forests to provide timber for their huts. There was also abundant stone for the more permanent structures, those enigmatic chambered cairns which became the dwelling place of their dead. Settlement was becoming a way of life, their wandering days were past, other peoples were coming to the area, the population was increasing and a civilised culture was evolving.

THE PICTS IN BADENOCH
AND STRATHSPEY

What we may never know in any detail is the transition from these early Iron-Age settlers to the later Pictish tribes. Other tribes and cultures came to these shores and became mixed in with the original inhabitants. Lost in the mists of time, we have no records of the names these early people used for their tribes – it was the Romans who called them the Picts, 'the Painted People'. Were these Picts, against whom the Romans built Hadrian's Wall and the Antonine Wall and with whom they fought but also inevitably traded, the direct descendants of the first settlers? This long-argued question may never be resolved but surely many Scots would be quite happy to admit to having some Pictish blood in their veins.

One thing is fairly certain, though – that Strathspey and Badenoch would have been settled originally from the north and the east. Faced with the arduous crossing of the mountains of the watershed of the Tay and the Spey, the easy route into Strathspey and Badenoch would have been along the Spey Valley or coming in from the east along the valley of the Dee. So it is here that we need to look for evidence of these early people.

And it is not difficult to find. Hut circles, standing stones, chambered cairns and field patterns all provide evidence of past lives. The distribution of these remains is almost a signpost to how people settled the area. Coming down the valley of the Findhorn and Strathdearn into the northern reaches of Badenoch, they left their field patterns and cairns to the north of the Slochd. The main route into Badenoch and Strathspey, though, was the valley of the Spey and, in the stone circles near Ballindalloch and at various points along the river as far as Dulnain Bridge and even along the tributary valley of the River Avon and way up into Glenlivet, the stones all give evidence of the earliest people in the area.

It was maybe later generations, or even new tribes, who ventured further upriver and the hut circles and cairns are numerous around Boat of Garten and Avielochan, to the north of Aviemore. It soon becomes obvious that these people favoured the northern banks of the Spey for almost all of its length, no doubt enjoying the morning sun of the south-facing aspect of this side of the river and staying away from the Insh Marshes and the other boggy areas along the course of

the river. They seem to have ventured upstream as far as the point at which the Spey meets the River Truim, just south of the present village of Newtonmore, but went no further. The hut circles here must have been the southern outpost of these northern people – the forbidding peaks of the mountains beyond were maybe only visited in the summer by the more intrepid hunters in search of new game.

By the time the Romans came to Britain, it is probably quite safe to say that we are able to refer to the people of Badenoch and Strathspey as being very definitely Pictish.

For the first seven or eight centuries of the first millennium, generation after generation of these people farmed, fished, lived and loved in the valley of the Spey and the surrounding hills. We have no written record of their lives – theirs was a language which only remains in some of the names which they gave to places in the area. The numerous enigmatic carved symbol stones tell us little and their way of life is, if not a mystery, a cause of discussion and sometimes argument amongst historians and scholars to the present day.

Life was now more settled for these dwellers along the Spey and its tributaries. Their agriculture, although it must have appeared primitive to later inhabitants, was enough to support the increasing population and, as time went on, they were growing enough grain and rearing enough beasts to be able to support the artisans in the settlements. These industrious members of the community were now becoming too busy providing the implements for agriculture, travel and all of the necessities for a more comfortable way of life to take much part in the day to day business of farming, apart from the growing of food in their own gardens.

Pictish houses were smaller than the roundhouses of their Iron-Age predecessors and their turf walls left very little mark on the landscape. This new smaller type of house maybe tells us that each of them was the home of just one family and not, as in earlier times, the dwelling of an extended family group. The roof may have been either thatched or turfed, with a hole in the centre to let out the smoke from the stone hearth which was set in the centre of the hut, but the hole in the roof was never, of course, put immediately above the hearth, otherwise the rain and snow so frequent in these parts would have put the fire out.

But other people had their eyes on this part of Scotland and for two different reasons – territorial possession and religious conversion. The Christian Church was becoming established in the west, with its focus

4

at Iona and later at Dunkeld. The Pictish king at Craig Phadrick near Inverness was visited by St Columba and doubtless also by many other missionaries and King Brudei was eventually converted to Christianity. The old Pictish gods were now under threat from this new religion and gradually succumbed. The Scots, coming from Ireland, had established their kingdom of Dalriada in the west and were anxious to expand their territory. The northern Picts, the tribes to the north of the mountains, and the southern Picts of Perthshire, Fife and Angus were now both under pressure from the rising militant Dalriadic presence in the west.

Whatever battles may have been fought in Badenoch and Strathspey have disappeared into the mists of unrecorded history or become the stuff of legend and, despite these conflicts, the melding of the Picts and the Scots seems to have been a fairly gentle and gradual assimilation of the two cultures. Marriages between the more important Scots and Pictish families were starting to form the basis of a power, especially in the north, which would, for a long period of time, ensure that these peoples had a say in the foundation of a modern Scotland.

Christianity, in the form initially of the Culdee Church, was also becoming a unifying power and the missionaries were soon establishing preaching stations, the predecessors of the early chapels and the later churches, throughout Scotland. Badenoch and Strathspey was no exception and the sites of some of the old, disused and overgrown burial grounds may give us a clue to the locations of these now lost places of worship. No massive cathedral for these early preachers, no church, just a hut for their shelter and a cross outside at which the new faithful would gather. Maybe the people were still looking over their shoulders to see whether their old Pictish gods were watching them and wondering whether this new god would protect them in the same way. Some of the carved Pictish stones, with their mixture of Christian symbolism, animal carvings and other patterns depicting things now lost to us, surely show that this was a gradual overlapping of faiths – the phrase 'the best of both worlds' springs to mind.

VANISHED TOWNSHIPS

The remains of burial places, the hut circles and the traces of agriculture all give us an idea of where these people lived, and how their way of life improved over the centuries, as we have already mentioned. Into

the second millennium, though, with an expanding population, these family settlements began to evolve into townships, the Highland equivalent of the *fermtoun* so common in Lowland Scotland.

Many of these small settlements have long since vanished or are now remembered only in the names of farms and croft houses. These townships were nowhere made up of more than about twenty cottages and, in many cases, far fewer but, nonetheless, each was an economically viable community from the point of view of both the residents and the landowner. Black houses, low, turf built, were really not much of an improvement on the houses of their Pictish ancestors. So where can we find any traces of these lost townships?

Places which we would now pass by without a second glance. Place names on a map, evolving through those dark mysterious centuries which saw the leaving of the Romans, the coming of Christianity and the founding of Scotland as we now know it. All through those almost lost years culminating in the twelfth-century organisation of the Church into parishes and the 'Golden Age' of King Alexander and King David, the life of the crofters continued its cycle, in sympathy with nature and the seasons. There were settlements such as Dalnaspidal, with its 'hospital' or inn for travellers facing the hazardous journey through the pass of Drumochter, places like Dalnacardoch, Dalwhinnie and Pitmain, and there were so many small communities which were almost entirely self-sufficient. These are the survivors but many of the small settlements in the tributary valleys of the Spey were not so lucky.

This new age was giving rise to a new way of life, in general focussed around the now dominant church building or sometimes a monastery. In many cases, the church was the only stone-built structure in the parish apart, of course, from the castles of the landowners, which were now evolving from the earlier wooden palisaded structures into more substantial stone fortresses. Although many settlements continued to take advantage of the good agricultural land along the Haughs of the Spey, the kirktoun was coming into existence. Around the church there was a place for the minister to have his manse and his glebe and a place for the artisans – the smith, the squarewright, the shoemaker – to have their workshops, a crossroads for the life of the parish.

Further away from the kirk, on the more marginal land and up the valleys of the tributary streams, the townships were now also developing. Maybe not developing as a fermtoun such as would have been thought of in the Scottish Lowlands or even in Aberdeenshire or

lowland Moray and Nairn, but the homes of a group of people with a common interest in making a living from the land in spite of the many hardships which this entailed. Most of these settlements date from the late medieval period but, by the middle of the nineteenth century, they were vanishing as the towns of Newtonmore and Kingussie expanded, an expansion which, in itself, was to contribute to the 'economic' demise of many of the townships.

A typical lost township was that at Easter Raitts, near Kingussie, and it is on this settlement that the reconstructed township at the Highland Folk Museum near Newtonmore has been based. Here the visitor can see life as it would have been in a typical community of rural tenants living in a settlement made up of timber cruick-framed buildings, with the typical turf-built walls based on a low stone foundation and with a thatched roof.

This desire for a more independent way of living had, over the years, taken people further from the main valley of the Spey into more remote country. Places such as Glen Banchor, nestled away in the shelter of the Monadhliath Mountains, where the crofts lay along the valley of the River Calder. Maybe it was not a much better living but a land which these tenants of the MacPhersons could work in peace.

One of the early townships in the glen was Dail an Tullaich but, by the time of the 1841 census, the eight townships in Glen Banchor were identified as Easterton, Westerton, Dalvalloch, Dalchurn, Lurgan, Milton, Luib and Croft Couneach. There was also a chapel in the glen dedicated to St Bridget or St Bride. These townships were small, a total of 21 houses, and the population of Glen Banchor was only 85.

Somehow they managed to survive until the second half of the nineteenth century but then, as in so many of the Scottish glens, the sheep came. The landowners liked the sheep – they provided a much better return than the miniscule rents which the crofters sometimes paid, but the sheep also needed a place to graze. So Badenoch and Strathspey had their own Highland Clearances, maybe not on the scale of those ordered by the Duke of Sutherland and his factor Patrick Sellar away up to the north or those which were suffered by the people of the western Highlands and the Islands but, nevertheless, they were just as real to the people who were evicted from their homes. By the time of the 1891 census, there were only three houses left in the glen and the population was down to about a dozen people. All along the valley of the Spey, these small crofting communities were being replaced by flocks

of sheep and the homes of those people are now reduced to mouldering heaps of stone, sometimes obviously the remains of a cottage, but all of them now lost and gradually returning to the landscape from which they were wrought.

The people of Glen Banchor and the nearby glens, however, did not need to go to America or Canada or Australia, unless they actually chose to. They were able, with the help of the landowners, to take advantage of the lands closer to the Spey, at a place where the cattle drovers rested their beasts on the long journey southwards, and they began to expand the settlement which was eventually to become known as Newtonmore. The inhabitants of many of the other small tributary glens along Speyside suffered a similar fate as the numbers of sheep rose inexorably and villages like Dalwhinnie and Aviemore were also to play host to many new residents.

STRATHSPEY IN THE EARLY EIGHTEENTH CENTURY

Walter Macfarlane, writing his *Geographical Collections* in about 1723, gives us a contemporary description of Strathspey, almost parish by parish. The following extracts have been selected from his works and retain the typically archaic, sometimes attenuated language of that time.

It takes its beginning at a great craig called Craig I'lachie, which divideth the Countrey from Badenoch. This word Craig Ilachie is the Laird of Grant's Slugan [slogan]. When ever the word is cryed through this Countrey, all the inhabitants are obliged under a great fine or Mulet, to rise in Arms and repair themselves to a meeting place in the middest of the Countrey lying on the Rivers side called Bellentone and there to receive the Lairds Commands.

The parish of Rothiemurchus contains six Daughs of land, each Daugh being four ploughs. [A daugh or davoch was usually about 416 acres.] It now belongs to Patrick Grant, a cadet of Grant's family, but formerly it belonged to the Schaws, who yet possess the parish, Alexander Schaw of Dell being the Head of the Tribe. The Schaws are able fighting men and acknowledge Mackintosh to be their Chieftain, and go under his banner. The Schaws killed the Cumins that dwelt

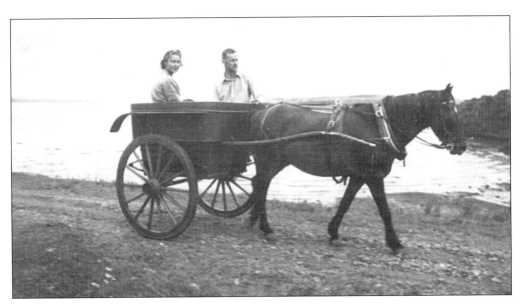

An afternoon jaunt

here and built a Castle in the middle of a great Loch called Loch-Iland [Loch-an-Eilan]. This castle is useful to the Countrey in time of trouble or wars, because the people put their goods and children here and it is easily defended. There is a great Firr Wood, with Deer and Roe, and a saw mill.

The parish of Duthell or the Lordship of Glenchernick formerly belonged to the Cumins, but now to the Laird of Grant through marriage. The water [of the Spey] is of ten miles in length here, being a pleasant water, good Corn land, excellent meadows, good pasturage in both sides. There comes no salmon in this water, but extraordinary much Kipper, that is salmon in the forbidden time, which are in such abundance that a Gentleman thinks nothing to kill 160 in a night. There are great Firr woods, and much of the timber is transported to Inverness. The gentlemen's houses here [are] of the name of Grant, given to Hospitality and Frugality.

The parish of Kincharden, anciently possessed of the Stewarts, who had their charter from King Robert Bruce, but being wrested from [them] by Conadge it now belongeth to Huntly. There is much talking of a Spirit called Ly-Erg that frequents Glen More. He appears with a red hand in the habit of a souldier and challenges men to fight

9

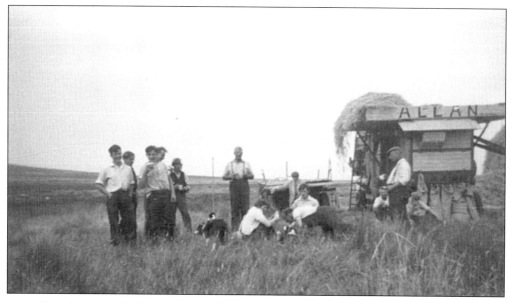

Farming scene in Strathspey, early twentieth century

with him, as lately as [16]69 he fought with three brothers one after another, who immediately dyed thereafter.

In the parish of Abernethie there are two saw mills, with ane old Castle built by the red friars. Several good gentlemen's houses on the water of Nethy are given to hospitality.

The lands of Cromdell in ancient times belonged to the Nairns, but now to Grant. Exceedingly good land on both sides of the river. Much Salmon is taken here. Here is Bella Castle, the Laird's Chief Residence, a stately house with parks about the same, great grassings.

Sadly it seems that Mr Macfarlane never ventured onwards into the lands of Badenoch or, if he did, he never wrote about it so we are left with no contemporary picture of those lands in the years immediately following the first Jacobite Rebellion.

THE LOST DROVE ROUTES OF BADENOCH AND STRATHSPEY

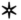

THE DROVING TRADE

Hundreds if not thousands of cattle, black cattle, the original small black beasts of the Highlands, were to be seen every year making their way southwards through Badenoch and Strathspey in the late summer, bound for the markets of Central Scotland and for markets even further away, many of the beasts being destined for the London market. Cattle from Caithness, coming from the tryst at Muir of Ord, had made their journey by way of Fort Augustus and the Corrieyairack Pass to Drumgask and then on to Dalwhinnie. Here they met the droves coming from Inverness over the Slochd and down into Strathspey, coming from the cattle tryst at Pitmain just south of Kingussie.

Cattle had been a measure of wealth in Scotland for time beyond memory. Cattle thieving was a fact of life in most of the country. Disputes between landowners, families and clans all led to the poor beasts being driven away, often in the worst of conditions, to settle some debt, some feud or, in some cases, just out of pure bloody-mindedness. The routes these cattle thieves took are lost in the hills and mountains – they wanted to keep the beasts out of sight until they were safe on their new pastures. From the records of the Privy Council between the middle of the sixteenth century and the early decades of the seventeenth century, it would appear to some outsiders that cattle raiding was the chief occupation of the people of Scotland.

From the smallest farmer to the greatest landowner, his neighbour's beasts were irresistible, a target for an acquisition which would improve their status. The Privy Council and the Crown, the bodies responsible for law and order in the land, could do little. They would find the culprits guilty but, in reality, the power of the law did not extend into the lands of Badenoch and Strathspey and any summonses, if they were ever delivered, were easily ignored.

The export of hides and of barrelled beef from the north of Scotland by sea, from Cromarty, Dingwall, Nairn, Findhorn, Garmouth and many other ports, was one way for the farmers in the north not to have to overwinter their beasts. The making of sufficient hay to be able to feed the herds of cattle during the lean months was not an economical proposition as the land could be better used for growing grain crops. So the regular slaughter of the cattle provided not just an income to the farmers but also to the merchants who shipped the beef to the southern markets and the hides to all parts of the country and even to the continent. The other way to export the hides and the beef was on the actual animal and the markets of the south were becoming an irresistible attraction to the landowners and their tenant farmers.

Many acts were passed to try to regulate the legal movement of beasts but, by the seventeenth century, the trade in live animals was becoming a profitable business enterprise. There was now much more free trade with England and, as A. R. B. Haldane notes in *The Drove Roads of Scotland*, 'by the middle of the seventeenth century the cattle trade to England had, despite all its handicaps, grown to such proportions that Scotland was described as little more than a grazing field for England'.

It was now, as the droving trade was starting to be recognised as an essential part of Scotland's economy, that the lines of cattle passing through Badenoch and Strathspey really began to increase.

The trade from the north, from Sutherland, from Ross and Cromarty and from Strath Carron, included beasts which had been brought over from the Western Isles. The great cattle fair on the Muir of Ord was the gathering point for these droves, before they set off southwards again, some of them travelling by way of Strathglass and over the hills to Glen Moriston before making their way to Fort Augustus and the Corrieyairack Pass. Their next destination was to be at Drumgask, where Strath Mashie joins the River Spey. Some of the cattle from Skye would have joined this stream of cattle at Fort Augustus, others going by way of Spean Bridge. Other drovers would have taken their beasts from the Muir of Ord to Inverness and, crossing the Slochd, would have made for the lush pastures of Strathspey. Some of these then headed over the high passes of the Lairig Ghru and Glenfeshie to join up with the droves from the northeast near Braemar, whilst others followed the Spey down to Kingussie. The tryst at Pitmain, just beyond that village, would have been a welcome event for both man and beast – the chance of a few days' rest. Here there was a 'stance'

with fresh grass for the cattle, an inn and other entertainments for the drovers and the chance to do some business, to talk about the state of the markets and the weather and to catch up with old acquaintances.

After the coming of the railways, the trade continued but was diminishing rapidly. The last herds of horses were brought over the Corrieyairack in 1890, the last cattle in 1896 and lines of sheep trod the narrow zigzag road between the steep black mountains surrounding the pass for the last time in 1899, at the mercy of whatever the elements could throw at them.

The two streams of men and beasts met up somewhere near Dalwhinnie, at that time little more than an inn and a few black, turf-built croft houses. They were now leaving the lands of Badenoch and Strathspey to face the journey through the Pass of Drumochter on their way to the great cattle tryst at Falkirk. At Dalwhinnie on 31 August 1723 Bishop Forbes noted that he had encountered eight droves, numbering about 1,200 beasts, all bound for Crieff on their way to Falkirk and, in the pass itself, a drove a mile in length. And so the men and the beasts passed beyond Badenoch and beyond the imagination of more recent generations but what lasting mark have they left on the land and on the way of life of the people?

PITMAIN, DRUMGASK AND DALWHINNIE IN DROVING TIMES

What exactly was a cattle tryst? In many places, they were more commonly described as a 'cattle fair', a 'market' or just a 'fair'. For example, the minister of the parish of Kingussie, writing his contribution to the *New Statistical Account* in 1835, noted that 'there are commonly five or six markets in the parish throughout the year; the principal one of which is held in June for selling wool, lambs, etc. Another is held in November for settling accounts, and engaging servants; and a third in February. The other three fairs are held for buying and selling cattle, at different times, so as to suit dealers passing from the southern and northern markets.' This surely tells us that the fair or tryst at Pitmain and similarly the ones at Drumgask and Dalwhinnie were not just one-off events every year but were arranged to fit with the times when the cattle droves were passing through. Inevitably, there must have been a certain amount of flexibility as the dates would have been dependent

on the weather, the drover's ability to get the cattle across swollen rivers and streams, the speed at which the beasts could be kept moving and the availability of the southern merchants and dealers who had to travel so far north.

The effect on the settlements of Pitmain, Drumgask and Dalwhinnie must have been, for a brief time, a sight to be seen. As the time of the tryst approached, the cattle were coming into the tryst ground, hungry, smelly, dirty animals after their journey from the north, and they were probably all spreading out over the surrounding area to find the best grazing. The 'great stalwart hirsute men were shaggy and uncultured and wild, their clothing and physique alike suited to the hardship of their lives' (Haldane, *The Drove Roads of Scotland*), and they, as well as the beasts, had to be fed and watered. Tented kitchens would have provided steaming bowls of food, probably the original Scotch broth, for the weary and, knowing the climate of Badenoch and Strathspey, the very wet drovers. The alehouse owners would have been rubbing their hands in anticipation as they set up temporary bars to provide the whisky and beer which would oil the wheels of any deals which were being done.

It was here too that the Lowland Scots tongue of Moray and the north mingled with the Gaelic of the drovers from the west, much of either language probably being quite unintelligible to any merchant who had ventured up from too far south and probably to some of the drovers as well. Many accounts of these trysts mention the dirty, unshaven gentlemen and drovers, the ill-kempt horses, the tents along the side of the roads and the general chaos of the event. To quote from a newspaper of the time, admittedly referring to a tryst further south but probably quite appropriate for these Highland events, 'The maledictions between the herdsmen are exchanged in Gaelic, and as the colleys [the dogs] seem to catch the spirit of their masters the contention is generally wound up to a regular worry, presenting altogether a scene of the most admired disorder and of no little amusement to those who have nothing else to do than to look on and enjoy it.' Maybe something like a modern shinty match?

It must have been profitable for the local people though – someone had to feed these people and farmers, tacksmen, drovers, cottars, factors, merchants and innkeepers alike would have mingled with the women who could always find an advantage in such a gathering.

It was not only at the trysts that hospitality was needed. A cattle

drove on a good day could travel about 12 miles and then they would stop for the night. If there was no accommodation, the drovers would wrap themselves in their plaids and spend the night on the hillside with their beasts and their dogs, eating the oatmeal which they always carried with them for such an eventuality. Sometimes the cattle were blooded in the spring and the autumn and the preserved blood could then be mixed with the oatmeal to make a fairly basic black pudding.

The dogs were invaluable to the drovers, especially when the route crossed large expanses of open country, and they were well cared for, the feeding of the dogs usually being the drover's main concern when they reached a new stance. But the dogs were not always with the drovers and, in the nineteenth century, it was, apparently, quite a common sight to see collie dogs, totally unaccompanied, making their way back north after the drove was finished and the beasts sold off. These were probably dogs which belonged to those drovers who had stayed in the south in the autumn to earn money at the harvest. The dogs were not needed for this work and so they retraced the route taken by their masters and were fed at the inns and farms where the cattle had stanced on their way south. The following year, as they came south with yet another group of beasts, the drovers would pay the innkeeper or the farmer for the food which the dogs had eaten the previous year. No more will the traveller encounter these dogs on their lonely way home, which is probably quite fortunate when we think of the amount of traffic on the new A9!

All of this, though, may have had some bearing on the distances between the settlements in Badenoch and Strathspey. Drumgask to Dalwhinnie, Dalwhinnie to Kingussie, to Alvie, to the inn at Aviemore, to Carrbridge and Cromdale, all of these places were quite conveniently situated for the traveller. Even the old hostelry at Dalnaspidal, to the south of Drumochter, now lost in the distant reaches of history, was just within reach if the weather was favourable and the cattle willing.

It was not only Drumochter which saw the passing of the cattle droves. The farmers of earlier years had other routes along which they could take their beasts to the markets of the south. From the areas between Craigellachie and Grantown on Spey, there were alternative routes by way of Glenavon and many drovers preferred the route up through Glenlivet, crossing the hills to Strathdon and from there on to Ballater and Aboyne to join the droves coming down from Buchan and the northeast. There was also a more direct route to the south which

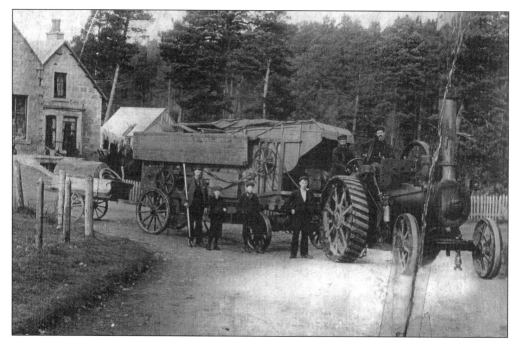

Travelling threshing team on Speyside

went up the Avon to Tomintoul, from where it followed the line of the military road to cross the River Don near the old castle of Corgarff. From here the drovers could head for Braemar and again join up with the eastern drove routes. Although the first of these routes took the cattle away from the established roads, the second one through Tomintoul, while it may be a route which the modern traveller in his car would probably never even consider as a way southwards, takes the visitor back into these long-lost times, to gain a sense of what it must have been like for the men, the dogs and the beasts.

The cattle farmers from around Nethy Bridge and Aviemore could also send their cattle across the high passes of the Lairig Ghru and the Lairig an Laoigh, leading again to the valley of the Dee and the village of Braemar. These, though, were also the routes used by the cattle thieves of the mid eighteenth century and going this way may have proved to be a greater risk to the profitability of the droving enterprise.

We will never know to what extent the droving trade was a serious influence on the growth of the settlements of Badenoch and Strathspey but it surely must have been a factor which allowed the people, or at

least the more enterprising ones, to establish profitable businesses. It certainly had an influence on the road network though, the routes followed the easiest path for man and beast, a fact which was taken advantage of not only by General Wade but continued by later road and railway builders, much to the advantage of the modern traveller.

BATTLES, REBELLIONS
AND RELIGIOUS DIFFERENCES

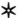

One of the earliest recorded battles to have been fought in Badenoch and Strathspey took place at Garva in Laggan in 1187, between the armies of the two competitors for the Scottish throne, William the Lion and Donald Ban. Whilst we know very little about the battle itself, it turned out to be a victory for William and an inevitable death for Donald Ban.

Almost two centuries later the lands of Invernahavon were the site of a battle between two of the Scottish clans. This small estate in Badenoch was the seat of the Davidson Clan, which claimed descent from, and the protection of, the Mackintoshes. There had been a long history of disputes between the Mackintoshes and Clan Cameron, especially over the lands of Glenlui and Locharkaig.

In 1386, a force of about 400 Camerons made an excursion into Badenoch and, after this foray, as they were returning home with the spoils of their attack, which would doubtless have included a good number of cattle, the group were intercepted at Invernahavon by Lachlan Mackintosh with a force which included not only members of the Mackintosh Clan but also Davidsons and Macphersons. As so often happens with a coalition, the Macphersons, in a fit of pique at not being allowed to command the attack on the Camerons, withdrew from the battle, leaving the Mackintoshes and Davidsons, who were now considerably outnumbered, to be routed and cut to pieces.

Tradition has it that, after this disaster, the Mackintosh bard was sent to the Macpherson camp, where he taunted them with a ballad about the cowardice of this clan who had left their friends to die. The chief of the Macphersons, in his anger, called his men to arms and attacked the Cameron camp in the dead of night and those who were not slaughtered fled into the darkness and the mountains. Such was life in the fourteenth century.

So we have yet another lost event in the turbulent history of this part of Scotland and it leads one to wonder how many of those staying at the caravan site at Invernahavon actually realise the battle and the bloodshed which took place over 600 years ago on the very spot where they are now enjoying their peaceful Highland holiday.

It was just over 200 years later, following the Reformation in Scotland, the fall of the Roman Catholic Church and the rise of Presbyterian power, that there were threats of a Spanish invasion in which the Scottish Catholic noblemen were to take an active part. Had this been successful it could well have resulted in the re-establishment of Catholicism in Scotland. Again we were to see a battle, now one not based on the older clan rivalries but on religious divide.

THE BATTLE
OF GLENLIVET

Just six years after the failure of the Spanish Armada, the pro-Catholic landowners – George Gordon, Earl of Huntly, Frances Hay, Earl of Errol, and William Douglas, Earl of Angus – had written letters which were intercepted as they were being taken to Spain. These 'diverse letters and blankes directed from George, Erle of Huntlie, Frances Erle of Errol, and Wilyam Erle of Angus, subscryvit with their hands written sum in Latin and sum in Frenche, togidder with their cachets, signets, &c' (Gordon Muniments), were also to become known as the Spanish Blanks and showed that the Catholic earls were either handling Spanish gold or were asking for more of it to encourage a Catholic rising in Scotland. They were even possibly trying to arrange another attempt at a Spanish invasion, to meet up with the armies of the Scottish Catholic nobles.

This was not just a Scottish problem, though, and, far away down in London, Queen Elizabeth and her ministers and many of the Protestant nobles all decided that these Scottish earls should be acted against and eventually the Scottish King James was forced to declare that the earls should be outlawed.

This caused the king a bit of a problem, as the Earl of Huntly was one of his favourites. Although he ordered that the Huntly estates should be forfeited, the countess was allowed to continue to live at the castle in Strathbogie, a deal which incensed the Protestant leaders.

The Earl of Argyll was just a lad of eighteen summers when he was

selected by the ministers, much against the better judgement of the king, to lead a punitive expeditionary force against the Catholics. His reward for success was to be the Earl of Huntly's lands in Badenoch. Heading eastwards with a 10,000-strong ill-disciplined and booty-hungry horde of Highlanders, Argyll first made for the castle at Ruthven. They besieged Ruthven without any great success and Argyll continued on his way north towards Glenlivet, aiming for his ultimate targets of the castle of Strathbogie and the Countess of Huntly. The next night the army camped close to Drumin.

In the meantime, the Catholic army under Huntly and Errol had met up at Auchindoun. A force of no more than about 1,200 men but with a section of mounted horsemen and also being armed with two small cannon, they considered themselves equal, if not superior, to Argyll's native hordes. They decided that attack was the best form of defence and at 10 o'clock on the morning of 3 October 1594, just five days after Argyll had left Ruthven, the Catholic army arrived on the bleak, boggy, mist-shrouded moor of Morinsh, above the little winding burn of Altachoylachan. At the same time, Argyll was making for the higher ground just to the north of the moor. He reached the rising ground and, through the swirling mists, saw the opposing force just a short distance away to the south. The hour of battle had arrived. It is reputed, incidentally, that the last ever use of the Highland harp on the battlefield was at this contest and the harp was eventually replaced by the bagpipes to lead the clans into battle.

Argyll's soldiers, poorly equipped, all on foot and most wearing little more than just a plaid, were totally unfamiliar with the opposing cannon or the horsemen. By the time of the third cannon shot, many of them were becoming totally demoralised but were still able to mount a stout resistance to Errol's cavalry. Huntly outmanoeuvred the Highlanders, attacking them from the rear, and, for a quarter of an hour, the battle raged fiercely. The treachery of Grant of Gartenbeg, a friend and ally of Huntly, soon put the issue beyond doubt. Gartenbeg had, at the suggestion of the Laird of Grant, seemingly taken sides with Argyll but, on a pre-arranged signal from Huntly, he withdrew his men from the battle, leaving the Highlanders to their fate.

The royalist army of Argyll broke ranks and fled down the steep brae to the burn of Altachoylachan and up the slopes of the hills, land on which the cavalry could not follow them. But the foot soldiers did

and contemporary reports suggest that over 500 men of the royalist army met their doom on the braes of Glenlivet, whilst only about a dozen of the Catholic soldiers were killed.

The Catholic landowners of the northeast of Scotland regarded Huntly's victory as a providential deliverance, having feared that, if Argyll's forces had taken the day, they would all have lost their estates and lands. Even King James seemed to be quite pleased with the result but Huntly decided that it would be a good idea to leave Scotland for a while. Two years later, conditions were agreed for his return, which included a caution (a bond) of £40,000 as a guarantee that he would have no further dealings with foreigners, would continue to live north of the River Dee and, most importantly of all, that he would satisfy the discipline of the Protestant Kirk. He and the other rebel lords made a ceremonial submission in Aberdeen in 1597 and not only was Huntly pardoned but, two years later, he was elevated to become marquis.

Not far from the scene of the battle stood the old pre-Reformation Chapel of Downan or Dounan, also known as Bridgend of Livet, safely ensconced within its turf-dyked burial ground on the banks of the River Livet. Some sources suggest that the walls of the old chapel, which had gone out of use shortly after the Reformation, were still standing in the late eighteenth century but, by 1869, the chapel was yet another lost building in Strathspey and only vague traces of the outlines of the foundations were revealed when the dawn sun was low in the east and the dew lay heavy on the homes of the departed. It may be here that many of the soldiers who took part in the Battle of Glenlivet, Catholic and Protestant alike, found peace in their last resting places.

Local tradition held that a cross-incised stone which lay near the chapel marked the site of the burials of some of those killed in the Battle of Glenlivet and there are also many smaller un-inscribed markers which are thought to mark the burial places of others killed in this battle. The carved stone is not lost and still stands amongst its more recent counterparts in the churchyard. Apart from a plaque which has been erected to mark the actual site of the battle, these markers are now the only surviving evidence of the battle which took place over 400 years ago on the mist-shrouded moor of Morinsh.

Almost another century was to pass until, just a few miles to the west, the valley of the Spey was the scene of another and even better-documented battle on the Haughs of Cromdale.

THE BATTLE
OF CROMDALE

Maybe it is useful for the reader to know just a little about the background to those events in the shadow of Creagan a'Chaise. It had all really started with the breakdown in relationships between the Catholics and the Protestants following the birth of a male heir to King James II in 1688. The Protestants, dismayed by the attempts of King James to install his Catholic supporters into positions of power, had invited William of Orange to become their Protestant King and, in November 1688, William and his wife Mary had landed at Torbay in the southwest of England. The scene was again set for war and, like the battle of a century earlier, it was all about the religious divide.

At the Battle of Killiecrankie on 27 July 1689, the day had ended in a rousing victory for the Highlanders, who continued to support King James despite the fact that he had by now already abandoned his throne and fled to France. There was always the hope to cling to, though, that, if their successes continued, he could be tempted back to his throne. It was not to be and just three weeks later, at the Battle of Dunkeld, the Jacobites were defeated and the Highland army was driven northwards and westwards into their strongholds in Lochaber and the west of Scotland.

It took them some time to regroup but, by the end of April 1690, the Jacobite army, under the command of Major-General Buchan, who had taken over command from the Chief of Clan Cameron, was again ready to do battle with the government army. Such was the nature of war even in the seventeenth century, though, that battle could not commence until the usual spring jobs had been done on the crofts, farms and estates of the Highlands. It would not do to disrupt the way of life or the economy of the Highlands just to fight a battle.

The government had assembled a force of some 3,000 men at Perth and other regiments and five troops of horse and dragoons were also put in readiness. The garrison at Inverness was, by now, on full alert.

Once all the spring jobs were completed on the crofts of the Highlands and the crops and the beasts could be left in the care of the womenfolk until harvest time, Major-General Buchan and his army advanced through Badenoch, with the intention of marching down through Strathspey into Gordon country. Here he planned to recruit more men but his dreams of attracting additional soldiers on the way

did not really materialise as he was, according to contemporary reports, not the most popular of leaders. He had already ignored the advice of his officers at the council of war at Culnakill not to advance so far but he pressed on down the Spey until he reached the settlement of Cromdale on 30 April 1690.

So, the reader may well ask, what is lost about all of this? Quite a lot. Never in this modern age will we see battles being put off so that they might fit in with the cycle of nature, with sowing and harvest times, and never again will anyone see the Highland Jacobite army marching from the west and down Strathspey but surely, in those days, the local people would have turned out to watch the soldiers go by. The large force of men, now under the command of Colonel Cannon of Galloway, camped for the night on the Braes of Lethendry, near to the castle. All told there were maybe 1,500 men of the name of MacDonald, MacLean, Cameron, MacPherson and Grant and their supporters. How colourful a scene would this have been, with the plaids of the soldiers, the smoke rising from the camp fires, the general hubbub of men ready for battle and, of course, the camp followers, the baggage trains and horses and wagons everywhere.

They were totally unaware of the government troops, under the command of Sir Thomas Livingstone, who had made their way from their garrison at Inverness across the bleak wastes of the Dava Moor. Six troops of Scottish Dragoons, a battalion of foot soldiers and two troops of cavalry were now descending from the moor into the wooded valley of the Spey. Even Castle Grant, the 'Bella Chastell', had been in a state of lock down so that no Catholic supporter, not even the meanest cottar or servant, could leave the castle or its policies to give the Jacobites an inkling of their impending doom.

In the misty dawn of the first day of May 1690, with the grey clouds hanging low over the Haughs of Cromdale, the government troops were spotted crossing the River Spey at the ford near where the bridge at Cromdale now stands. The alarm was raised in the Jacobite camp but this only encouraged Sir Thomas to make a sudden cavalry charge on the bleary-eyed soldiers just awakening from their slumbers. Sir Thomas had an advantage as part of the route of his attack was concealed by the birch woods along the riverbank. The attack was so sudden that many of the Highlanders had no time to reach for their belted plaids or their weapons and they fled naked into the hills beyond Lethendry. Many of them had already been wounded and the hills became a dying

field for those who had collapsed from their injuries. Some of them, but very few, managed to make it over the hills into the valley of the River Avon and find some sort of sanctuary in the pro-Catholic Braes of Glenlivet.

The few who stayed to face the government forces had little hope and their resistance was futile. Fortunately for some of them, the mist came down from the hill, making pursuit almost impossible, but about 400 men were either killed or taken prisoner on that day. Others were rounded up and imprisoned in nearby Lethendry Castle and in the mill at the castle's farm. According to General Mackay, the commander of the army in Scotland at that time, the government forces lost no soldiers and only a few horses but other sources put the Redcoat losses at up to a hundred. We will never know the real tragedies which resulted from the Battle of Cromdale.

Some of the Camerons and MacLeans escaped and, the following day, this party, said by some to be about a hundred men, were pursued by a troop of Livingstone's men, who caught up with them on the Moor of Granish near Aviemore. Some of them were killed but the survivors took refuge in the high crags of Craigellachie, just west of Aviemore. They were soon joined by the Laird of Keppoch and his Highlanders and they attempted to seize the castle of Loch an Eilein, in Rothiemurchus, but, suffering even more losses, they were repulsed by the proprietor and his armed tenants and the remnants of the once-proud Jacobite army fled westwards to their homelands.

The Jacobite defeat ended any hopes of King James being restored to power in Scotland and, apart from an abortive invasion attempt in 1708, it was not until 1715 that the Jacobites once more found the collective will and confidence to attempt another rebellion.

THE 1715
JACOBITE REBELLION

Despite what we may think, this rebellion had a considerable effect on Badenoch and Strathspey – maybe not in battles, either great or small, but in skirmishes and, more to the point, in its divisiveness amongst the landed gentry. But its aftermath was in many ways to prove to be a blessing for the area.

The 1715 rising, led by John Erskine, the Earl of Mar, called on the

support of those people who lived north of the River Tay, especially in the northeast and the Highlands of Scotland, areas which had not really received much benefit following the Act of Union almost a decade earlier. These were mainly Episcopalian families, who viewed the Stuart family as the head of their Church, and also some Catholics who would go to almost any lengths to rid the country of the Presbyterian way of worship.

Mar was not a good leader and, despite outnumbering the Hanoverian forces at Sheriffmuir by nearly two to one, he failed to take advantage of his superior numbers and could not win a decisive victory. Confusion reigned and, whilst one wing of the Jacobite army was pursuing the King's troops towards Stirling, the other was retreating in the opposite direction, northwards into the snows of the mountains.

Eventually the rebellion died out. This was not only due to the arrival of six thousand Dutch troops in support of the Hanoverian side but also through a general lack of organisation and commitment on the part of the Jacobites. A large number of the Jacobite soldiers stayed together until they reached Badenoch, from where they were able to make for their homes and vanish from the scene. The gentry withdrew to their estates and mansion houses where they fearfully awaited their fate. Retribution was not long in coming and the consequences for many of the landowners were quite dramatic with many of them losing their estates.

In the aftermath of the rebellion, the Forfeited Estates Commissioners reported that, in 1716, there 'met at Edinburgh a set of commissioners appointed under a late act to inquire of the estates of certain traitors, and of popish recusants, and of estates given to superstitious uses, in order to raise money out of them for the use of the public.' The estates of rebels were forfeited to the crown and, in 1719, commissioners were appointed as trustees for the sale of these estates. 'The first and most prominent object was to appropriate the lands of the Scottish nobles and gentlemen who had taken part in the late insurrection for the House of Stuart.' This was a time when some of the Highland landowners had serious financial problems which may have led to a very definite change in the way of life on their estates. Other lairds, though, had seen this coming and, despite their own political or religious leanings, had managed to stay on the 'right side' of the 1715 Rising, much to the benefit of their estates and their tenants.

Scotland, and especially the north of Scotland, continued to be a

thorn in the side of the government and, although the Duke of Argyll and many other prominent Scots viewed Jacobitism as a political problem, to the government in the south it was a military problem. And so they devised a 'Military Solution'. We have this decision to thank for many of the roads and bridges that we still use in our travels around this part of Scotland.

As part of their plan to garrison the Highlands, new forts and barracks were built. This included the demolition of what was left of the old castle on its mound at Ruthven and the building of the new barracks there, as mentioned in a later chapter. General Wade was appointed to plan out and supervise the building of a system of roads with the purpose of pacifying the Highlands, to permit the rapid deployment of troops and supplies to the new forts should another rebellion occur. General Wade was to build over 250 miles of roads and numerous bridges, all at a huge expense to the still rather nervous government. The plan to pacify the Highlands was scaled down in the early 1740s as the threat of another rebellion receded – or so they thought! At least the people of Badenoch and Strathspey got a considerable improvement to their previously almost non-existent road network and, in modern times, if we look carefully alongside our modern Tarmacadam roads, we can still see traces of the old routes and quite often see the old bridges, now becoming ruinous, which may still serve to provide access to farms or crofts or to the ways up the mountains.

THE 1745
JACOBITE REBELLION

Maybe the government had let up too soon on their stranglehold on the Highlands but the Jacobites had not given up. The details of the '45 are too well known for them to be described here but it is the effect of the Rebellion on the lands and the people of Badenoch and Strathspey which are of interest and which resulted in several Highland estates again being lost.

After the arrival of Prince Charles Edward Stuart, the Jacobite army made its way south towards Edinburgh. Directly in the path of the rebels' advance on Edinburgh lay the lands of Cluny and the decision of Cluny Macpherson was vital. Did he support the rebels or the King? He dithered. Whatever he decided to do could have serious

consequences: he could lose his estate and he could also lose at best his freedom, at worst his life.

On 28 August 1745, with his mind now made up, he was on his way to raise his clansmen to support King George when he was seized by the rebels and taken off as their prisoner. What went on during the next few weeks we will never know but eventually he returned to Badenoch and gathered a force of about 300 of his MacPherson clansmen. Pausing on the way only to force out the men of Glenlyon and Rannoch, Cluny's force then joined the Jacobite camp at Edinburgh on 29 October, after a march of 14 days. Just two days before Cluny had been seized by the rebels, Sir John Cope had paused amongst the bleak hillside surrounding Dalwhinnie, pondering the ascent of the Corrieyairack Pass along the new road built not so many years previously by General Wade and his men. He decided against it, probably because of the rumours of 3,000 armed clansmen waiting for them, and set off northwards towards Aviemore, bound for Inverness. In doing this, he had left the way open for the Jacobite army to pass through the now unguarded lands of Badenoch and make their way towards Perth and ultimately to Edinburgh.

These are sights long lost to us as we now pass through Badenoch. No lines of marching soldiers with their baggage train and their camp followers will ever cross these hills again and the valleys will never resound to the shouted orders of the officers, the grumbles of the troops or the chatter of the women following them.

Following the Jacobite adventures into England and the subsequent retreat back north of the Forth, Lord George Murray, with his troops now in Inverness, headed south to join up with Cluny and his 300 MacPhersons in Badenoch. At dusk on 16 March 1746, Lord George and Cluny MacPherson led their force of 700 Highlanders from Dalwhinnie southwards out of Badenoch to Dalnaspidal, from where they were to mount what were virtually guerrilla attacks on the enemy's outposts in Atholl. The raiding parties returned after a successful operation, despite the large government forces they encountered, and all were able to return safely north over the mountains. The somewhat irritated government troops now proceeded to lay siege to Blair Castle as some sort of retribution against the rebels, who were in turn able to blockade them.

Just two days before the final, tragic and decisive battle on Culloden Moor, Cluny and his men were still in Badenoch and there was no

possibility of them reaching the bleak wastes of Drummossie Moor in time to take an active part in the Battle of Culloden. But they continued to make their way northwards and they were within just a few miles of the scene of carnage when they met up with the fugitives fleeing the battle and were able to form a rearguard for the 3,000 Jacobites who were now retreating southwards towards Badenoch and the Ruthven Barracks.

The flight of Bonnie Prince Charlie put an end to any hopes of a Jacobite king and the majority of the clansmen surrendered their arms under a general amnesty called throughout Badenoch. Cluny's own house was burnt by the Duke of Cumberland's army in June 1746 and, following several years as a fugitive, Ewan MacPherson of Cluny fled to France, never again to see his native hills and glens.

Others fared better. Evan Macpherson, farmer at Dalwhinnie, Lewis MacPherson, farmer at Dalraddy, Alexander McQueen, the smith at Ruthven, and most of the other tenant farmers and crofters on Cluny's lands surrendered in the days following Culloden and were fairly quickly released. There were very few casualties among the men of Badenoch: Kenneth MacPherson, a merchant in Ruthven, had been taken prisoner back in January and was later set free; Aeneas Kennedy had been taken prisoner at Carlisle and died; William Macpherson, the farmer in Catobeg, had also died; and William MacPherson, Cluny's purser, had been killed at Falkirk. The only prisoner from this area to be transported was James Smith, a Strathspey man, who, in all likelihood, ended up in Australia. So Cluny's force got off very lightly compared with some of the Jacobites and the area soon returned to the quiet backwater it had been before the battle.

THE AFTERMATH
OF THE '45

Behind all of this, of course, was the religious conflict – Protestant against Episcopalian, Catholic against everybody. In reality, there were no winners. But what of the aftermath of the '45 in Badenoch and Strathspey?

To the men and the women of the Highlands, of Badenoch and of Strathspey, the consequences of the Jacobite defeat at Culloden had a long-lasting effect – their way of life and, to a great extent, their culture

were to be changed forever. No more the wearing of the plaid, the philabeg, the Highland dress, no more the carrying of arms to defend themselves from the unwanted attentions of strangers, no more the sound of the bagpipes across the bleak moorlands of Badenoch. From the Mackintoshes and the MacPhersons in the south to the Grants at Rothiemurchus, at Freuchie and at Ballindalloch, and all the way down Strathspey to the lands of the Gordons, the victorious government proscribed all of these things. The 'rebellious Scots' had to be kept under control – under the control of an English government.

The common people suffered in many ways and just one example is that of James McKeran, a servant to Widow Jean McKeran, who was employed by John Garrow in Belnacoul of Ruthry, near to Aberlour, to help him with the repairs to a cruive dyke. These cruive dykes in the River Spey were used to control the flow of water and were of special value to the salmon fishermen but they were often damaged by the great rafts of logs being floated down the river. James did not want to get his breeches wet while he was working in the river so he temporarily went back to wearing his philabeg, which he hitched up to keep it dry. Along came Lieutenant James Grant, one of the Grants of Ballindalloch, who saw him working in the river. Despite James's reasoned argument, the Lieutenant immediately arrested him for wearing proscribed clothing. Whether the threats to take him to the tollbooth of Banff or the jail in Elgin were ever carried out is not clear but it was left to the best arguments of Sir Thomas Grant of Arndilly to secure his release. This is just another indication of how strictly the rules were enforced.

Estates were again forfeited and, although landlords sympathetic to the government were allowed to make offers for the lands, in effect few did or not, at least, on a long-term basis. Badenoch and Strathspey were changed. The old ways of life were now lost and only in the old clan stories was much of the history remembered – the poets and the storytellers must have had a busy time of it.

It was not a good idea to be a member of a Catholic congregation. Episcopalianism was tolerated and Presbyterianism was encouraged. The landed gentry, with their private Catholic leanings and outward demonstrations of support for the Episcopalian faith, were perhaps the worst affected. But some rebelled, if a little secretly. The Duke of Gordon, whose lands extended up Strathspey to the territory of the Grants, provided safe havens for those who still wished to follow the Roman practices. Just to the east of Strathspey, among the heather-clad

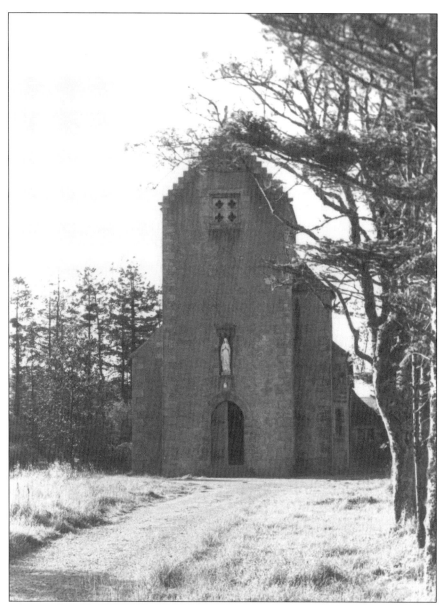

The Church of Perpetual Succour at Chapeltown, built in 1897

hills and moors of the Braes of Glenlivet and also even closer to home, in the wooded hills of what had once upon a time been the great forest of The Enzie, to the east of Gordon Castle, the Duke supported those who continued to follow the Popish way of worship. It was not always easy, especially in the years immediately following Culloden, but the power of the Duke and the silence of the local people meant that these Catholics could work and worship in peace. No doubt, though, they were always keeping one eye on their backs.

The Braes of Glenlivet may not truly be a physical part of Strathspey, being along the tributary valley of the Avon, but historically the braes are such a fundamental part of the texture of life in Strathspey that it is surely impossible to ignore them. This remote place of sanctuary, nestling in the hills beyond Ben Rinnes and the Bridgend of Glenlivet, was, in its own way, to provide the basis of a secure future of Catholicism in Scotland.

Chapeltown has been a place of worship for many years and maybe there was a church here from very early times but any traces of this and also of the church which was built in 1829 are now long gone. The later Church of Our Lady of Perpetual Succour was designed by John Kinross in 1897 and the work was financed by the Marquess of Bute. It is an unusual church with a tall crow-stepped tower. But it is not Chapeltown that we are really concerned with, for about a mile further up the track lies Scalan.

THE CATHOLIC SEMINARY
AT SCALAN

There seem to be many conflicting ideas about Scalan. Some of the more popularised sources seem to indicate that it only came into use as a Roman Catholic seminary after the events of the '45 but other, more reliable records show that Scalan actually came into use following the earlier rising and was probably taking students from as early as 1716 or 1717, when the seminary at Morar had to close following the first defeat of the Jacobites. There are yet other sources which suggest that Bishop Nicholson and Bishop Gordon were considering the possibility of a seminary at Scalan as early as 1712. Maybe even the foundation of Scalan is now a secret lost in a time of religious persecution.

The site was perfect in view of the dangers which could be faced by

practising Catholics. Here, in upper Glenlivet, secure in the lands of the pro-Catholic Gordons, was the ideal location in this treeless wilderness without roads of any description and where whatever tracks there may have been were merely an indication of a slightly easier route through the hills. The circle of hills concealed the primitive turf cottage, with its heather thatched roof, from the ordinary traveller until they were almost upon it. There were probably very few visitors here anyway, as the only access to the cottage was by way of a bridle path through the nearby bog.

It was not always totally immune from attack, though, and in 1726 it had to be closed temporarily due to the arrival of hostile soldiers who drove the inmates out of the seminary. Thanks to the intervention of the family of Gordon, however, the students were able to return less than a year later but, just two years on, the priests and their scholars received two more visits from the soldiers. These efforts to suppress the work of Scalan, however, were always overcome and the old faith survived in the Braes of Glenlivet.

Originally it was described as the seminary for the whole of Scotland but, by 1732, it became the seminary for the Lowland District. The name was probably derived from *sgalan*, the Gaelic word for a turf shieling, a place where the herdsmen would have lived in the summer months whilst their cattle grazed the hillsides.

In 1746, Scalan was deemed to be of such importance or maybe just such an irritant that Cumberland's troops made a long detour to burn it to the ground. The scholars and their teachers were able to escape with their lives and were also able to hide the altar furnishings. Although the turf cottage was rebuilt, there are now very few traces of this first building near to the bridge and the Bishop's Well, which lay in the bank beside the burn. The building on the opposite side of the Crombie Water is still standing and was possibly originally a farmhouse which became the college in 1762 when Mr John Geddes came to take charge. The original thatched roof was replaced by slates in the nineteenth century and the exterior and part of the interior have now been restored.

Following the departure of John Geddes, Bishop Hay came to take charge at Scalan and, according to the Reverend Hamilton Dunnett, a later minister of the parish of Invera'an, 'the story of his life's work is practically the subsequent history of the college. It was all to him, and it may be said that it owed all to him.' Under his authority the plain two-storey building was extended to contain the 'Boys' Chapel', which

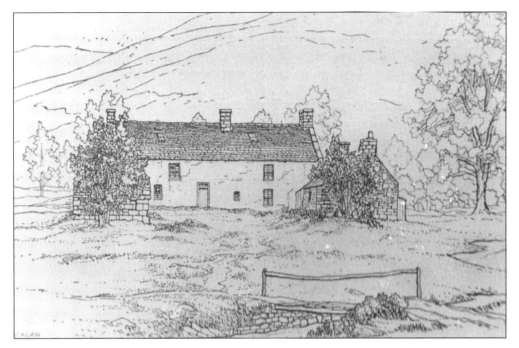

Scalan, the old seminary

also served as the schoolroom and refectory, 'Bishop Hay's room' above which was a private chapel reached by a stone staircase, the 'Blue Room' which was once occupied by Mr Geddes, the boys' dormitory, the teacher's two rooms and the kitchen.

In addition to the teacher, there were also a housemaid and a farm servant who, with the help of the boys, was employed to look after the few acres of croft land adjoining the seminary. An earlier document even describes the boys' 'uniform' as 'Highland dress of black and blue tartan and home-made brogues'. It goes on to tell us that the leisure hours of the boys during the long winter evenings 'were beguiled in the genial society of the bishop relating stories of his many adventures in Jacobite times, or in playing battle-dore and shuttle-cock for their exercise'. Scalan seems to have had, at any one time, maybe ten or twelve students under the charge of a teacher who would also have been a priest. Under his authority, they were not only educated but learned to manage the farm and the house, a good all-round training for the often quite lonely lives they were to lead as celibate Catholic priests. It is interesting to contemplate how many of the younger generation of the modern world could cope with such a disciplined upbringing.

Hidden away in the Braes, this Roman Catholic college was properly described as 'the Bishop's seminary for educating a few of the Catholic youth in the principles of grammar and morality, and training them to a regularity of discipline in preparation for the Colleges on the Continent'.

Even in the somewhat more emancipated years of the later eighteenth century, though, the Catholics were still very wary and they had every right to be. They were afraid to bury their dead in the churchyards of Downan and Kirkmichael as some of the Presbyterians considered publicly that these Papists from the braes had no right to a Christian burial. The Catholics established their own cemetery at Buiternach, high on a hill guarding the entrance to the Braes of Glenlivet and enclosed by a turf and stone dyke. A desolate but beautiful place, with panoramic views and looking up from the glen below, you would think it just any ordinary farm dyke along the brow of the hill. This was surely not just a place of burial – in times of trouble, it may well have been a place from which to keep watch for any unwanted attentions from the Hanoverian soldiers. It is not a 'lost' burial ground but it does take quite some effort to find it.

There were also two other burial grounds in the area used by the Catholics. Phonas was the site of an early chapel, with a burial ground which was in use before 1760, but this site is now totally lost. Nevie or Chapel Christ was also the site of an early chapel and burial ground but the remains of the burial ground were washed away by the river during a flood at some date prior to 1760. The chapel ruins were still known as 'Chapel Christ' and were visible in 1794 but all traces had been obliterated by agriculture by the middle of the nineteenth century – just two more of the 'lost' places of this remote area.

The very remoteness of Scalan became a disadvantage after the penal laws against the Catholics were abolished in 1793 and, by 1799, the college was moved to Aquhorthies, near Aberdeen, having trained over a hundred priests during its lifetime. One such priest was Abbe Paul MacPherson, who had been born at Wester Scalan, right on the doorstep of the college, in 1756. With Catholicism still proscribed in Scotland during much of his early lifetime, his religious career lay in Europe and he eventually became the Rector of the Scots College in Rome, with the title of Abbot.

He came into his own during the Napoleonic Wars, when he helped the agents of the British government in some diplomatic missions that

many think bordered on spying. He made use of this status and forced the government to consider removing the restriction they had placed on the Catholic Church, maybe demonstrating that all Papists were not traitors, and eventually, in great part due to his endeavours, the Catholics were emancipated in 1829.

That was the year when he returned to Scalan to found a church and the land he was given for this by the family of Gordon was just a mile down the valley, at what was later to become known as Chapeltown. Here he was at last able, in freedom, to build his church and school and, in his own way, ensure that these remote braes were once more a part of the culture and heritage of Strathspey.

The ruined Crofts of Scalan, adjacent to the seminary on the hillside above the valley of the Crombie Water, bear testimony to a way of life now vanished – just another of the lost townships of Strathspey.

CHAPTER 4
CASTLES AND FORTRESSES

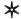

Badenoch and Strathspey was an area of conflict, of disputes between the various families, and a land of castles and fortresses. When all is said and done, however, it was the families of Grant, MacPherson and Gordon who really ruled the roost in this corner of Scotland. Apart from Ballindalloch Castle and Castle Grant, these castles were maybe not the grand structures of the Moray and Nairn lowlands or of Aberdeenshire, just beyond the mountains to the east, but, nonetheless, this was an area where family honour, clan traditions and customs needed to be upheld.

The two large castles of Castle Grant and Ballindalloch Castle have a long and well-documented history but it is some of the smaller ones, many of them now little more than crumbling ruins or even, in some cases, totally lost, which are worthy of our first thoughts.

RUTHVEN CASTLE
AND BARRACKS

The earliest record of a castle at Ruthven is in 1229. Like most castles of this period, it had probably started life as a wooden defensive palisade around a settlement on the top of an artificial mound, much like the castle at Elgin. The concept of castles gradually changed, though, and they evolved from being just a place to which the people and their valuable animals could retreat in times of trouble into expressions of status with stone walls containing the buildings inside and also giving a much greater possibility of a robust defence against any attackers.

Alexander Stewart, the fourth illegitimate son of King Robert II of Scotland by Elizabeth Mure of Rowallan, was legitimised in 1349 at the age of six, when his parents eventually married. In 1371, he was made Lord of Badenoch and his father granted him large estates in

Ruthven Barracks, high on its artificial mound above the valley of the Spey

the Highlands. At this time, the castle at Ruthven, together with his fortresses of Lochindorb and Drumin further to the north and maybe also the castle of Loch an Eilein, became one of the main centres for the activities of Alexander Stewart, the infamous 'Wolf of Badenoch'. He went on to abuse his power, maintaining a rule of tyranny across much of the Highlands, pillaging the countryside and imprisoning and murdering any who were bold or stupid enough to defy his authority.

In 1382, Alexander Stewart was made 1st Earl of Buchan and with that came the office of justiciar, which allowed him to exercise the full authority of the Scottish Crown all across the Highlands. He married Eupheme, the Countess of Ross, at this time, which meant that he was now able to exercise his ruthless control over a much greater part of the country. He blamed his wife for the fact that they had no children – he had already proved himself by fathering a total of about 40 illegitimate children by various women – and, seven years after the wedding, he asked the Bishop of Moray to intervene to bring the marriage to an end. The Bishop refused and, when Alexander threw

his wife out to make way for a new mistress, he was excommunicated. It was Alexander's retribution for this which led to the destruction of the town of Forres, the sacking of Pluscarden Abbey and the ruin of the town and Cathedral of Elgin, as has been mentioned in *Lost Moray and Nairn*.

Not a nice man and not one to be on the wrong side of. Maybe it is fortunate for us that these times are now just another part of the lost way of life in Badenoch and Strathspey. But retribution was to come.

After his attacks on Forres and Elgin, Alexander Stewart begins to fade out of the history of Badenoch and Strathspey and even the details of his death are not very clear – some sources suggest that he lived until 1405 or even 1406 – but another story is much more intriguing. Legend has it that, on one summer's evening in July 1394, a visitor, dressed all in black, arrived at the Castle of Ruthven. As was usual in those times, he was welcomed in a most hospitable manner and, later in the evening, he challenged Alexander Stewart to a game of chess. The two men played on well into the night but, at the very moment when the visitor cried 'checkmate' and rose from the table, the castle was beset with terrible thunder and lightning and the storm continued unabated for much of the night. In the calm of the following morning, the scorched and blackened bodies of the castle servants were found outside the walls, all of them apparently killed by lightning. The body of the Wolf of Badenoch himself was found in the banqueting hall where the chess match had been taking place. His body was unmarked but all of the nails in his boots had been torn out. Just one of the perils of playing chess with the devil, and a much more exciting story!

The legend continues, for when his funeral procession took place a couple of days later, his coffin was carried at the head of the procession. The thunder and lightning and the hailstorms started all over again and it was not until his coffin was removed to an insignificant place at the back of the cavalcade of mourners that the heavens relented and the procession was allowed to go in peace. The remains of the Wolf of Badenoch finally found a quiet resting place in the Cathedral of Dunkeld, his crimes against the church having been forgiven.

The earlier castle was destroyed by a fire in 1451 but, during the following eight years or so, it was rebuilt on a much more impressive scale. In the 1590s, the Earl of Huntly resolved to strengthen the castle even further, to secure his estates in Badenoch, but these plans seem to have been abandoned in the face of the forces of the Earl of Argyll on

their way to the Battle of Glenlivet. The castle, in whatever form it now stood, was badly damaged by John Graham, 1st Viscount of Dundee, and the Jacobites at the time of the Battle of Cromdale in 1689.

Following the Jacobite uprising of 1715, the government of the day decided to build several new barracks – Fort William, Fort Augustus, Fort George and also the new barracks at Ruthven. The old castle, on its mound overlooking one of the principal crossing points on this part of the River Spey, was demolished and all traces of it were removed. The building of the new barracks was finished in 1721, although the stables were not completed until some 13 years later. The new building had been designed to house 120 troops in two barrack blocks and the officers lived separately from the ordinary rank-and-file soldiers. The stable block was eventually built just to the west of the barrack blocks, to house 28 horses for the dragoons.

The work of General Wade and the building of the military roads as mentioned in a later chapter all enhanced the importance of the new barracks at Ruthven, which stood at the junction of the roads from Perth, Fort Augustus and Inverness and also controlled the head of the old routes down Speyside.

By the time of the next Jacobite rising in 1745, 200 Jacobites tried to capture the barracks but were fought off by a force of just 12 Redcoats under the command of a Sergeant Molloy. The Jacobites returned in greater numbers the following year, equipped with artillery. Sergeant Molloy had, by now, been promoted to Lieutenant but the defenders were faced with such superior forces and arms that the garrison surrendered and the barracks were taken by the Jacobite forces in February 1746. The Battle of Culloden was fought many miles to the north on 16 April 1746 and, the following day, some 3,000 Jacobites retreated to the relative safety of Ruthven to re-form, ready to do battle again in support of Prince Charles Edward Stuart. This was not to be as word reached them that Bonnie Prince Charlie had fled, leaving instructions that 'every man seek his own safcty in the best way he can'.

This was the end of Ruthven Barracks. The Jacobites had little option but to flee the government forces and get away to any safe haven they could find. Setting fire to the building, they fled the scene, many of them going into hiding for many years to avoid the inevitable retributions. The remains of the barracks which stand to this day are much the same as how they would have been left by the fleeing rebels some 250 years ago.

MUCKRACH

Muckrach Castle stands about four miles southwest of Grantown on Spey on the top of a steep bank overlooking the pleasant valley of the River Dulnain. The castle was originally built in 1598 by Patrick, the second son of John Grant of Freuchie, and was the original seat of the Grants of Rothiemurchus. A stone dated 1598 carries the arms and initials of Patrick Grant and his wife and bears the motto 'In God is al my trest'. It was a simple L-shaped four-storey tower house, typical of its time, comprising a square tower with the first floor being reached by a staircase and the upper ones by means of a spiral staircase in a turret corbelled out on the northwestern angle of the tower. This first floor at the top of the main staircase would have been the great hall, with the kitchens and cellars beneath. There was an enclosing wall surrounding the castle and, at one time, this retaining wall enclosed quite an extensive collection of buildings associated with the castle and forming a courtyard. A smaller round tower lay in the southeast corner of this outer retaining wall. By the late nineteenth century, the only evidence of the buildings within the outer wall was to be found in the grassy mounds which covered their ruins.

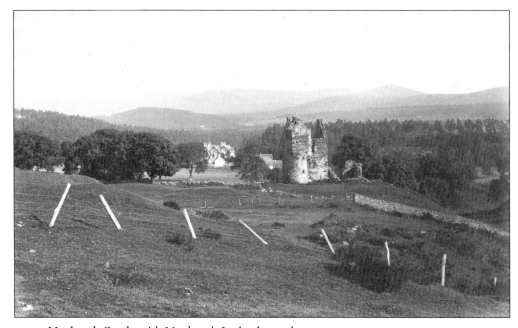

Muckrach Castle with Muckrach Lodge beyond

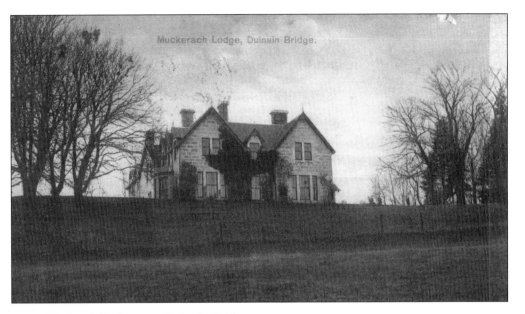

Muckrach Lodge near Dulnain Bridge

At that time, much of the keep was still standing as a roofless tower, with the spiral staircase being virtually intact. The base of the tower was vaulted, to give additional strength to the upper floors, and had several loopholes for defence. The hall on the first floor was 21 feet by 19 feet, with windows on three sides and a garde-robe adjoining the entrance door. Above this first floor the spiral stair was corbelled out to a square shape to provide other useable rooms in the upper storeys and there were two attics above in the gabled roof. The lower staircase was built of hard granite and the stairs above were supported by a peculiar rough arch thrown across a segment of the circular stairs beneath. In the 1890s, the ruined castle was owned by J. Dick Peddie Esq., RSA.

Muckrach Castle was re-roofed and restored between 1978 and 1985, under the watchful eye of the architect Ian Begg, and now provides luxury self-catering accommodation within its gleaming white exterior. Thanks to this restoration, a castle which was once lost is now alive again and stands to remind us of the functional beauty of a sixteenth-century tower house.

Muckrach Lodge, a classic Victorian shooting lodge built for the Seafield Estates in 1860, stands nearby and, in 1960, it became a hotel, which passed through several owners before reaching its present luxurious standards.

LETHENDRY

Lethendry, sheltering beneath the Haughs of Cromdale, was a small L-shaped tower house which was probably built sometime in the sixteenth century. It overlooked the Braes of Lethendry and the valley of the Spey and probably gave some protection to the ford near Cromdale in times of trouble. Lethendry, or at least its policies, was occupied for just a few days by the Jacobites at the time of the Battle of Cromdale in 1690 but it was to be the site of the final stand for many of them.

It is difficult to determine how the castle originally looked but it may well have been built on a similar style to nearby Muckrach Castle and was probably made up of a basement and at least two and maybe as many as four upper storeys. There is scant evidence for any outer enclosing wall but that is not to say that it did not have one to provide at least some protection to the main building or to enclose the stables and other offices which would have been associated with a castle such as this. Too much is now lost for us to be absolutely sure and the few surviving remains of the castle, built of rubble masonry bonded with lime mortar and with small stone pinnings, are now incorporated into the farm buildings of Wester Lethendry.

BALNACLASH

There was a very early castle site, on which only traces of a motte now remain, near to the farm of the same name. It may originally have been a motte with a wooden palisade to protect the buildings within or it may just have been built as a means of protection for the local people during times of trouble. It may even date from a much more remote period in the history of Badenoch and Strathspey but too much is now lost for us ever to know the when or why of the remains at Balnaclash.

CASTLETON OF
GLENLIVET (BLAIRFINDY)

Blairfindy Castle was built in 1564 by John Gordon as a tower house but retained many of the defensive characteristics of earlier fortresses.

In 1586 the building passed to another branch of the family and became a hunting seat of the Earls of Huntly. The building stands on a rise above the steep banks of the River Livet, almost acting as a sentinel to guard the entrance to the Braes of Glenlivet. Maybe even just a few years after the Reformation, the Catholic Gordon families were already beginning to feel threatened by the rising tide of Presbyterianism.

Built to the ubiquitous L-plan, the wing was projected slightly so as to be able to command and defend, if necessary, two sides of the main building. The other two sides were defended by round turrets which were corbelled out on the angles, with the main entrance door being situated in the re-entrant angle of the wing and defended by a squint-hole in the wall.

Fortunately for us, enough remains of the structure to allow an understanding of what it was originally like to live in. On the ground floor, a passage led to the kitchen with its large fireplace, oven and a water drain and then to the cellar. Both the kitchen and the cellar were vaulted as was common in a structure like this to help support the enormous weight of the upper storeys. The cellar had a private stair, built into the thickness of the wall, leading up to the main hall on the first floor above. The main, wide staircase took up most of the wing, starting near the entrance door and just going up to the main hall. From this, a newel staircase was corbelled into the re-entrant angle of the wing and would have led to probably another two floors above, the top floor being in the gabled roof. A boldly corbelled turret was erected near the roof, above the entrance doorway, a somewhat deliberately anachronistic addition which, in earlier times, would have been placed there to make it easier to defend the main door in times of trouble. By the sixteenth century, however, it would have just been designed to give a war-like appearance to what was essentially a residential building and one that was a lot more comfortable than the nearby castle at Drumin which the family had now virtually abandoned.

Above the entrance doorway was a shield containing the Gordon arms, the initials IG and HG and the date 1586. This date, when the Earls of Huntly took over the building, is quite telling as the castle, occupying as it did one of the main passes between Banffshire and Aberdeenshire, could well have played an important part in the Battle of Glenlivet just eight years later. In this battle, as we have already mentioned, Argyll, the young commander of the Protestant army, was defeated by the insurgent Catholics under the Earl of Huntly.

DRUMIN CASTLE

The castle of Drumin is situated on a prominent bluff overlooking the confluence of the River Avon and the River Livet and, with its extensive views along the valleys, the castle once dominated the approaches to Speyside from the east. It lies just a short distance away from the buildings of Drumin Farm.

It was an impressive fortification, having its origins in the fourteenth century and was the centre of the Lordship of Inveravon, the seat of the Barons of Strathavon. It may have been erected on the instructions of Alexander Stewart, the infamous 'Wolf of Badenoch', the son of King Robert II, or it may possibly have been built by one of Alexander's many illegitimate sons, Sir Andrew Stewart. Andrew's son, Sir William Stewart, later sold Drumin to the Gordon family but, within a century of the purchase of Drumin by the 3rd Earl of Huntly in 1490, the Gordons had allowed it to become almost derelict, favouring their new building at Blairfindy. Many of the stones were probably robbed for the construction of nearby buildings and this action would have led to the gradual collapse of the wall at the southeast side, which was eventually reduced to little more than the base courses.

From what it is possible to tell, Drumin was a simple rectangular castle, 53 feet by 38 feet, with walls about 7 or 8 feet thick. Only two of the walls of this four-storey structure now remain to their full height and these show evidence of the fashionable parapet corbelling. The rounded barrel vault of the cellar survives for part of its length and the upper floors show evidence of fireplaces and other features so common at this period.

In 1723, the Aberlour parish mortcloth was used by the Laird of Drumin and, at the time of the Jacobite Rebellion of 1745, there was a large amount of correspondence between the Grants of Ballindalloch, the Laird of Arndilly, and 'Drumin'. This leads us to wonder whether the Grants were still using the old name of Drumin for their new house at Blairfindy or whether some parts of the old castle were still habitable.

In 1839, Drumin seems to have been used as a jail for poachers but, again, whether this was the remains of the old castle or the farm itself is unclear. In a letter to the Duke of Richmond and Gordon's secretary on 24 April 1839, it is noted that 'Cameron the fish poacher has not escaped [from Drumin] so far . . . his farm has been let to another tenant who is already in possession of it.'

During the nineteenth and twentieth centuries, parts of the building were used as a farm store. There is also some suggestion that the remains of the tower were, at one stage, incorporated into the garden of Drumin Farm as a 'romantic ruin', with yew trees being planted on the southeastern side and the ivy encouraged to climb over the remains. This may well have happened when the farm was the residence of William Marshall who, although employed as the agent or factor for the Duke of Gordon, is perhaps better known as the composer of the beautiful strathspeys and airs so beloved by the performers and students of Scottish fiddle music. Later developments to the farm have erased any evidence of former outbuildings to the castle.

CASTLE ROY (BAILLIEMORE)

Situated just to the north of Nethy Bridge, Castle Roy, also known as the Red Castle, was a simple late twelfth- or early thirteenth-century structure built on rising ground about a mile east of Broomhill Station, on what is now the Strathspey Railway. In a prominent position above the valley of the Spey, it was possibly a stronghold of the Comyn family but we have no documented evidence of its early history. The ruins stand on a rocky site which is raised some 10 to 15 feet above the level of its surroundings and now consist of little more than a high wall of stone rubble, some 20 feet high and 7 feet thick and with internal measurements of 80 feet by 53 feet. It had a square tower in the northwest corner and in the opposite corner the wall is broken down so whether or not another tower was built here is unclear. Maybe the wall was knocked down to do this but, as the times of unrest began to fade into history and whatever passed for peace in those times began to prevail, there was no need to build this other tower. There was a recess in the wall at the southwest angle, probably used as latrines, as it had a projecting garde-robe above it. There is no trace of a ditch around the outside of the curtain wall and, indeed, its situation would have rendered it difficult and probably pointless to have such a defence.

Inside what was basically a curtain wall, with its main entrance in the north wall, there would have been wooden buildings, probably built in lean-to fashion against the curtain wall, and the main purpose of the castle would have been to shelter the local population in times of trouble. It would have been a relatively easy place to defend from the top of the curtain wall.

LOCH AN EILEIN

This castle, like that of Lochindorb, is situated on an island in the loch but, in this case, it is probably a natural island and not a man-made one. The origins of the castle are unclear but it is thought that, sometime in the thirteenth century, the Bishop of Moray built a half house at the southern end of the island, surrounded by a defensive wall. There are suggestions that it was probably originally another of the numerous strongholds of the Wolf of Badenoch, who may have built a sturdy tower house as a fortified hunting lodge at the north end of the island. This early house had a barrel-vaulted cellar, a hall on the first floor and chambers above. In 1600, Patrick Grant of Rothiemurchus built a curtain wall between the old half house and the 'new' tower house to improve the security of the site. It is of interest as a castle in that the surviving ruins demonstrate five different periods of castle building or rebuilding, from the fifteenth century to the seventeenth.

There are possible mentions of the castle in documentary sources from 1527 and 1539 and it is known that it came into the possession of the family of Grant in 1567.

In 1690, the castle was besieged by the defeated Jacobites fleeing from the Battle of Cromdale and, following the events at Culloden in

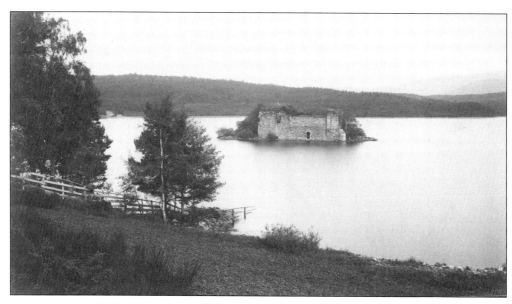

Loch an Eilein, the castle 'the home of the ospreys'

46

1745, Jean Gordon, the widow of the 5th Laird, sheltered fugitives in the castle.

The island on which the castle was built is probably smaller now than it was in earlier times due to the sluice which was built in the 1770s, in connection with the logging and floating trade. This had the effect of raising the level of the loch and the water now obscures any traces of the supposed zigzag causeway which was said to connect the castle to the shore.

Elizabeth Grant, the 'Highland Lady' of Rothiemurchus, would often visit the loch with her cousin James Griffith, as this was one of his favourite places to sketch and paint. She describes the ruined castle as a stronghold, 'a memento of the days of Bruce, for it was built by the Red Comyns, who then owned all of Badenoch and Strathspey'. She comments that 'the tower supported an eagle's nest, which wheeled majestically over the lake in their search for food for their young', and it seems from this statement that there was, as mentioned later, little differentiation between eagles and ospreys at the start of the nineteenth century.

The ruined walls now extend to a height of about 10 feet, maybe a little higher in some places. As part of their survey of Scottish castles, Ross and McGibbon visited Loch an Eilein in the late nineteenth century. They found the building was occupied by ospreys 'whose nest is seen on the top of the tower, to the right'. No boats were allowed on the loch to avoid any disturbance to the birds and they and later visitors were unable to reach the island. These early attempts at conservation, sadly, were not to succeed.

The osprey, that symbol of Strathspey, was once lost but has now returned. The year 1899 saw the birds' last attempt to nest and breed successfully but the greed of the egg collectors made sure that it did not happen. The birds gave up and, apart from the occasional one seen flying over various lochs in the area, there seems to have been no attempt to breed. Then, in 1954, a nest was found and its location became a closely guarded secret. The RSPB bird sanctuary at Loch Garten is now a popular visitor attraction and, despite the numerous and sometimes successful attempts to steal their eggs, the breeding population of ospreys has continued to increase. They now take their place as one of the wonders of Speyside alongside their cousins the golden eagles, so often seen soaring the ridges of the Monadhliath Mountains and the Cairngorms.

CLUNY CASTLE (BALGOWAN)

Cluny Castle in Laggan was the hereditary home of the chiefs of Clan MacPherson. There are some sources which suggest that nothing now remains of the old castle which was burnt down by the Duke of Cumberland in 1746 and that it can truly be described as 'lost'. Others think that part of the burnt-out shell of the old building was eventually incorporated into the new structure. In the mid twentieth century, the head gardener at Cluny castle, Mr H. MacLean, recalled there being a subterranean room about 15 feet by 12 feet, with a barrel-vaulted roof, in which was a well which was fed by a natural spring. This room lay beneath the modern courtyard, had a stone-flagged floor and was probably a remnant of the older castle built in the fourteenth or fifteenth century. Ewan Macpherson, the eighteenth chief of the clan, was the last person to occupy the old castle before it was put to the torch by Cumberland's Hanoverian troops. Captain Lindsay, the owner of the present house in the mid twentieth century, had the well and the room filled in and covered over. The cobbled area of the east side of the courtyard may now be the only surviving remnant of the old castle. It is often suggested that the old structure was never really a castle in the accepted sense of the word but was merely a Highland chief's private dwelling house.

Colonel Duncan Macpherson started work on building the new house in 1802 and, in November of that year, he wrote to his nephew, who was serving in India, saying, 'I have, this year, commenced a pretty large house upon the hill in front of the old burnt one. My progress hitherto is not very great and from the expense I suspect that it will take some time before it is completed.' Work was still in progress in 1805 when Duncan Macpherson received a letter from William Marshall, the Edinburgh dealer who was supplying the lead for the building work, asking for payment of some unpaid bills. There is, in the National Archives of Scotland, also an illustrated quotation from William Marshall for the supply and fitting of a flush toilet, complete with a description of how it actually worked. In 1805, this was an entirely new concept and it needed an instruction manual. It also came at a vast cost – some £186 for just the one flushing toilet! There is no indication, though, as to whether or not it was ever installed at Cluny. The lead work on the gutterings and the plumbing was not finished until the spring of 1806 and it took until 1810 for the whole project to be completed.

Andrew Carnegie and his wife rented Cluny Castle for their summer holidays and they tried to buy Cluny before they eventually settled on Skibo as their Highland home. Queen Victoria also almost bought Cluny but the story is that the bad weather in the area put her off and she settled on Balmoral instead.

Sir Robert Peel rented the castle in 1881 for the shooting season and a fire in August 1927 caused some damage to the castle. The direct line of the MacPhersons of Cluny died out in 1943 and the house was subsequently sold.

CASTLE GRANT

Castle Grant, despite its long and illustrious history as the seat of one of Scotland's most important clans, is rapidly falling into decay and soon looks set to join the list of the 'lost' castles of Badenoch and Strathspey.

The building of Castle Grant, known at first as Freuchie Castle, was probably commenced following a precept by Alexander, Earl of Huntly, on 4 December 1502, followed by a sasine by Farquhar Mackintosh on 7 December 1505. In 1514, John Grant of Freuchie, although he was a native Gaelic speaker, was able to sign his name and designation in Scots on one of the numerous documents relating to the establishment

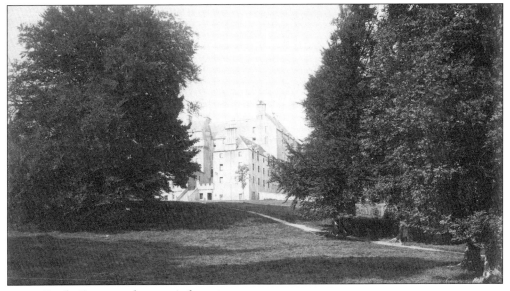

Castle Grant, early twentieth century

of the family of Grant at the castle, which now held the designation of the Barony of Freuchie.

On 28 May 1517, a precept of clare constat of the Lands of Freuchie was granted by John, Lord Gordon, in favour of Lachlan Makintosche, which then paved the way for the family of Grant to begin to exercise their sole superiority over the lands and Freuchie Castle became the ancestral seat of the chiefs of Clan Grant.

In 1694, by act of William and Mary of England, the lands and baronetcy of Freuchie were erected into the Regality of Grant, and it is probable that it is from that time onwards that the castle was renamed 'Castle Grant' and the chiefs were styled 'of Grant' instead of 'of Freuchie'.

The early history of this characteristically L-shaped sixteenth-century castle is unclear and, in many documents and maps from the later part of the seventeenth century, the castle was known as 'Bella Chastell'.

Even as early as 1728, Sir James Grant of Grant had begun work to make the castle more comfortable. Archibald Grant in Invercardnen wrote to Sir James to tell him that 'The Measons are very bussy Slapping and repairing the windows and have finished fourty of them, the work I think is very sufficiently handsome'. This just shows how many windows there must have been in the castle in these pre-Window Tax times. He continues, saying, 'the masone tells me he will begin the Garden Wall the first of March, and Mr Baillie the wright comes to the castle to begin work on the 20th March. The froast was so severe and of so long continuance that the timber could not be wrought sooner either in the wood or at the miln'. This resulted in the timber which was already cut for the work on a burial aisle at the Kirk of Cromdale being used for the castle instead – the church had to wait. The letter continues, 'the walls on the north syde of the Castle Grant are very insufficient as the masone tells me, the lime is perfectly roaten and groun as small as pouder'. Obviously the castle was in need of considerable work.

By the middle of the eighteenth century, the work on Castle Grant becomes even better documented and, at this time, Sir Ludovick Grant is beginning to make major improvements, which means that only the sixteenth-century wing with its original corbelled parapet is now visible amongst the later developments. He also began to make major improvements to the estate. He spent several decades and no doubt vast amounts of money almost completely submerging the old building in a new construction to bring it up to the standards of the time.

By 1756, there was a memorandum detailing the proposed additions to the north side of the castle. This included the decision to open up quarries to enable the building work to start the next spring, to lay in lime nearby and to keep the masons hewing through the winter. The memorandum also included the dimensions of the stones to be cut, including for the stairs, the window sills and lintels, all to be taken to the appropriate places in the castle grounds.

Much of this work is well documented in the Seafield Muniments, the collection of documents of the family of Grant held in the National Archives of Scotland. Frazer, a very well-known master mason in Fochabers, was required 'to make a large door in the body of the House of Castle Grant, of any of the five orders of architecture the said Frazer pleases, also a large window either side of the door proportionate thereto. Two turrets are to be taken down viz; one at the northwest corner of the body of the house and the other at the west corner of the east wing, the four windows to be filled up [could this have been as a result of the window taxes then being imposed?] and the place where the turrets are to be built into a square wall.'

One of the other master masons employed was David Frew who had, it seems, been working on Hopetoun House. John Adam wrote about him to Sir Ludovick Grant saying, 'I am extreamly glad that David please you, and as he is an intelligent man in his own way, I hope he will continue to give satisfaction.' By the end of 1756, however, Mr Frew was getting quite irritated that the stones for the work were not all ready, which meant that he was hanging about idly when he could have been working elsewhere. He was also somewhat annoyed that some of his earlier bills had not yet been paid.

These latter extensions enclosed the main building and attached the two outer buildings to the south, creating 'wings' on the south side which now enclose the courtyard. The castle has stayed roughly the same since that period. The castle contains dozens of rooms, one of which is a massive dining hall. While the southeast aspect of the castle with its two extended wings protruding from it, and its large stone staircase and courtyard, make that aspect appear to be the front of the building, in reality it is the back. The main door from the courtyard leads down a long hall to the front of the castle. Viewed from the north, the castle appears rather plain and unassuming, its north face consisting of a large, flat, four-storey stone façade. This led Queen Victoria, on her tour of the Highlands, to describe it in her journal as 'looking like a factory'.

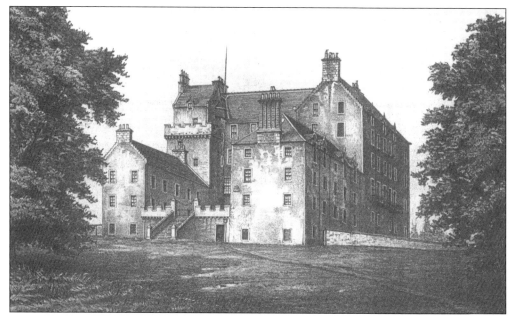

Castle Grant, a nineteenth-century drawing

This plain northern aspect of the castle is the result of a training school set up by Sir James Grant, the chief of the clan from 1773 to 1811. This school was to train local men as masons to be employed in building work on his estate and also to work on the new and now expanding planned village of Grantown on Spey.

The Castle was the centre of all clan activity as it was the primary residence of the Chief of Grant. Here he dealt with various clan matters, resolved disputes and gave grand parties on festive occasions. Elizabeth Grant of Rothiemurchus gives an interesting account of the castle in her *Memoirs of a Highland Lady*, where she notes:

Our great house then was Castle Grant, the residence of our Chief. It was about twenty miles off down Speyside. My Father and Mother were much there when they were first married. My Aunts Mary and Lizzy delighted in the gaiety of a scene so new to them. Generally about fifty people sat down to dinner in the great hall in the shooting season, of all ranks. There was not exactly a 'below the salt' division so marked at the table, but the company at the lower end was of a very different description from those at the top, and treated accordingly with whisky punch instead of wine. Neither was there

a distinct 'yellow drawing room' party, though a large portion of the guests seldom obtruded themselves on the more refined section of the company unless on a dancing evening, when all again united in the cleared hall. Sir James Grant was hospitable in the feudal style. His house was open to all; to each and all he bade a hearty welcome, and he was glad to see his table filled, and scrupulous to pay fit attention to every individual present; the Chief condescending to the Clan, above the best of whom he considered himself extremely. It was rough royalty too, plenty, but rude plenty. A footman in the gorgeous green and scarlet livery behind every chair, but they were mere gillies, lads quite untutored, sons of small tenants brought for the occasion, the autumn gathering, and fitted with the suit they best filled.

Truly this is now a lost way of life in Badenoch and Strathspey.

With the coming of the railways, Castle Grant had its own station, little more than a platform, on the Dava line between Grantown on Spey and Forres, near to where the railway crosses the main Grantown to Forres road. This was, of course, exclusively for the occupants of Castle Grant and their visitors and has long since become just another piece of lost railway architecture, although traces of the station can still be found if you look carefully.

In 1923, the castle was let to a businessman called Clarence H. Mackay basically as a shooting lodge but the effects of troops being billeted there during the war and the lack of maintenance led to the rapid deterioration of the building. By 1966, the castle was unoccupied and described as becoming ruinous. David Ward, a later owner of the castle, put forward proposals for the restoration of the building in 1984, after which the castle was opened to the public at various times during the summer, but, just two years later, it seems that this summer opening was no longer considered viable and the decay and the ruin were allowed to continue.

BALLINDALLOCH CASTLE

According to the old charters, for his 'good and faithful service', the lands of Ballindalloch and Glencairnie were granted to John Grant of Freuchie by King James IV on 4 February 1499, just a few years before the founding of what is now Castle Grant.

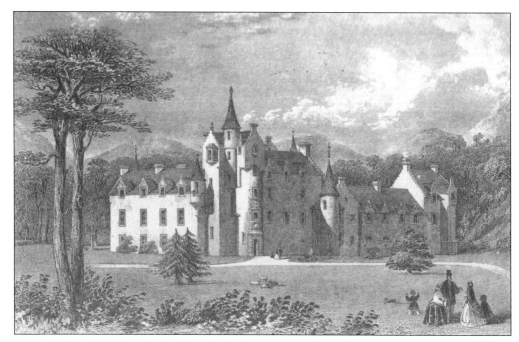

Ballindalloch Castle, in the nineteenth century, with its fairy-tale dormers, crowsteps, carvings and turrets

The story of the original castle at Ballindalloch is the stuff of legend. There is evidence of the foundations of the first castle on a hill above the present building and these would have almost certainly been the basis of a wooden palisaded structure. The story goes that the first laird of Ballindalloch started building there but was compelled to change his plans as every attempt he made to erect the castle was blown down during the night. A voice was heard to repeat over and over again 'build it on the coo-haugh' (the pasture where the cattle grazed) and this was eventually chosen as the site for the first stone castle.

It seems more likely, though, that there was, in fact, an original defensive wooden structure on the hill, which may have been built as a temporary measure whilst the actual castle was being built. Work on the fortified house was probably started in about 1542 by another John Grant, the grandson of John Grant of Freuchie through his putative son Patrick, and the work was completed in 1546, as shown by the inscription on a lintel in one of the bedrooms, probably a fireplace lintel. The original building was a traditional tower house built to a variation of the then popular Z-plan, with a main tower to the south, a

residential block, three storeys high, as the middle arm of the 'Z', and a round six-storey tower to the north. The main entrance, at this time, was on the western side of the castle and bore a date of 1602.

In 1645, the castle was plundered and burnt by Montrose's army but, although the damage at Ballindalloch was quite extensive, it was nowhere near as severe as at many of the other castles and other buildings in the north.

Without going into the details of the family history, it is suffice to say that the family of Grant of Ballindalloch lost their patrimony in about 1711. At this time, the estate was purchased by Colonel William Grant of Rothiemurchus, whose daughter married into the MacPhersons of Invereshie, the current family of MacPherson-Grant being descended from this union of two of the major families in the north.

A further tower was added, probably at the time of some improvements which were being made in 1718, and the crow-stepped north and south wings were added by General Grant in the 1770s.

The nineteenth century saw the transition from the now very old-fashioned and probably not all that comfortable tower house to a home fit for the Victorian era. In 1847, Thomas Mackenzie, a Morayshire architect, enlarged the castle in a fashionable style, and, according to Charles McKean of the University of Dundee, he 'heightened the baronial atmosphere, but mercifully spared much of the original, leaving us with the fairytale dormers, crowsteps, carvings and turrets we have today'. He moved the main entrance to the east side of the building and a courtyard was constructed, along with wings to the north of the original tower. Gabled dormer windows were added and also a lot of other decorative detail which all added to the overall effect.

In 1860, the 3rd Baronet, Sir George MacPherson Grant, was instrumental in developing the Aberdeen Angus breed of cattle and this breed has continued to be a feature of the stock at the castle – indeed, the Ballindalloch herd is now the oldest surviving bloodline of Aberdeen Angus in the world.

By 1911, the castle even had its own fire engine house with a fire engine and it seems that electric lights, from a private generating plant, were illuminating the castle by 1913. The more recent history of Ballindalloch is well documented in many sources.

THE VICTORIAN ESTATES

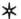

MANSION HOUSES, SHOOTING LODGES
AND THE VICTORIAN WAY OF LIFE

By Victorian times, most of the castles – in fact, all of them except for Castle Grant and Ballindalloch Castle – were little more than romantic ruins, mouldering into anonymity under their green veil of ivy, the only residents the bats and the birds.

The more comfortable mansion house was now the place where the landed gentry wanted to live and the 'big house' was becoming the focus of life on the various estates. Friends and acquaintances, business partners and, in many cases, paying guests would visit during the season for the 'hunting, shooting and fishing' and, in order to be certain that these visitors had the most convenient access to their quarry, many shooting lodges were built in the more remote reaches of the estates. This must have given those who stayed there, often gentlemen from the city, the feeling that they really were out in the wilds of Highland Scotland, many miles from the nearest road.

These shooting lodges are numerous throughout Badenoch, Strathspey and Glen Avon, and although some of them are now in a state of disrepair and in danger of becoming lost, many others are still in existence, and still fulfilling their original purpose. Glenrinnes Lodge, just to the south of Dufftown, may even be described as a small country house, having its own home farm, whilst others, such as Pitchroy Lodge, near to Blacksboat, and Tulchan Lodge, a little further upstream, still bear all the characteristics of the typical shooting lodge, albeit now with twenty-first century standards of comfort. Strathavon Lodge, lies in the shadow of the Hills of Cromdale not far from Bridge of Brown, whilst Inchrory Lodge and Dorback Lodge are two of the more remote shooting lodges, sheltering in the northern foothills of the Cairngorm mountains.

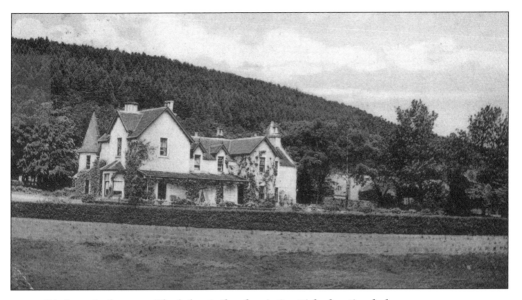

Pitchroy Lodge near Blacksboat, the classic Scottish shooting lodge

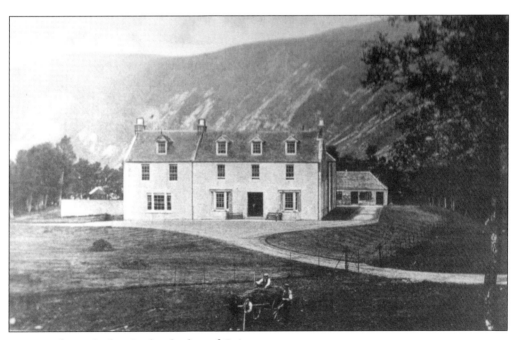

Inchrory Lodge, in the shadow of Cairngorm

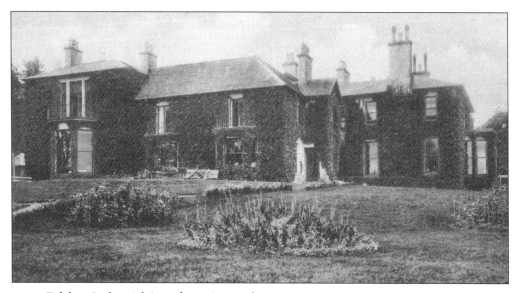

Tulchan Lodge, Advie, a favourite royal retreat

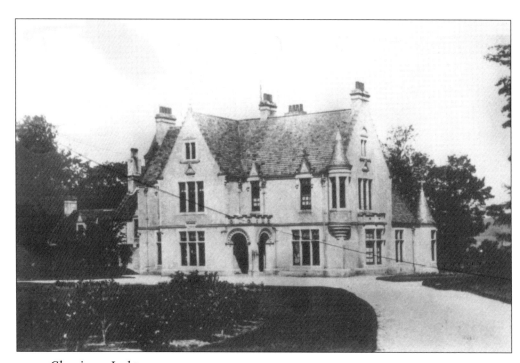

Glenrinnes Lodge

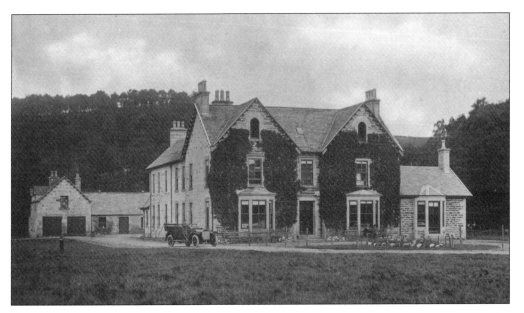

Strathavon Lodge near Tomintoul, with a very impressive motor car in the drive

It was, of course, in early August that most of these houses became alive and every country house, every farmhouse and every inn was full, in anticipation of the Glorious Twelfth. The shooting season also encompassed the Pitmain Tryst and the Inverness Meeting and it was not only the wealthy who became involved in the shooting – almost every facet of society was represented in one way or another. It was a period of great excitement for everyone and another lost way of life that is almost impossible to imagine in this day and age.

The Highland homes of the wealthy Victorian families feature largely in the story of Badenoch and Strathspey. Although some of them are now totally lost, many others have been 'improved' beyond recognition and several are now in use as holiday accommodation. From the point of view of many of the modern generation, however, they may as well be considered as 'lost' as few of us can afford the luxury of being able to stay in these houses. But those who can are fortunate indeed because such visits give an opportunity to experience life as it would have been in the surroundings enjoyed by these Victorian families, but with all modern benefits tagged on.

Working our way down the course of the River Spey, with perhaps a bit of dotting about here and there, the first house we come to is

Glentruim House. Near to Newtonmore, the house, which stands near the boundary of the parishes of Laggan and Kingussie, was originally built by a branch of the MacPherson family. Although it started life as a typical mid-nineteenth-century country house built to a fairly standard design, Glentruim underwent various improvements and alterations between 1869 and 1874 and some other additions were made in 1901. It has, however, basically served as a family home throughout much of its existence but, in recent years, the estate has been broken up so that it is now a mere shadow of its former glory.

Near to Kingussie, we find the house of Balavil. It was originally known as Belleville but is now probably better known as 'Killwillie Castle' in the television series *Monarch of the Glen.*

Belleville, to use its original name, was built by James 'Ossian' Macpherson in 1790. The house has remained in the family ever since and provides an exceptional centrepiece to the surrounding estate. Elizabeth Grant of Rothiemurchus, travelling north from Edinburgh to her home in 1812, noted that a mile on from where they had stayed the night at Pitmain there 'were the indications of a village', now the town of Kingussie, and 'a little further on rose Belleville, a great hospital looking place protruding from young plantations, and staring down on the rugged meadow land now so fine a farm'.

According to Elizabeth Grant, the laird of Belleville was, by this time, one of the four acknowledged children of the Mr Macpherson who had pretended to translate Ossian and had also made a fine fortune out of the Nabob of Arcot's debts. James Macpherson, having returned from India in about 1800, took up possession of Belleville but he had inherited many of his father's financial problems. He and his wife were obliged to shut up the mansion house, lease out the farm and return in relative poverty to London. But Belleville was not lost to them for long and, by the winter of 1812, they were back in residence – he to farm and she to look after the family finances.

Despite her initial rather unkind description of Belleville, Elizabeth Grant was later to record many happy days spent at the house, which was now beginning to settle down amongst the new and thriving plantations. The house has continued as a family home for the last two centuries and now offers extensive sporting facilities to the house guests.

Kincraig House is built adjacent to an original shooting lodge which is over 250 years old and is situated on the lower slopes of

the Monadhliath Mountains. It has proved impossible to find out the precise date when the existing house was built but, in 1821, there are records in the National Archives of Scotland which tell us that work was needed by a mason, a slater and a plumber, especially on the staircase. In 1832, a letter from the Duchess of Bedford, in the same records, asks Mackintosh of Mackintosh to have Kincraig House examined by an architect who could give estimates for the work which would be needed to bring it up to a standard for the Duchess to be able to live there and also whether any additions would be needed to the house. The building now displays all the characteristics of a typical mid-Victorian house and it currently provides accommodation for visitors to the area.

The old house of Dalchully provided a safe haven for Ewan 'Cluny' Macpherson and possibly also some of his followers, in the aftermath of the Battle of Culloden. The land later formed part of the Duke of Gordon's estates but, in 1870, it was bought by the Ardverikie Estate, which later doubled as Glenbogle Estate in the *Monarch of the Glen* television series. Since 1955, there have been no fewer than five owners but the old house can now most definitely be described as 'lost' and, in fact, it was demolished and a new house was built on the site in 2004.

Tim Dawson, writing in the *Sunday Times* back in 1999, comments that Strathmashie House 'wears its past like a good tweed'. The original seventeenth-century farmhouse is now totally lost amongst the 'improvements' made by the wealthy Victorians in the nineteenth century. The house as it stands now has white harled walls and the typical exterior of a Victorian Highland home. In the grounds is an Edwardian pavilion which gives a view of the ancient Pictish Fort on Black Craig.

The Doune was very nearly a 'lost' building but, thanks to the attentions of the 17th and present laird, John Grant, who returned to the Doune with his family in 1991, the house is now being returned to its former glory. The ancient hill fort or dun – hence the name of the house – which stands adjacent to the house was the early home of Clan Shaw and it was the Shaws who built the earliest house on the present site, dating from the early sixteenth century. By the second half of the sixteenth century, the seat of power of Clan Shaw had moved northwards and a branch of the family of Grant moved to the Doune in the 1560s. Patrick Grant erected the marriage stone there after his wedding to Jean Gordon.

The old house had narrow windows, which provided light for the rooms inside, and there was a kitchen built of black turf (peat), with an open chimney, at one end of the house. A typical fermtoun surrounded the 'big house' and this would have included the usual smithy, barn, squarewright's workshop and houses for the beasts.

Various modifications to the house were made – the dining room was added in 1780 and then, in 1803, the Grants added a library. This had bedrooms above and it then formed a Georgian front to the house. In 1876, the ninth Laird of Rothiemurchus, Sir John Peter Grant, added a staircase, morning room, more bedrooms, a new kitchen wing and third floor to the original house. After these renovations, though, there came a period of time when the Grants were not resident at the Doune.

But it is through the *Memoirs of a Highland Lady* that the Doune is perhaps better known. The writings of Elizabeth Grant of Rothiemurchus give the modern reader an insight into a way of life which is now most definitely lost. Some of her childhood memories, sadly for us, were dulled by the passage of time and by the fact that the Doune was, to all intents and purposes, a summer home.

It is not until 1808 that we have any clear recollections of the Doune. On her return from the south, there had been many changes since the last visit. The old barn and the stables in front of the house had vanished, as had the poultry house and the duck pond, and all vestiges of the old farmyard were now lost, removed to the new offices at the back of the hill, as was the laundry. The whole gardens had been landscaped and the new house of the Doune was taking shape.

By 1812, the Doune had changed yet again. The old garden had vanished, as had the backwater and much of the hill. The landscape artists were having their way and the garden had been moved to the 'series of pretty hollows in the birch wood between the Drum and the Milltown Moor'. The kitchen garden had also been removed and replaced with an attractive shrubbery and the vegetables and the fruit were now well out of sight of the main house, probably much to the discomfiture of the cook. But, according to Elizabeth Grant, the new arrangement 'was the admiration of everybody' – except, seemingly, Elizabeth herself, who could no longer raid the gooseberry beds, to say nothing of the other fruit bushes.

In 1814, the library was at last in use, the walls painted in French gray, with panelling in black, and the bookcases, with their handsome cornices, were filled with three or four thousand volumes, all precisely

catalogued. There were plenty of easy chairs and on little tables stood a telescope, a microscope, a theodolite and other scientific instruments which would have interested the visitor.

Elizabeth's father, being a Member of Parliament, was only infrequently at the Doune but the family stayed there as much as they could, until family circumstances intervened, after which the Doune once more retreats into the anonymity of the Highland mists.

In the 1920s and 1930s, the house was let out to Lord Darnley and, in the late 1930s, the Doune was run as a hotel by the Edinburgh firm Gifford & Bailey. As with many of these mansion houses, the Doune was requisitioned by the army for the duration of the war but, like many buildings which had been requisitioned and occupied by army and by soldiers who probably wondered what on earth they were doing in the wilds of Scotland, the Doune gradually fell into a state of decay.

In November 1963, the house was owned by John Peter Grant of Rothiemurchus and was said to be unoccupied and becoming derelict. This fascinating building was almost lost to ruin until renovation work was begun in 1978 and continued by Johnnie Grant of Rothiemurchus prior to his return to the house.

Kinrara House was designed and built in the late 1700s by Jane Maxwell, the Duchess of Gordon, as part of an estrangement agreement with her philandering husband, the 23rd Duke of Gordon. After the house was built, she embarked on a life of wild parties.

Kinrara was the centre of social activity in the early years of the nineteenth century. The Duchess of Gordon held open house and all the people who mattered in society in the north visited Kinrara to enjoy the freedom, the fresh air and the company.

The river lay between the Doune and Kinrara, which were only about a mile apart, and, although it was fordable at several places, it was prone to violent spates and the crossing between the two houses could be hazardous at times, even though there were several small boats belonging to the estates.

During the years between 1806 and 1812, the Gordon Castle Muniments reveal that there were many changes and additions made to the building at the behest of Jane Maxwell, with numerous plumbers' and masons' accounts being preserved. In 1811, Thomas Gray and Sons, Glass Painters in London, provided 'a bordered window in stained glass and a painting of ornamental arms in stained glass' for the mansion house at Kinrara.

After the death of Jane in 1812, the estate passed briefly to the Duke of Richmond and Gordon. The contracts made for the work on the house between Jane and James Russell the mason were set aside by the Duke, who required 'any work already done to be taken down and the house returned to its former state'. The Duke soon wanted to be rid of the place but buyers were not so easy to come by. In a letter of 10 January 1839, held in the National Archives of Scotland, it is recorded, 'As the Duke of Richmond is not satisfied with the offers he has received for Kinrara, he intends to keep it in his own hands until a more suitable offer is made.'

For the next century, it becomes quite difficult to find out very much about Kinrara. In the years between the two World Wars, it came into the ownership of Lady Lucy Houston, who became very active in her support of Britain's war effort.

Another house on the lands of Rothiemurchus was Inverdruie. An old house, it was, in fact, one of the larger farms on the estate and, as with many of them, was tenanted by members of the Grant family. Little is know about the original house, now long lost to us, except that it was a very ugly house, probably little more than an upmarket but and ben, with maybe four rooms rather than the usual two. But, by all accounts, Inverdruie was a home which had a warm welcome to all who passed the door and a house where the now lost art of telling the stories of olden times was appreciated by all who visited it.

Dell was maybe not a mansion house in the accepted sense of the word but it was, according to some sources, the largest farm on the estate of Rothiemurchus and was a house worthy of such status. The old house of Dell was, however, not a very fashionable building to early-nineteenth-century eyes.

Dell was prominent in the early history of Clan Shaw, being one of the first houses erected by the early septs of that clan, probably in the fifteenth or in the early sixteenth century. How many houses there have been at Dell is unclear – the early black house would have soon given way to a more respectable stone building, which was probably modified and expanded in various ways over the centuries.

Elizabeth Grant of Rothiemurchus, writing in the early nineteenth century, describes Dell as 'an ugly place, a small low house, only two or three stunted trees in the garden behind it, and a wide, sandy, stony plain all around'. Despite this, though, she spent many happy days there, with the dancing and the company more than compensating for

the inadequacies of the house. 'Many a happy hour we have reeled away both at the Doune and at the Dell, servants and all included in our company, with that one untiring violin for our orchestra.' That was the violin of Duncan McIntosh, who she describes as 'a second Niel Gow for all lively musick'. And, of course, the whisky flowed. To our modern eyes, it is a way of life now long past. How tastes have changed – but maybe we all sometimes yearn for these lost evenings which are now only to be found in the much more remote parts of our land.

By the later years of the nineteenth century, the agricultural business at Dell was predominant and the single-storey steading was ranged around a hollow square, in a typical adaptation of Sir John Sinclair of Ulbster's earlier design – as well as compiling the *Old Statistical Account of Scotland* (1791–99), Sinclair was a leading advocate of agricultural improvements. The steading had five cart bays and was adorned by a square water tower with a pyramidal roof crowned with a tall cast-iron weather vane.

Drumintoul was built in 1877 with the proceeds of just one year's income from the shooting. It was let out to shooting and stalking tenants right through until the 1960s, at which time, with electricity having been installed, it became a family home.

During the Second World War, Drumintoul was used as a training base for some amazing raids into Norway. The Norwegian Independent Company 1 was a British Special Operations Executive (SOE) group formed in March 1941 for the purpose of undertaking commando raids into Nazi-occupied Norway. The company was commanded by Captain Martin Linge. The early raids by the unit were those to Lofoten and to Maloy and it was during the latter that Martin Linge was killed on the raid against the German positions of the island of Vagsoy. Following his death, the unit became known as 'Kompani Linge'. The unit's best-known raids, though, are probably the ones on the Norwegian heavy water plants. The King of Norway often stayed at the lodge on his frequent visits to inspect his troops and the original bunkers used by the commandos are still visible along the tree-lined driveway leading to Drumintoul Lodge, which is now used for corporate events and other such functions.

Easter Elchies lies on the northern bank of the Spey, high above the valley. This typical T-plan laird's house has a datestone carrying the initials JPG for John Patrick Grant and the date of 1700. Many sources suggest that this is the date of the original building but there are many

mentions of what was an earlier building, possibly dating back to the time of the Reformation. Some charters note that the lands of 'Easter Elloquy or Elchies' were granted to the family by the Bishop of Moray in January 1543 and it is also suggested that a Covenanting army had plundered the 'Palace of Elchies'. Captain John Grant supported King William's cause following the abdication of King James II and VII in 1689 and, when General Buchan arrived in Speyside from the west with the Jacobite Highland Host in April 1690, on his way to ravage Elgin and Aberdeen, he was in command of the Grant stronghold of Ballachastell, also known as Castle Grant, near to Grantown on Spey. A monument to him, which was erected by his son Patrick, stands in the now locked and boarded burial aisle in the churchyard in the grounds of the Macallan Distillery.

There were some minor modifications to the house in the mid nineteenth century, especially in 1848 and 1856, with further changes in 1893. Between 1950 and 1960, the additions which had been made to the house were demolished and the remainder was left derelict and unoccupied. By 1969, it was reported that the house was becoming ruinous and so nearly another of the 'lost' houses of Scotland. In 1980, work was started to restore Easter Elchies to its former glory, closely resembling the original 1700s structure, as the headquarters of the Macallan Distillery. This work was completed by 1985 and the interior was also largely remodelled at this time. Easter Elchies House now houses the offices and the visitors' centre for the Macallan Distillery.

A truly 'lost' house, the mansion house of Wester Elchies was built in 1681 and was situated about two miles up the River Spey from Easter Elchies. The old traditional Scottish mansion house belonged to the Grants of Carron until 1783. Sir Archibald Grant of Carron sold part of his estate to another member of the Grant family, who had returned from England and from North America with a fortune in his pocket. Robert Grant became first Laird of Wester Elchies in 1783 but his son Charles was the one who went on to found the new village of Charlestown of Aberlour in 1812. His brother James became third laird and, despite being an absentee landlord due to his businesses in India, he was very sympathetic towards the financial needs of his tenants. He provided land and materials for churches in Archiestown and Aberlour following the Disruption. This new landlord also made changes to the house and was known to have added a large castellated structure between about 1828 and 1850, which hid most of the original

building. Like many houses of the time it had a doocot and also its own private observatory.

In 1893, the grounds of Wester Elchies were, according to the local newspaper, the venue for picnics by parties of local schoolchildren. During the twentieth century, the estate changed ownership several times. The Gordonstoun prep school was opened at Wester Elchies in 1936, just three years after Gordonstoun itself was founded. The school expanded such that, in 1947, nearby Aberlour House was bought. The younger boys attended Wester Elchies until the age of about ten, after which they went on to Aberlour House and moved up to Gordonstoun at the age of 13.

In the 1960s the house fell into disuse, mainly due to the dry rot which had infested the timbers of the building, and, together with the observatory, it was demolished sometime between 1968 and 1970, with only the doocot now remaining.

Alexander Grant, the son of a farmer from Glen Rinnes, had made his fortune out in the West Indies and, on his return to Speyside in

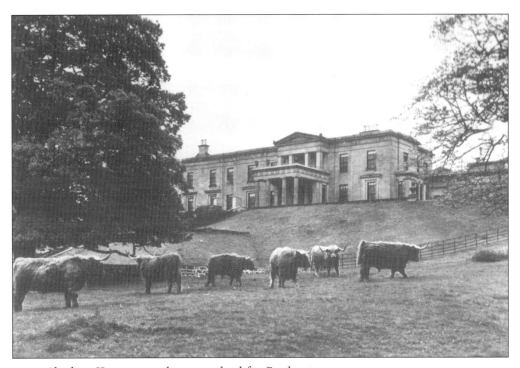

Aberlour House, once the prep school for Gordonstoun

1838, he bought the old ancestral seat of the Gordons of Aberlour. He commissioned William Robertson to design a large country house overlooking the River Spey, near to the site of the old house of Aberlour, and the result was Aberlour House, a large two-storey house with a porte-cochère. The stable block to the rear has its own bellcote and the gardens sweep down towards the Spey.

In 1947, it became the home of the Gordonstoun prep school and Aberlour House School saw many generations of youngsters ascend the cold stone grand staircase to their dormitories. The various rooms in the house served all sorts of functions for the school, from dining rooms to assembly halls, from classrooms to kitchens, and eventually the school expanded so much that the stable block itself also became classrooms.

The 60-foot-high column in the grounds was built in about 1835 but collapsed in the 1880s. It was rebuilt in 1888 with a heraldic unicorn on the top, an obvious emblem for Aberlour House School.

The school is now gone, the shouting of the children as they made their way to the stable block, the sports matches on the level lawns in front of the house and the welcome quiet period for half an hour after lunch, so beloved of the teaching staff, are now all but a memory. In recent years, the house was sold to the nearby business of Walkers, those makers of fine shortbread, and now provides office space and other facilities for that business. But the Aberlour House name is not forgotten – the new building on the Gordonstoun campus, designed to house the children of prep-school age, still bears the name of its predecessor.

It is fairly certain that there was a house or large farm near to the site of present-day Arndilly in late medieval times. This was the predecessor to Arndilly House and was adjacent to the Ford of Ardentol, later named the Ford of Arndilly, where, in 1296, the army of King Edward I crossed the Spey after his expedition to suppress the rebellious north of Scotland.

The Church or Chapel of Arndilly was situated on the site of the present house. At the time of the Reformation of 1560, when the Catholic Church in Scotland was banned and replaced by the Presbyterian Church, it was noted that the Chapel of Arndilly was already falling into ruin. Ardentol, Arndilly, Ardnellie or even Ardentulliach, as it was often known at this time, was a parish in its own right and, with the rise of the Presbyterian Church in Scotland, we find a few references to the church. In 1567, William Keith was the reader at the kirk – a reader

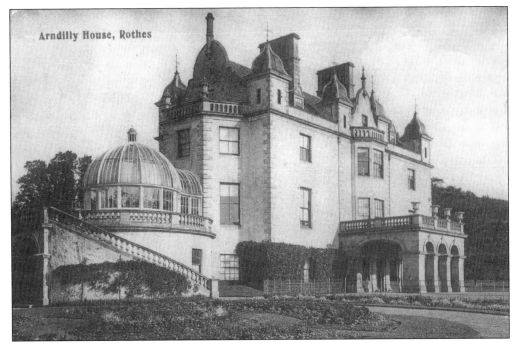

Arndilly House, near Craigellachie

being a temporary minister who was allowed to read the gospel and to lead worship but not to deliver a sermon or conduct baptisms and marriages. In these early times of the Presbyterian Church, ministers were scarce and one man would often minister to several adjacent parishes. In 1568, William Peterkin is recorded as being the minister of Arndilly, a post he held until at least 1586. In 1574, he was helped by another reader, one George Collie.

With the increasing pressures on the church, however, Arndilly soon became uneconomic as a parish and, in 1618, it was united with the adjacent parish of Boharm. This did not mean the end of the church at Arndilly, however, as it seems to have been used at various times for the occasional service.

The precise location of the earliest house of Arndilly is not known but it is likely that it was not far from the church building and may even have started life either as a pre-Reformation manse or even as a small monastery. This theory is reinforced by details of the house in 1704, which suggest that it was built of stone, with a slated roof and wooden floors.

The earliest record of a laird of Arndilly is in 1634, being one Walter Grant of Arndilly. In 1684, a testament is recorded of a Walter Grant of Arndilly, which may well refer to the death of this early laird. In 1686, another Walter Grant, probably his son, is noted as being a Kirk elder and he is mentioned in various documents until 1717. In 1714, a new bridge across the burn was built at Arndilly by two local masons, Alexander Cruickshank and James Ord, who were well known at that time in the parish of Boharm for their bridge-building skills.

Building work on the first mansion house of Arndilly was commenced in 1750 and it was built on the site of the burial ground associated with the now ruined and derelict kirk of Arndilly, even though records suggest that some parts of the old church building were still standing. A Pictish symbol stone said to be from the old church was built into the wall of the house. It is remotely possible that there were, somewhere in the structure of this first mansion house, other remnants of the old kirk walls. It was the fact that the house was being built in consecrated ground, on a burial ground that had been in use until little more than a few years earlier, which caused the greatest indignation amongst the local people. There is a legend that, when the foreman supervising the work on the new house reported to the laird that his men had dug up yet another corpse in the old burial ground, the laird's response was to tell them to 'throw them into the Spey, it will give the Lord something to do on Judgement Day'. The legend goes on to tell that, at a later date, the laird and the workmen were all drowned as they forded the Spey.

This first house of Arndilly had a very short life and, in about 1770, work was started on a new house. By 1797, there are mentions of one Captain William Grant MacDowall and this family was to have a very important influence on the future of the Arndilly Estate. The Captain was to be a heritor of the parish, and a major figure in the agriculture of the estate, until his death from cholera in the Borders in 1849.

Colonel Alexander Grant of Arndilly and Edinvillie had only one child, a daughter, Mary Eleanor, and, in the early nineteenth century, she married Lieutenant David MacDowall. By virtue of the Arndilly entail, he was obliged to add the name Grant to his own name and, in many records, he is identified clearly as the husband of the proprietrix of Arndilly, showing that the estate was still, to all intents and purposes, the property of the Grants.

On the instructions of David MacDowall, additions and improvements to the house were carried out in 1826 under the direction of the Elgin

architect William Robertson. Some traces of the original 1770s building, such as the rear central stair turret and also the drawing room with its fine late-eighteenth-century plaster ceiling, still remain.

Following the death of William Grant MacDowall in 1849, his grandson by David MacDowall and Mary Eleanor Grant, one Hay MacDowall Grant, having made his fortune in the West Indies, returned with his wife to Arndilly, only to find the house virtually uninhabitable and in need of repair. Under the direction of the Elgin architect Thomas MacKenzie, the house was remodelled over the following years.

The large conservatory on the terrace was demolished in about 1908 but the terrace area remains. According to records held in the local archives, it was during the alterations to the house in 1965 that about 20 skeletons, of indeterminate date, were found beneath the floor of the kitchen. The skeletons were lying in an east-to-west orientation, indicating obvious Christian burials, and were almost certainly corpses which had been interred in the old churchyard.

There were many other fine houses in Badenoch and Strathspey but very few of them are lost. Some of them, such as Insh House, a Thomas Telford design from 1828, were originally built as manses for the local Church of Scotland minister whilst others were just large comfortable houses following the Victorian fashion for a home in the Highlands. Some, such as Inshriach House, which was built in 1906, and Invereshie House, parts of which date back to 1685, were specifically built as shooting lodges for the huntsmen following the deer, the pheasant and the grouse.

Many of these are now still used for their original purpose but others have been modernised to provide very comfortable high-class accommodation for a different type of visitor, armed now with cameras and not with rifles.

CHAPTER 6

BRIDGES AND BOATS

The crossing of the fast-flowing River Spey and its numerous tributaries was a hazardous venture and there were several bridges and numerous ferries across the Spey. The most impressive of the bridges are the ones at Craigellachie and at Grantown on Spey. Further upstream towards Badenoch, where the Spey was not quite such a force to be contended with, except in times of spate, there are still relatively few bridges and, in fact, until the building of the bridges at Boat of Garten and at Aviemore, there were no bridges on the Spey between Grantown on Spey and Kincraig. Even further upstream, the usual way across was by way of the 'boats' – or ferries, as we would call them now – or by means of the often quite hazardous fords, many of which are long gone, becoming lost as times changed and it became easier to drive a horse and cart or a motor car along to the nearest bridge.

The tributaries of the Spey – the Dulnain, the Druie, the Feshie and the Truim – all added considerably to the quantities of water which eventually flowed through Badenoch and Strathspey, giving the River Spey the status of being Scotland's fastest flowing river. Each of these tributaries, of course, was also an obstacle to communication in earlier times, especially to the traveller following the tracks along the banks of the Spey. Several crossing points developed, either fords or primitive bridges, on these tributary rivers, some of which are now lost with the passing of time. In most cases, these smaller rivers were not large enough or even suitable for a boat but they still had to be crossed dry-shod by both the traveller and the local people alike. As a result of this, settlements such as Carrbridge, Dulnain Bridge, Coylumbridge and Feshiebridge gradually evolved to fill the needs of both the people and beasts who wanted to cross the water.

Not everyone was in favour of these new bridges and, indeed, some of the Highland chiefs suggested that, if bridges were built across the rivers and the streams, it would make their people more effeminate

and incapable of crossing them without recourse to artificial aids. They were happy enough to make use of them during the Jacobite Rebellion of 1745, though, even if only as a means to make good their escape, and, in due course, they came to accept them.

Working our way upriver from Craigellachie, we can look at the various bridges and ferries, some of them still in use, others now lost apart from the faint traces of mooring points along the banks of the Spey.

CRAIGELLACHIE BRIDGE

The bridge over the Spey at Craigellachie is not lost, except to the motorist, but is an engineering masterpiece of a lost age, well worthy of consideration in a book such as this. Maybe some extracts from the document published almost 200 years ago, in October 1812, inviting subscriptions for the building of the bridge, can describe the reasons behind it more eloquently than a modern writer can. The use of the English language in all its beauty, even as shown in these extracts of a purely commercial venture, is maybe one of our greatest losses, not only in Badenoch and Strathspey but to the nation as a whole.

The document, which now survives in the National Archives of Scotland, is entitled 'Bridge over the Spey at Lower-Craig-Elachie near Aberlour' and starts off with a preamble typical of the period:

> The Spey, from its great rapidity, the vast body of water which it discharges, and the frequent and excessive floods to which it is subject, is perhaps of all rivers in Britain the most dangerous, and opposes to travellers the greatest difficulties in passing its stream. From above Grantown in Strathspey, to Fochabers near the influx of the Spey into the sea, a distance of upwards of 40 miles, there is no bridge for the accommodation of passengers; the ferry boats are in general insufficient and incommodious, and it very frequently happens that for days and weeks together no boat can safely pass the river, to the great inconveniency of the public, and to the interruption of all communication thro' the interior of the country, from one extremity of the Kingdom to the other: the necessity therefore for at least one bridge over the river in some convenient situation between Grantown and Fochabers is sufficiently obvious.

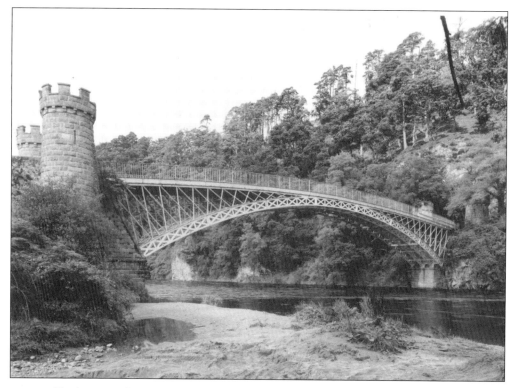

Telford's Craigellachie Bridge over the River Spey

A good sales pitch, made even better for Craigellachie by the fact that the Parliamentary Commissioners for making Roads and building Bridges in the Highlands of Scotland had just turned down an application to build a bridge a few miles to the north at Boat of Bridge, on the grounds that it was too close to the Spey Bridge at Fochabers.

'This induced the contributors to the bridge at Boat of Bridge to select a situation further up the river . . . holding out the certainty of infinitely greater utility to the community, namely at a place called Lower-Craig-Elachie.' The nature of the riverbanks here was perfect for building a bridge and, as many of the new turnpike and commutation roads all centred on Craigellachie, a good case was made for the new bridge.

The Parliamentary Commissioners 'directed their engineer, the justly celebrated Mr Telford, to prepare a plan and estimate of the bridge, and to report upon the public utility which might be expected to arise from it. In obedience to these directions Mr Telford has now visited and minutely inspected the spot and the roads in the neighbourhood,

and has not hesitated to express the most favourable opinion of the situation, expediency and public utility of the bridge, which he will not fail to report to the Commissioners.'

The subscription document went on to note that it was hoped that the Commissioners would also contribute half of the cost of the bridge. 'Mr Telford is of opinion that the situation is particularly adapted for an Iron Bridge of one arch . . . which may be put up without experiencing the least obstruction from the depth or rapidity of the stream, or even coming in contact with it, a consideration of no mean importance on a river such as the Spey.'

His estimate for the work was £8,000, of which half had to be raised by voluntary contribution before the Commissioners would advance the other half. As a further encouragement, the document goes on to suggest that 'to the philanthropic and benevolent, to all interested in the cause of humanity, it affords a favourable and noble opportunity of snatching, from a watery and untimely grave, hundreds of their fellow creatures; for the number of lives which are annually sacrificed in the passage of this rapid and impetuous river exceed all belief'. What gentleman or, indeed, what country lady could refuse such an appeal?

The document ends by saying, 'The public of all ranks are therefore anxiously and urgently called upon to come forward with their contributions; and it is confidently hoped that the subscription will be promptly and effectually filled up to the required amount.'

The new bridge was built and paid for. It is now considered to be one of the finest of its type in Britain and is the oldest surviving cast-iron bridge in Scotland. Rustic ashlar abutments with castellated terminals provide support for the four ribs which form the sweeping single 150-foot arched span of the bridge, above which the roadway is carried by latticed girders. The wing walls are built of rubble but, to all appearances, even the rubble was of high quality.

As noted on the cast-iron plaques on the terminal on the Banffshire side of the bridge, the ironwork is Welsh, being cast at Plas Kynaston in Denbighshire by William 'Merlin' Hazledine, Telford's usual ironmaster, in 1814. The ironwork was transported by sea to Garmouth and then conveyed overland to the site of the bridge, a massive undertaking at that time. The stonework was erected by John Simpson, a mason from Shrewsbury, and the actual ironwork of the bridge was put in place by Telford's foreman, William Suttie. He obviously wanted to employ his favourite and most trusted overseers on this site.

Local legend has it that some of the local people made the suggestion that the bridge should be 15 feet higher than originally planned and it seems that Telford may have heeded this advice. In the Great Moray Flood of 1829, the bridge was able to withstand the fact that the Spey here rose 15 feet and 6 inches and, although the flood arches were washed away, the iron bridge stood secure.

The bridge was finally completed in 1815 at a cost of £8,200, a mere £200 above Thomas Telford's original estimate. Surely there are few, if any, engineers who could achieve a result like that nowadays?

The local councils – Moray and Nairn and Banff – shared the cost of a restoration project in 1964 and, in 1972, the old bridge, by now rapidly becoming a bottleneck to the traffic on the main road, was bypassed by the new bridge just a few hundred yards downstream.

THE ABERLOUR
AND ELCHIES BOAT

Before the building of Thomas Telford's bridge at Craigellachie, the Elchies boat was the main crossing on this part of the Spey. It was a crossing steeped in history and an essential part of communications in this part of Strathspey.

The 'Ferrie Cobbil' known as the Elchies Ferry was mentioned in documents from just five years after the Reformation of 1560, when the church was assessing who was due to pay what for the upkeep of the new Presbyterian churches.

There are mentions of Patrick Grant at the Boat of Elchies in 1700 and, through the latter decades of the eighteenth century, the Boat Town of Wester Elchies features quite frequently in the records. In the 1790s, Robert Gordon was the ferryman, living at Boat of Elchies, and, in 1835, William Thomson was plying the oars across the Spey, charging his passengers 1d each for the crossing. If he had to take the larger boat to convey a horse, a cart or a carriage across the river, he charged 4d.

Even after the building of the new bridge, the ferry continued to operate. The roads down to the river on either bank were never very good and a continual source of complaint but these seemed to have little effect. Up to about 1896 or 1897, the boats were worked with oars and probably also the ubiquitous 'sting' or long pole. Somewhere about

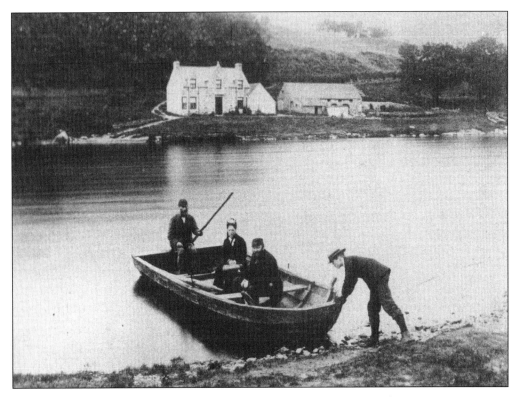

The Aberlour Ferry, with the ferryman getting ready to pole the ferry across the Spey

this time, a tackle was erected consisting of a carrying rope and poles. This 'flying wire' system was also often known as the 'otter' system. The ferryman, who still lived on the Elchies shore, could be summoned from the Aberlour side by means of the new-fangled electric bell.

In 1900, the ferryman, a Mr Stuart, owned the boat and all of the equipment and, like all of the other boatmen, emphasised that, if the state of the river was dangerous, he would not cross. The building of the new suspension footbridge, 'the penny bridge' across the river in 1903, may have dented his earnings to some extent but, as the bridge was only for foot traffic, the ferry boats continued to carry bulky cargoes or beasts which could not be taken over the footbridge. It is interesting to note that people were charged exactly the same to walk across the bridge as they would have been charged for the ferry ride and it seems that the passenger fare had remained unchanged since 1835, at just one penny.

The old Aberlour and Elchies ferry seems to have made its final crossing in 1908 and it had certainly lasted in one form or another for nearly a century after the new road bridge at Craigellachie was built and also for another five years after the building of the penny bridge. The improvements in roads and vehicles in the early decades of the twentieth century, though, finally meant that yet another link with the past was now severed.

BLACKSBOAT

Although there were other local ferries such as the Boats of Aberlour, Elchies, Carron, Cromdale and Balliefurth, it was Blacksboat which was the most vital link in the transport network of not just the local area but of the north of Scotland as a whole.

How long the boat had been in operation we will never know but it was certainly providing a safe crossing of the Spey in medieval times. The main routes from the north crossed the hills from the royal burghs of lowland Moray. Traffic from Nairn, Forres and Elgin and, later, from Fort George and the port of Burghead all headed south, converging on

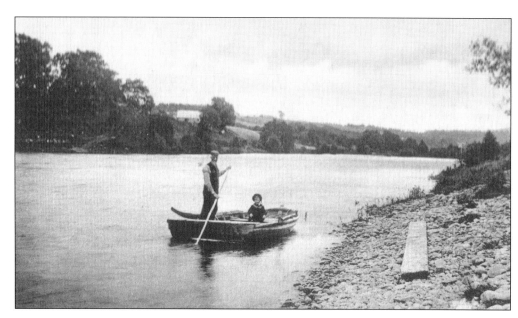

Blacksboat Ferry, the boatman using a 'sting' or pole

the little village of Knockando. The Mannoch Road was, for centuries, the main route south from Elgin and the Laich of Moray, the Old Scots Road and the road through Rafford and Dallas carried travellers and goods from Forres, Nairn and other places to the north and the west.

Just southwest of Knockando lay the ferry of Blacksboat. Like many of these crossings, there were probably two boats in operation, maybe even more. It is quite interesting to look at the ferry over a century ago. On 10 February 1903, the *Elgin Courant* newspaper carried a feature about the ferries on the Spey. The writer of this article had visited Blacksboat in 1900 and noted that the boatman was 'Mr William McPherson, who lived on the Banffshire side of the river' and he had provided a ferry service across the river since 1853. William McPherson said that he had made an average of ten crossings a day during that time, which works out roughly as 171,500 crossings, and there had never been an accident within living memory.

The river at this point is about 240 feet wide, flowing at three miles an hour in its normal state. The ferry boat, which was worked with

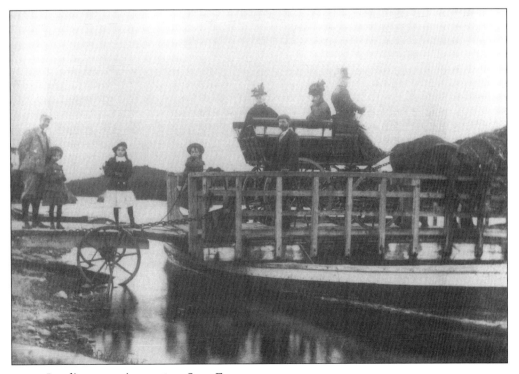

Loading a carriage onto a Spey Ferry

oars and a sting, could carry 18 passengers if the weather was good, fewer in stormy conditions, but one condition written into the boatman's lease was that he 'would not cross any passenger when the state of the river is dangerous'. In 1900, just as further downstream at Aberlour, it cost the passenger one penny to cross the river.

Before the coming of the Speyside railway there had also been a large boat capable of carrying cattle, horses, sheep and carriages. The price for a horse and gig to cross was one shilling, a horse and cart 18 pence. Once having crossed the river, the traveller could continue south by way of Tomintoul and the Lecht, past Cock Bridge and down into the valley of the Dee and Braemar to the softer lands of the Mearns, Angus and the valley of the Tay.

All this is now lost. Traffic from the north crosses the mountains by way of Drumochter or crosses the hills to Aberdeen and only the tourists and the winter sports' enthusiasts now use the old roads. Once the road bridge across the Spey was opened in 1908, there was no more need for the centuries-old Blacksboat and the way of life that went with it.

CARRBRIDGE

Not a boat this time but a bridge. A very early bridge now lost, an old bridge still standing and a yet more recent one serving the needs of the old great road north, itself now bypassed.

It was not the Spey itself which formed an obstacle to those who had ventured southwards over the Dava Moor but its rushing tributary the River Dulnain, frequently swelled by the copious amounts of rain being deposited on the Monadhliath Mountains to the west.

There was a river crossing here from early times and also almost certainly a ford but some of the people had to cross the river to get to the parish kirk of Duthil on the Sabbath. The old Bridge of Carr was built in 1717, mainly at the expense of Brigadier General Sir Alexander Grant of Grant. It cost £100, took about six months to build and was for foot passengers, horses and stock. It was also, of course, used to carry coffins to the churchyard of Duthil and this led to it being referred to by some of the local people as the 'coffin bridge'.

As traffic increased along the new military roads built by General Wade and his men, the need for a better crossing became apparent

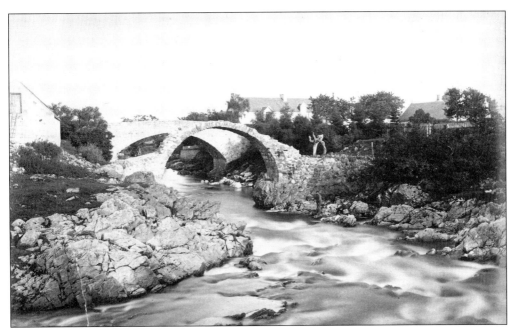

Carrbridge, the two bridges

as Carrbridge lay on one of Wade's main routes south. In 1791, a new toll bridge was built, able at last to carry wheeled traffic. Just 12 years later, in 1803, the new road to Inverness was also routed across the toll bridge before turning northwestwards to make its climb towards the summit of the Slochd.

The T-junction to the north of the new Carr Bridge was described by some as a 'settlement-in-waiting' and, as would be expected, the first building at the road junction was an inn. It was in 1808 that plans were eventually being drawn up for a 'Village at the Bridge of Carr', as even now it had not been granted its present appellation of Carrbridge. Some 70 plots appear on the plan and the largest one and a few of the half-acre plots along the new Inverness road were the first to be taken up but, even half a century later, few of the ones to the south of the river were occupied. The idea of a planned village, along the lines of Grantown on Spey or Archiestown, was too late – the moment had passed – and the harsh taxes which had been imposed to fund the Napoleonic Wars meant that Carrbridge was never to achieve its full potential.

In 1809, Carrbridge is described as 'a single arch over the Dulnan,

near which had clustered a few cottages; a little inn among them sheltered by trees, altogether a bit of beauty in the desert'.

Although the oldest bridge still stands and is visited by many tourists, the 1791 bridge is now lost, any traces now hidden beneath the modern structure. The old croft houses to the north of the village are no more and, with the arrival of the Aviemore to Inverness spur of the Highland Railway in 1898 (now the main line to Inverness) and the eventual closure of the line over the Dava to Forres, Carrbridge became a Victorian Highland village for those who wanted a quiet retreat to the Highlands. New buildings sprang up to the south of the bridge, hotels and guest houses were built and Carrbridge was, at long last, on the map.

During the First World War of 1914–1918, a German prisoner-of-war camp was established at Inverlaidnan, just to the west of Carrbridge, and some 400 prisoners were employed in felling timber.

During the Second World War, a company of the Canadian Forestry Corps was stationed nearby, again employed in felling the trees which were so vital for the war effort. They were known locally a 'Newfies' and, although they lived at first in the village hall, they very soon built their own log cabins from the trunks of the young trees which were not suitable for anything else. These log cabins must have been a constant reminder of the country they had left behind them. Many of them also volunteered for the Home Guard, especially in 1942 when it was thought that the northeast of Scotland could be a target for a possible German invasion. This led to the formation of the 3rd Inverness (Newfoundland) Battalion Home Guard, which was composed of the Canadians not only from Carrbridge but from the many other logging camps in the area, a total of 700 men. They trained at weekends and a rifle range and an assault course were built on one of the abandoned logging sites at Carrbridge, which was used not only by the Inverness Battalion but was also frequently used by other Home Guard units and also by the regular army.

The village settled down to its quiet life again after the war but this quiet holiday village on the fringes of nowhere in particular came back to life in the late 1950s and the 1960s when it beat neighbouring Aviemore in the race to become Scotland's first ski centre. The building of the Landmark tourist complex, with its adventure playground for children, meant that the peace and quiet of the village of Carrbridge was maybe now not quite so peaceful, but these new visitors also now

found the old bridge, with the rushing waters of the River Dulnain beneath, to be well worth a visit in this typical Highland village.

DULNAIN BRIDGE
(BRIDGE OF CURR)

A site of human activity for many centuries, Dulnain never achieved the status of nearby Carrbridge. Stone Age coffins were found nearby to the south of the river in a burial cairn in Curr Wood and there are standing stones in the haughs of the Spey to the east of the village. Pictish carved stones were also found in the area, a reminder of some of the earliest inhabitants.

This is the lowest crossing point of the River Dulnain before it meets the Spey and, with all of this history of occupation, it would certainly have had a ford and probably some form of footbridge from early times. There is now no trace of any original old bridge, though, and even the seventeenth-century structure, a single arch with a 65-foot span, was only able to withstand the forces of nature for about two centuries, being demolished in the Great Flood of 1829. In the flood,

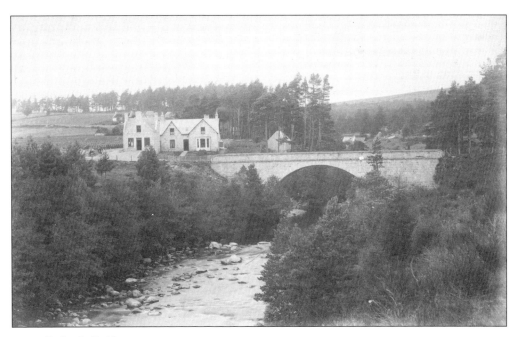

Dulnain Bridge

the southern abutment of the bridge was undermined by the rushing water and, according to eye-witness reports at the time, as the support gave way, 'the force of the immense body of water was so great that it made the arch spring fifteen feet into the air'. It apparently maintained its perfect semicircular form as it rose into the air but, as it fell, it folded in on itself, the two ends met and the whole thing fell back into the river. The bridge was rebuilt and the high arches now carry the road from the south across the river.

The main settlement of Dulnain Bridge is situated to the north of the river and to the south of the bridge lies the crofting settlement of Skye of Curr. Just to the east there is an area of glaciated rock known as 'roches moutonnées', a reminder of long distant times when this part of Scotland lay beneath the vast ice sheets of the Ice Age. Now just a village at a road junction, the traveller can easily almost miss Dulnain Bridge.

BOAT OF CROMDALE

Nothing remains of Boat of Cromdale now apart from a place name on the northwest bank of the Spey. At one time, though, it must have been

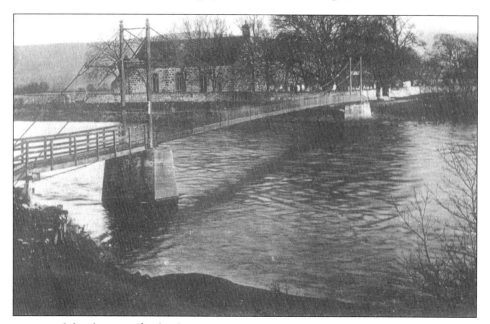

Cromdale, the 'new' footbridge

quite an important crossing point, situated as it was between Advie and Grantown. What scant records there are all point to the Boat of Cromdale being much like any of the other ferry crossings on the Spey, such as those of Aberlour or Blacksboat.

Advie had got its bridge in 1869 and Cromdale was only 12 years behind as in 1881 a suspension footbridge was opened. The Great North of Scotland Railway, which had contributed £150 to the cost of building the bridge at Advie, helped with the bridge at Cromdale by carrying materials and providing rail passes for the men working on the building of the bridge. When the new road bridge was built in the 1920s, however, the competition between road and rail was increasing and the railway refused to make any contribution to this latest bridge.

BOAT OF GARTEN

A lost boat, a bridge and a railway village – Boat of Garten, as we now know it, is really a new settlement, only brought about by the coming of the railways. It is, though, a very old river crossing, the origins of the ferry being lost in the mists of time. One of the earliest mentions of a ferry in this area – but which may, in truth, actually relate to a ferry at nearby Kinchurdy, just a mile upriver – is in documents from as early as 1662. It is an area, however, with little documentation – after all, there would probably only have been a boatman's cottage and maybe a few crofts but nothing of significance at this place called 'Gart' or 'Gartn'.

It was in 1863 that the railway line from the south came down through Badenoch and Strathspey. After passing though Aviemore, the original main line ran northwards to Gartenmore, at which point it split. The Highland Railway continued north through Grantown on Spey and the Great North of Scotland Railway went down Strathspey to its own station on the east side of the Spey at Grantown and then onwards to Aberlour, Craigellachie, Elgin and Lossiemouth. Like so many of these new railway junctions, the station formed the nucleus of a new settlement. There was a railway bridge now, near to Broomhill Station, and, in 1866, a large locomotive shed was built at Boat but still the ferry continued to cross the Spey.

The village grew up at the junction station, the boatman's cottage and the inn at Gartenmore, and now took its name from that of the railway

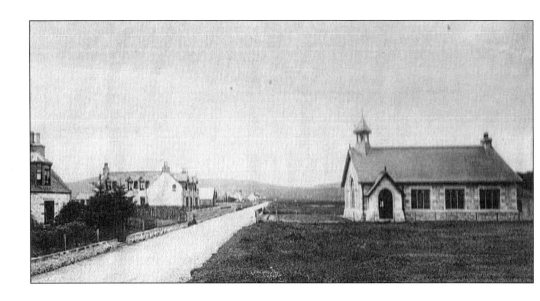

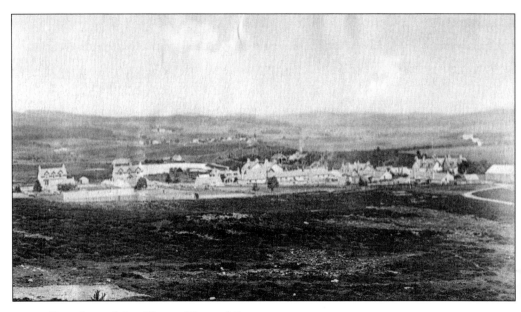

Two views of the village of Boat of Garten

station and so Boat of Garten was born. In 1898, it was recorded that there was still a chain ferry there but, just a year later, it was replaced by a wooden bridge, now lost and replaced by the modern crossing.

Thanks to Dr Beeching's cuts, the railway was so very nearly lost but, like the phoenix, it rose from the ashes and that is for a later chapter.

NETHY BRIDGE

It was always the tributaries which caused the problems. The roads following either bank of the Spey were generally quite level and easily passable, until the traveller came across one of the many watercourses crossing their way. Most of the smaller burns were quite easily forded or crossed by a wooden bridge but others, such as the Nethy, were more formidable obstacles.

Originally called Abernethy and giving that name to the parish where it stands is the settlement of Nethy Bridge. The earliest reference to the

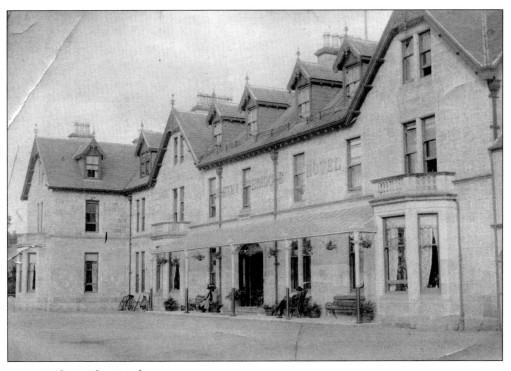

Nethy Bridge Hotel

settlement is in a document dated 1461, which refers to 'Abirneithi' as a focal point for commercial activities in the area. It was given the name of Nethy Bridge by the Great North of Scotland Railway Company in the 1860s to avoid any confusion with their other station of that name. And, unlike the station, the name stuck.

The earliest bridge is now long gone, as is the 'excellent bridge' built by Sir James Grant in about 1768 (Lauder, 'The Great Moray Flood'). Gone too is the grey granite bridge built to a design by Thomas Telford in 1810. This third bridge, its central arch having a span of 36 feet and the two side arches each being 24 feet in span, succumbed to the Great Flood of 1829 when the western arch was completely swept away by the force of the water. It was not only the bridge which fell victim to the waters but the sawmill of Straanbeg, a timber building some 500 yards upstream, which was entirely carried away from its foundations and floated down the flood 'like some three-decker leaving dock'(Lauder, 'The Great Moray Flood'). If it had not been smashed to pieces against the bulwark just above the bridge, it would probably have demolished the bridge itself, which would have led to even more destruction.

The flood also revealed the ironworks at the appropriately named Iron Mill Croft, where the York Buildings Company had an ironworks smelting the iron ore brought down from the hills of the Lecht beyond Tomintoul. This is discussed more fully in a later chapter. The ironworks had fallen out of use by the time of the Great Flood in 1829, when most of whatever remained fell victim to the river. It is just possible, though, to find traces of this old industry, another lost trade of the Spey Valley, but one which pales into insignificance when compared with the timber industry.

COYLUMBRIDGE

There is no record of when the first bridge was built across the River Druie at what is now Coylumbridge. There was always a ferry there, though, on the Spey at Inverdruie. Mentions of this, too, are few and far between – it was just an accepted fact of life that you could get a boat across the river there if you needed to. There were, as usual, two boats – a small one for foot passengers and a larger one for carriages, carts and beasts.

In July or August 1803, Elizabeth Grant records that, on their way

back from England to her home at the Doune, 'we crossed the Spey in the big boat at Inverdruie in a perfect fever of happiness'. Other than that, it is just one of the many boats lost in the mists of time.

BOAT OF INSH

Kincraig was, according to some sources, originally called Boat of Insh but it seems more likely that the village and the boat existed concurrently. It was here, though, that the traveller could cross the River Spey at the northern end of Loch Insh, the ferry providing a means to cross the river to and from Invereshie House and the numerous grand houses on the southeastern banks of the Spey. Queen Victoria, on her travels in the Highlands, probably on her way to Grantown on Spey, crossed by this very boat. The ferry was eventually made redundant when the bridge was built in the late nineteenth century. The eight-span wooden bridge rests on two masonry piers, with the rest of the supports being entirely of wood protected by V-shaped iron cutwaters.

Insh Parish Church, just a few miles upstream from the bridge, is dedicated to St Adamnan, the seventh-century biographer of St Columba. The original church is now vanished, being replaced by the present church which dates from 1792. The church is said to stand on Tom Eunan or St Adamnan's Mount and has, in its possession, a very ancient bronze bell, possibly dating, like the Ronnel Bell at Birnie Kirk, to the origins of the kirk in the eighth or ninth century. A stone basin set in one of the window alcoves of the kirk is possibly an early baptismal font, a relic of the earlier church.

GARVA BRIDGE

General Wade's military road from Fort Augustus over the Corrieyairack Pass crosses the Spey at Garva Bridge, a place which really marks the eastern end of the pass. A well-buttressed two-arched bridge, well able to stand the spates of the river in its juvenile years, this was the first two-arched bridge which Wade constructed, back in 1732. The bridge is 180 feet long and each of the two arches spans 45 feet. The arches are widely separated and, as the central pier is founded on a large rock which juts out of the bed of the Spey, it seems almost to be two

separate single-arched bridges joined in the middle. The narrow road and the high parapets of the bridge seem to hem in the traveller to protect him from the rushing waters of the river below. In earlier times, it was apparently known as St George's Bridge, probably named after King George II.

Nearby, along the old military road, is the former inn or 'kingshouse' at Garvamore. The long two-storey building is nearly contemporary with the bridge and was certainly built before 1740. In design, it is essentially a tacksman's house but it may originally have been intended as a barracks – the kingshouse was, in fact, used by soldiers and civilians alike before they ventured across the Corrieyairack Pass. Or, maybe, having just come down from the pass, they needed the warmth and sustenance of the inn. The cattle drovers coming down from the pass would have used Garvamore as a stance for their cattle as it was an ideal place for an overnight stay with grazing and water available on the doorstep and a roof over their heads for the drovers.

Prince Charles Edward Stuart is reputed to have slept there on his march southwards from Fort Augustus and, at one stage in its existence, it also served as a school for the local children. It is difficult to think now that there would have been any children in the area but, in the late eighteenth century and probably well into the nineteenth century, crofting communities would have extended right along these upper reaches of the Spey. The kingshouse at Garvamore was lived in by a shepherd and his family until just after the Second World War when, like the old farmstead of Drumin some miles further up the strath, it was finally abandoned.

What may be thought of by some as a place of national interest, Garvamore was too far off the beaten track to be of any great concern to those who had any say in the matter. Although two of the box beds from the building were donated to the West Highland Museum in Fort William, the structure itself was allowed gradually to fall into decay. In 1976, it was subjected to some restoration, which involved patching and repairing the stonework and repairing the roof. In 1997, this Category A listed building was de-scheduled and a contract worth some £205,000 was awarded for ongoing repair and restoration. But whatever happens to Garvamore, it will probably never again provide sanctuary to the marching soldiers or soothe the sore feet of the walkers coming down from the pass.

Continuing along Wade's road towards the village of Laggan and just a few miles east of Garvamore is the site of not one but two old Catholic churches known as St Michael's Chapel. The oldest building stood in a graveyard surrounded by a turf-covered rubble wall and, although there is now no trace of the old church, a few gravestones are still visible. There are suggestions that this old church was taken down stone by stone and rebuilt at Pluscarden Priory but no documentary evidence has been found for this. This chapel was replaced by a new building in 1845 but was bulldozed, some say blown up, in the mid 1950s leaving large quantities of rubble on the site. This was done, according to some sources, to prevent any further desecration of the site.

Near the centre of the old graveyard stands a carved stone, leaning slightly, with one side showing carvings of beasts, the other side a cross. The sides of the stone are carved with saltires. The presence of this significant stone, seemingly of Pictish origin, would indicate that this church was, at one time, of considerable importance, especially as it is only a few hundred yards from the fort of Dun-da-Lamh, considered to one of the most perfect examples of a Pictish fort to be found. This was evidently a centre of some importance in early Christian times, controlling this important route through the Scottish Highlands.

LAGGAN BRIDGE

Just a few miles past Dun-da-Lamh is Laggan Bridge. This is where General Wade's road from the Corrieyairack Pass turns southwards towards Dalwhinnie and the Drumochter Pass. Across the bridge the road carries on northeastwards to Newtonmore, Kingussie and into Strathspey. The original wooden bridge at Laggan was built to a design by Thomas Telford, on the site of an earlier ford, and possibly also a boat. The traces of this old bridge are now lost and the modern bridge which replaces Telford's structure is of no great architectural merit, just functional.

LOGGERS, FLOATERS AND SAWMILLS

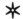

LOGGERS

The forests of Badenoch and Strathspey were a vast source of wealth to the landowners but it was not until the eighteenth century that they began to take advantage of this natural resource.

The forests above Nethy Bridge were relics of the great forests which, in early times, covered much of Scotland. Their relatively inaccessible location had saved these magnificent trees from exploitation and the proprietor found it of little value, an insignificant part of the vast lands of the family of Grant.

As already mentioned, there was extensive but not very well documented felling at Carrbridge and in other parts of the forest during the First World War but that was not the end of timber felling at Nethy Bridge – the need for timber during the Second World War, especially by the coal-mining industry, led to the establishment of a base nearby for a company of the Canadian Forestry Corps, who were employed in felling trees which were so vital for the war effort. Many of them, like their comrades in Carrbridge, volunteered for the Home Guard and became members of the 3rd Inverness (Newfoundland) Battalion Home Guard.

These more recent loggers, though, had the benefits of mechanisation and also the nearby railways. This, however, is the story of the early loggers and floaters, which is really one of the lost industries of this area.

In 1730, the York Buildings Company purchased a portion of the forest from the family of Grant for £7,000 and spent the next seven years felling these ancient trees. In his submission for the *Old Statistical Account* some 60 years later, the Minister of Abernethy, the Reverend John Grant, described the immigrant workers and their employers as 'the most profuse and profligate set that were ever heard of in this

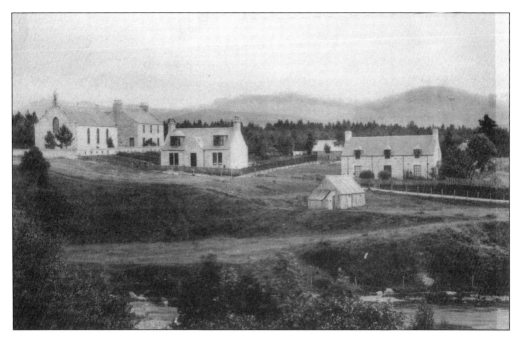

The church and village of Abernethy in the early twentieth century

corner. Their extravagancies of every kind ruined themselves and corrupted others. Their beginnings were very great indeed, with 120 working horses, sawmills, iron mills and every kind of implement, and apparatus of the best and most expensive sorts. They used to display their vanity by bonfires, tar barrels, and opening hogsheads of brandy to the country people, by which five of them died in one night. They had a commissary for provisions and forage, at a handsome salary, and in the end went off in debt to the proprietors and the country.' The minister did admit, however, that the company had made great improvements in the roads in the area and had given the local inhabitants the basis for a sound timber industry.

In earlier times, the timber which had been felled was drawn by horses, rough little horses each attended by a young boy, and the logs were taken to the nearest running water. As the stock of logs built up sufficient timber was collected to make it worth while opening the sluices which had been built on the lochs which fed these streams. This meant that many of the earlier sawmills, which had taken advantage of the power provided by these streams, were no longer needed. Lost to us now is the single cut sawmill in its clearing in the woods, with a

couple of little cottages and a cultivated patch of garden ground for the millers. It was more profitable to operate the large mills nearer to the Spey, with their double saws.

FLOATERS

The big problem, of course, was how to get this timber to the markets. But near at hand were always the rivers and, by the judicious building of dams and sluices on the tributary streams, they were able to float the timber in great rafts down to what was, at that time, the major port of Garmouth on the coast of the Moray Firth.

In earlier times, the idea was to float small and poorly constructed rafts of timber down to the sea, or even just masses of individual logs, which were conducted by men in small hide boats known as currachs, a slightly larger version of the coracle. According to William Ashley-Bartlam, in his unpublished *Mining at the Lecht*, the currachs were 'made of hide, in the shape and about the size of a brewing kettle, broader above than below, with ribs, or hoops of wood in the inside and a cross stick for the man to sit on, who, with a paddle in his hand went before the raft to which his currach was tied by a rope'. The earliest record of this industry seems to have been in 1540, on the estate of Rothiemurchus.

The felled timber was launched into the River Nethy at the edge of the forest and floated downstream to be recovered at Coulnakyle, where the Nethy meets the Spey. It was here that it was assembled into rafts. It was reckoned that, with a good flow of water in the rivers, the roughly 40-mile journey from Abernethy to Speymouth would take about 12 hours. After guiding the raft all the way down to the mouth of the Spey, the currach was so light that the men were able to carry them on their backs to the bothy which had been constructed for them at the mouth of the Druie at Rothiemurchus. The York Building Company employed 18 currachers in its early days but the whole idea was not only slow and cumbersome – it was also downright dangerous.

Things had to change and, on the advice of one Mr Aaron Hill, poet, manager of the Drury Lane Theatre and a gentleman with some involvement in the York Building Company, they devised a method of building a larger raft consisting of two or three branders of spars in the bottom, joined end to end with iron or other hoops and tied together

with ropes of withies (willow). Deals (planks) were placed on the top to make a deck on which two men, one at each end, had a seat and an oar, which they used to keep the raft in the proper direction. The coracles now seem to have been abandoned to a large extent and it must have been an impressive sight to watch the men guiding these great rafts of timber, maybe as many as 20,000 timbers at a time, down the river. In addition to the men on the raft itself, there were also numerous men who followed the floats down the river and, using long poles which they called cleeks, something like a modern boathook, they were able to steer the timber past any obstructions and to unscramble the inevitable log jams on the river.

The York Building Company is credited with improving the clear flow of the river by removing rocks and various other obstructions on which the rafts may have become snagged and foundered. The 'floating dams' with their sluice gates, especially along the River Nethy, were improved, as they were, in general, just earth dams. Some traces of them can still be found along the course of the river.

From looking at the old records, it seems that sometimes the rafts were taken all the way down the Spey by the same crew, whilst other journeys were done in stages with a new crew taking over maybe at Ballindalloch. This was where most of the floaters lived and there seems to have been a series of family businesses based there although, according to contemporary reports, 'anyone living near the water was at it'. It was a dangerous journey, especially if the river was running strong, as it often did, and the Speymouth Kirk session minutes relate several instances of the raft and the crew being unable to beach at Speymouth and being carried well out to sea.

These good times were not to last and, by 1737, the York Building Company had overstretched itself and was forced to abandon its logging activities in the forests of Rothiemurchus and also its mining activities at the Lecht. The floating continued, however, and led to disputes between the Duke of Gordon and Sir Ludovick Grant. In 1780, the Duke of Gordon brought an action in the High Court in Edinburgh to prevent Sir Ludovick Grant and other proprietors from floating logs down the River Spey, on the grounds that they were damaging his fishing. In some of the shallow places, the Duke had built stone dykes across the river and these were known as 'cruives'. There were gaps in these cruives, where cages could be set to catch fish coming upstream to be caught at certain times of the year. These cruives were sometimes

damaged by the great rafts of logs but the court upheld the Grants' use of the river and the floating continued. A whole industry of shipbuilding and of timber exporting grew up at Garmouth and Kingston all as a consequence of the idea to float the great logs of Abernethy down to the sea.

The Spey floaters went up to Rothiemurchus in the season when the Spey spates were due and a large bothy was built for them at the mouth of the Druie. A primitive bothy it was too, with a fire on the stone hearth in the centre of the floor, a hole in the roof to let the smoke out and no windows. The heather which was spread on the floor served as a mattress for them and, after a hard day's work, they would settle down for the night in their wet clothes for each man had worked all day on or more often in the river. The men would spend the night lying there, 'each man's feet to the fire, each man's plaid around his chest, a circle of weary bodies half stupefied by whisky, enveloped in a cloud of steam and smoke, yet sleeping soundly till the morning'. It was a hard life but they seem to have been a healthy bunch of men although various contemporary sources suggest that the floaters suffered greatly from rheumatism in their later lives. It was, though, only for one season of the year, the rest of the time the men could live at home and till their little crofts in their own lazy way, always knowing that the money from the floating would cover the payment of their rent to the laird. Maybe this sort of life is better to be lost in distant memories or at least to be viewed through rose-tinted spectacles?

It was one of these very experienced floaters, Charles Cruickshank, who was also the innkeeper in Aberlour, who was to lose his life in the Great Flood of 1829, as mentioned in a later chapter.

To Elizabeth Grant, writing in 1812, one of the great events of the winter season was the floaters' ball. According to her memoirs, '[T]he amusement began pretty early in the day with a game of Ba', the hockey of the low country.' In fact, what she is describing is shinty and the game went on until it was dark, after which dancing, music and general festivities took over until the early hours of the morning.

SAWMILLS

In early times, before the invention of large saws, the timber had to be cut using a series of hardwood wedges which were forced into the

tree trunk, gradually forming a crack which would then be widened to allow the rough planks to be split off from the trunk, which were then finished as boards using axes and adzes.

The development of the large saw allowed the employment of 'sawyers', who worked in pairs to cut the planks from the trunk. They worked at a sawpit, usually some six or eight feet deep, across which the log was set up on trestles. One of the pair, usually the master, would stand above the pit at the top end of the saw blade, which was fitted with a wooden cross handle. The other, usually the apprentice, would operate the bottom end of the saw, standing in the pit amidst a shower of sawdust. Not a nice job and they had no showers to go home to after work in those days!

The earliest water-powered sawmills would have been just a water-driven version of the manual saw in the sawpit but, by 1762, the circular saw had been patented and gradually double or even multiple circular saws were brought into use. The logs were mounted on a sliding bed which passed through the circular blades and, by this process, straight, evenly shaped deals could be cut. It was these deals, cut at the water-powered sawmill at Coulnakyle, which formed the decking of the rafts which were then floated down the Spey.

According to the *Old Statistical Account* of 1794, there were four sawmills along the lower reaches of the River Nethy – in addition to the mill at Coulnakyle, there were also mills at Balnagown, Lower Dell and Craigmore.

BORING MILLS

In 1766, a boring mill was built at Lower Dell to produce wooden water pipes. This mill was situated beside the sawmill and used the same power source. The boring mill had been designed by William Forbes, the Grieve at Castle Grant Home Farm, and comprised augers of 3-inch, 4-inch or 5-inch diameter, which would drill holes down the centre of selected, very straight tree trunks. By this method, water pipes of about 10 feet long were produced and, for some reason, only trees with complete, undamaged bark were suitable for the purpose. Many of the products of this boring mill were transported to London but the process of floating them down the river sometimes resulted in damage to the bark and they were deemed unsuitable for this prestigious

market. Samples of the bored pipes were exhibited in London in 1767, having been taken there by boat from Garmouth, but a rival business, which was established in Rothiemurchus just four years later, denied the Nethy Bridge enterprise the success which it deserved. By 1774, the market for these pipes had vanished, overtaken by the production of English elm pipes on estates much closer to the final markets.

THE GREAT FLOOD

As well as destroying the bridge at Nethy Bridge, the Great Flood of 1829 wiped out three of the four sawmills in Nethy Bridge and only one was able to continue in business afterwards. Many of the river channels which had been cut or deepened were now lost and the business of floating the rafts of logs down the river, which was already in considerable decline due to the changing needs of the shipbuilders, gradually came to an end along with a way of life probably unknown anywhere else in Britain.

CHAPTER 8
INDUSTRIAL GLENLIVET

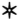

TOMINTOUL AND
THE LECHT

The pastoral Braes of Glenlivet, in the area of Conglass and Abernethy, and the later village of Tomintoul were the sites of considerable industrial enterprise at various times in the eighteenth and nineteenth centuries.

Leaving the high road from Perth and Blairgowrie, the traveller can decide to head for Strathspey over the River Gairn and, climbing towards Cock Bridge and Corgarff Castle, the Lecht Road takes us to the planned village of Tomintoul. This is not strictly Speyside yet but very nearly as it is here that we are coming into the whisky country for which Speyside is so famous. A choice of equally attractive routes lets the traveller make for Grantown on Spey, down Strath Avon, along the back of the Hills of Cromdale, or down the valley of the River Livet towards Aberlour.

Roads converged on Tomintoul from the south, the west and the north. And there was very nearly a railway but, as usual, economics prevailed. The village of Tomintoul was laid out as a focus for the scattered crofting communities of this upland part of Moray and Banff. Originally just a small farm, with its turf-built cottages, the Duke of Gordon, like his contemporaries, wanted to do the best he could for his tenants and, of course, also for himself. So what could be better than to build the highest village in the Scottish Highlands?

Tomintoul was planned and built in 1775 and 1776 by the 4th Duke of Gordon and has the typical layout of such a village with its central square and wide main street. The area was to have a flax and linen industry, which the Duke hoped would provide work for his tenants and give employment to the cottagers. The village was also situated on the recently built military road on its route from Corgarff to Grantown on

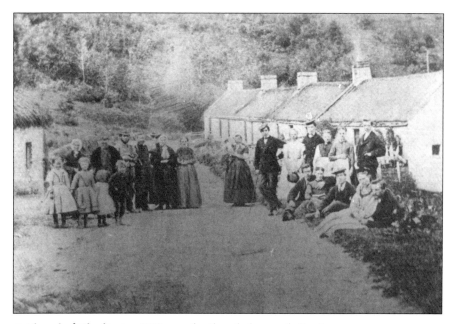

Bridgend of Glenlivet c. 1881, maybe the whole population?

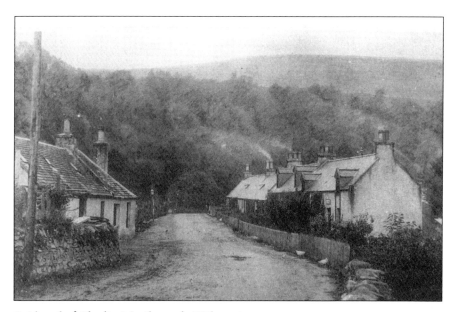

Bridgend of Glenlivet in the early 20th century

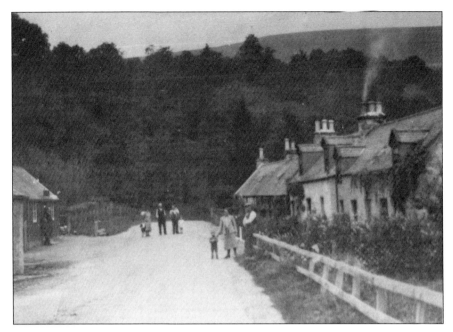

Bridgend of Glenlivet c. 1940

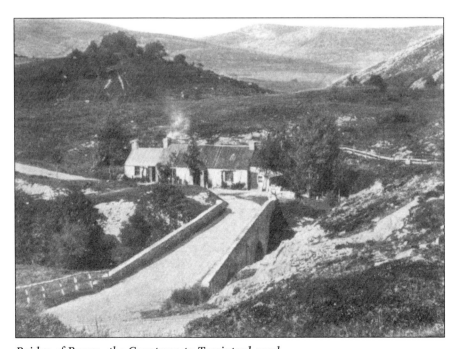

Bridge of Brown, the Grantown to Tomintoul road

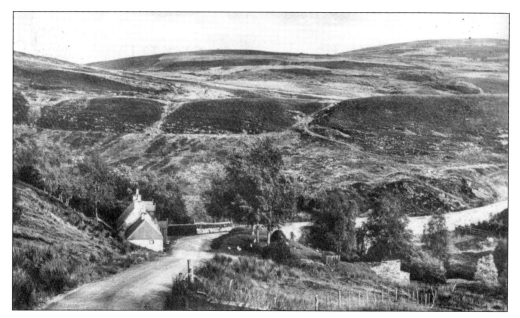

Bridge of Brown

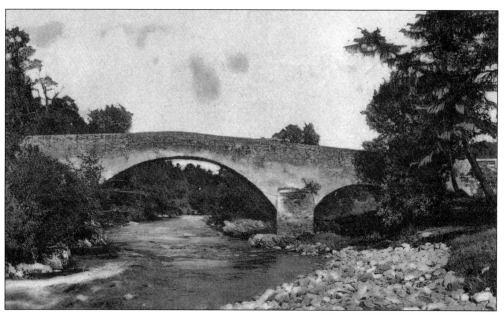

Bridge of Avon, Ballindalloch

Spey and eventually over the hills to the Moray coast and Fort George, with whatever passing trade this may have brought to these parts.

THE CHARCOAL AND IRON INDUSTRIES

*

The industrial history of this wild and remote area, though, goes back over half a century earlier. In 1730, veins of manganese and iron ore were found at the head of Conglass and, initially, an iron-ore mine was established at the Well of the Lecht. The York Building Company, which had been originally incorporated in 1691 to supply water to the fashionable districts of London, fell under new management in 1719 and diversified into land ownership and exploitation. A charter was granted which empowered them to acquire land and they used this to buy up the Scottish estates of the rebels which had been forfeited after the Jacobite uprising of 1715. This enabled them to acquire not just large areas of the forests, as mentioned in an earlier chapter, but also to exploit this new source of minerals. The mined iron ore was carried by pack horse over the hills to be smelted at Nethy Bridge, where there are still traces of the old industry to be found.

The York Building Company was able to make use of an industry which was already well established in the area around Abernethy – that of making charcoal. There was already a well-established and profitable market for the products of the charcoal burners, in England, Holland and elsewhere in Europe. The branches from the pines which had been felled for floating down the River Spey provided an ideal source of fuel for the charcoal burners and, to provide fuel for their various furnaces, the company increased production to such an extent that there were fears for the future of even these extensive forests. As charcoal was used exclusively as a fuel in these early blast furnaces, there are suggestions that some individual furnaces used the wood from over 150 acres of forest in the course of a year. This caused great consternation; the various wars in which the country was involved at this time meant that large quantities of prime timber were also needed by the Navy for their great warships.

The beehive-shaped stacks in which the wood was burned are another long-lost feature of the countryside in this part of Badenoch and Strathspey, but how exactly was this charcoal made? The wood was carefully stacked around a chimney of split logs which had been formed around a central stake. It was then covered with earth and

ashes in order to exclude nearly all the air and the stack was set alight with burning embers dropped down the chimney after the central stake had been removed. Once the embers had caught fire the chimney was closed and the whole structure was carefully monitored, both day and night, to make sure that it burned slowly and evenly, but without the wood ever being allowed to burst into flame. The whole process could take eight or nine days and provided a good deal of employment for the local area.

The iron ore being brought down from the mine at the Lecht had already been crushed to some extent to make it easier to transport and, in the 1700s, 15 boys were employed to crush the ore by hand into pieces 'about the size of a billiard ball or smaller', ready for the smelter. Limestone, from the several limestone quarries around Abernethy, was also crushed and added to the mix as a flux to extract impurities from the ore, which could then be skimmed off the molten metal as 'slag'.

The exact site of the smelter is unclear, especially as the whole enterprise had a working life of but seven years. A local minister, writing at the end of the nineteenth century, says, 'Baileghobain, Smith's Town, is the site of the forges connected with the great wood and ironworks conducted by the English in the 18th century.' Sir Thomas Dick Lauder, when writing about the Great Moray Flood, had commented about the 'Iron Mill Croft, where iron beams were seen and water from the River Nethy was taken off by sluices to operate ponderous hammers to pound iron ore, moved by active machinery in the bed of the River Nethy'. This machinery was probably a large waterwheel and, although, after the Great Flood, it lay ruined in the bed of the river, it would have originally stood beside the river when it was in operation.

It seems reasonable, therefore, to think that the Iron Mill Croft, with all its associated machinery, may have been in the area of Causar, just to the east of the Nethy Bridge Hotel, and the two 'ponderous hammers' recovered from the river bed provide further evidence that this was the site of the smelter complex. The hammers have since been moved to Kinveachy Lodge.

For just seven years, this part of Badenoch and Strathspey must have been a hive of activity, reverberating to the sounds of what at that time would have been 'heavy industry'. The conversion of iron ore, the manufacture of pig iron and the eventual refining to produce wrought iron required at least three closely integrated furnaces, the smelter, the bloomery and the chafery, and there would almost certainly have also

been a blacksmith's forge operated by the company, probably employing several smiths, where the many iron articles needed by the company would have been made. This latter forge may well have been at Coulnakyle, where the manager lived and the company had established its headquarters, the site later becoming a sawmill.

The streams of pack horses transporting the ore from the Lecht to Nethy Bridge would have been a daily feature of life, providing employment for, at its peak, 120 horses and 60 men. The pack horses would have probably been 'loose headed', which meant that they were not tied together. The matriarch of the pack would have had a bell hung around her neck – she would be known as the 'bell mare' – and the rest of the pack would follow, always staying within sound of the bell. They would soon have come to know the 16-mile route and the clanging of the bell would have become just another sound lost on the winds of this wild and remote area.

Visitors to Nethy Bridge now can find almost no trace of any of this industrial background but a closer look may reveal the remnants of a later use of some of these facilities. For example, the blast furnace at Straanbeg was replaced with a sawmill and the foundations of this mill and the lade associated with it can still be traced. There are, of course, now no traces of the workers' 'elegant wooden houses' (RCAHMS) nearby down in the Straanmore.

As has been said in an earlier chapter, a combination of bad management and economic circumstances, mainly the former, led to the demise of the company in 1737 and the mines were abandoned.

Manganese Mining
*

A century later, maybe to some extent due to the failure of the flax and linen industry at nearby Tomintoul, the Duke of Richmond and Gordon decided to re-open the mines in 1841 – this time to exploit the manganese found there. The Lecht was to become the largest manganese mine ever to be worked in Scotland, employing, at its peak, some 60 men and boys, including 12 miners and 15 boys to crush the ore. Although the enterprise was established by the Duke of Richmond, it was very soon leased out to Messrs Cookson and Company of Newcastle.

The site of the mine is marked by the remains of the tall two-storey rubble building with its slated roof which housed the crushing plant and there are still traces of the line of the mill lade together with some

evidence of the remains of smaller buildings on the site. The high-level lade, which was served by a dam some 400 yards to the northeast of the building, powered an overshot waterwheel and the aperture for this wheel is still visible in the gable wall of the old building.

The manganese was taken some 45 miles by pack horse across the hills to the port of Gollachy, later known as Portgordon, near to the mouth of the River Spey. The pack horse men, according to Haldane, would have armed themselves with a broadsword, a poniard (a type of dirk) and a pistol as, even at this time, the countryside was unsettled, with cattle thieves and groups of vagrants roaming the land. The pack horses would probably have followed the old drove road or the whisky road from Glenlivet, going down Avonside to Craigellachie where there would have been a stance where both men and beasts could take a well-earned rest.

The export of the first cargo of manganese from Portgordon was reported in the *Aberdeen Journal* of 7 June 1843, on board the '*Mary Ann*, of Spey, a fine new clipper schooner'. This cargo was, as would be expected, bound for the Cookson Company in Newcastle, where it was processed for use as a bleaching agent.

Imports of manganese from Russia, however, soon reduced the price of this commodity from £8 per ton to just £3 and, within five years, the whole enterprise had been abandoned as uneconomical and all of the workers at the mine and also the pack-horse men were unemployed.

One Last Glimmer of Hope
*

Mining in this desolate area still seemed to have its attractions, though, and, in 1863, samples of iron ore from the Lecht mines were sent to the manager of the Ferryhill Ironworks in County Durham. The manager, James Morrison, would gladly have taken 50,000 tons a year from the Lecht but the problem was how to get the iron ore to the ironworks. A railway would have been needed, probably running from Tomintoul to the Strathspey line, but the 1860s were a time of economic retrenchment, even of stagnation, and it proved impossible to find anyone willing to invest in such a project. The iron ore still lies beneath the snow-covered mountains around the Lecht, maybe waiting until the world is so desperate for such a resource that ways will be found to make it viable.

The site of the mine is still visible but few traces of the buildings

remain – just the path from the old military road remains to lead the visitor to this outpost of Scottish industry. Lost too are the old pack-horse trails from the Lecht down to Nethy Bridge and down to Craigellachie, although some of the forest tracks may still reveal traces of this old route.

THE FLAX AND
LINEN INDUSTRY

Sadly the flax and linen industry which the Duke hoped would provide work for his tenants in Tomintoul did not succeed; maybe at a height of over 1,100 feet above sea level it was not, with hindsight, the most suitable part of the Duke's lands to attempt such an enterprise. But the village of Tomintoul did not die. Building continued and it became a classic example of a planned village in the Highlands. Georgian and Victorian buildings later sprang up around the central square and, throughout its history, Tomintoul has been a resting place for travellers along the 'other' road into Strathspey. The villagers and the other inhabitants of this parish of Kirkmichael found different ways to make a living, whether by finding casual employment on the Duke's estates, by tending their own small lots of land to provide a subsistence living or by going back to one of their earlier occupations, that of breeding and exporting cattle to the markets of the south. And there were, as always, still a few who thought it would be less work to make a living from other people's cattle – the days of the reivers were not totally lost.

The *First Statistical Account* of the 1790s reveals that, like most of the neighbouring parishes, the local people had a liking for whisky. Speaking of the inns and other houses in the area at that time, the minister commented, 'All of them sell whisky, and all of them [the people] drink it. When disengaged on this business, the women spin yarn, kiss their inameratos [sic], or dance to the discordant sounds of an old fiddle. The men, when not participating in the amusements of women, sell small articles of merchandise or let themselves occasionally for a day's labour.' One senses that the minister was fighting a losing battle against the conceived pleasures of the local alcoholic brew!

There was even a royal visit, in 1860, when Queen Victoria commented on the three inns in the village and also on the beauty of the surrounding scenery. Even today, Tomintoul is still on the tourist

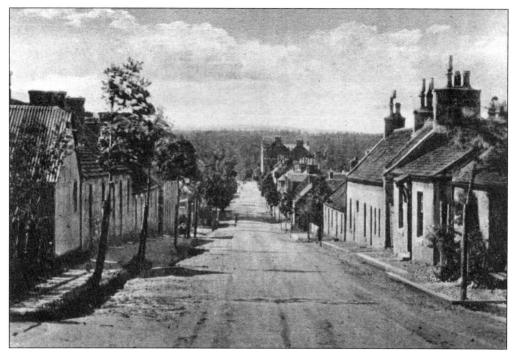

Tomintoul, the main street

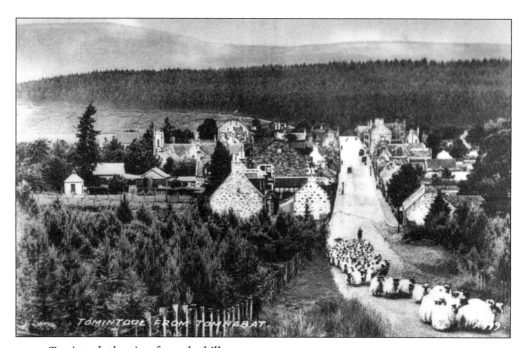

Tomintoul, the view from the hill

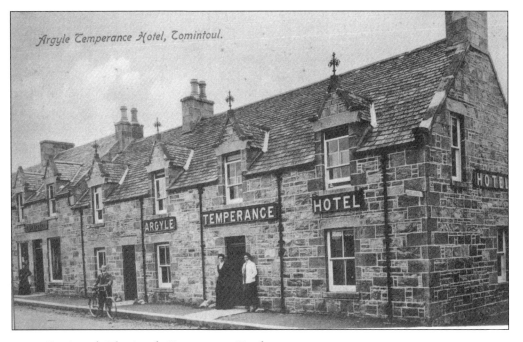

Tomintoul, The Argyle Temperance Hotel

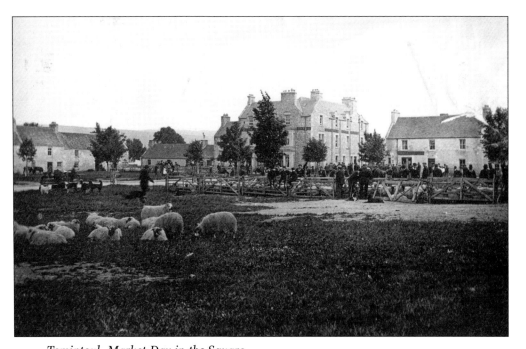

Tomintoul, Market Day in the Square

route but for other reasons. With a population which is ageing and gradually declining, the village still gives the visitor a good picture of what life was like in those times which are now only held in some dimming memories of 'better' days.

A NEW INDUSTRY

*

Just on the limits of the area we are considering lies the ski centre at the Lecht. Maybe it is just a little way outside Badenoch and Strathspey but, attracting enthusiasts from all over the country, it surely has had a revitalising effect not only on Strathdon but on the whole area. Maybe, in some way, it compensates for the loss of the earlier industries and makes this wild area better known to the visitor, even if it is only the usual winter message on the road reports that 'the A939 Cockbridge to Tomintoul road is closed due to snow'.

CHAPTER 9
WHISKY

It is impossible to think of Speyside without thinking of whisky. All along Strathspey and into Badenoch and up the tributary valleys of the Avon, the Livet and the Fiddich, the gleaming pergolas of the distilleries beckon the traveller to the source of this, our national drink.

From Dalwhinnie in the south, through Newtonmore and Kingussie, through Aviemore to Nethy Bridge, one is rarely out of sight of a distillery. Into Speyside itself, from Grantown on Spey all along the valley to Aberlour and beyond to Rothes and even further, the place names read like a 'who's who' of the amber nectar.

THE EARLY TIMES

How and when distilling began in Scotland will never be known, lost somewhere in the mists of time, maybe in an alcoholic haze? *Uisgebaugh*, Gaelic for the 'water of life', was corrupted into *usky* and then into whisky, a word the English-speaking world was soon to become very familiar with.

It seems probable that the art of distilling was brought to Scotland by missionary monks from Ireland, in the twelfth century if not earlier, and it is interesting that some of the earliest centres of distilling are near to the sites of early monastic communities. One of the earliest documented mentions of it in Scotland is in the Exchequer Rolls of 1494, when it is referred to by its Latin title *aqua vitae*, also translated as the 'water of life'. It was as a medicine that whisky first seems to have become popular amongst the Scottish people. David Daiches, in his *Scotch Whisky*, describes it being prescribed 'for the preservation of health, the prolongation of life, and for the relief of colic, dropsy, palsy and smallpox, as well as a host of other ailments'. In the harsh existence which many of the people had at that time, maybe whisky also made life more bearable or at least masked the worst of their hardships.

In 1597, it was feared that there would be famine following a very poor barley harvest and this led to the earliest attempts at government control, the production being temporarily restricted to 'Lords of Barony and Gentlemen of such degree'. Some fifty years later, an Act of Excise was passed by the Scottish Parliament, fixing a duty of 2/8d per pint of strong liquor. A Scots pint at that time was about one third of a gallon. This imposition of taxation led to the long and turbulent history of illicit brewing, distilling and smuggling. There were widespread riots, the Revenue Officers suffered the worst of the violence and, when bribery didn't work, they were, at best, often bound and gagged and abandoned somewhere in the countryside or, in the worst cases, they were killed. Rioters were often sentenced to be whipped by the common hangman and then transported.

The illicit distilling continued through the eighteenth century and one wonders whether an entry in the Ruthven Death Records on 26 April 1749 may be a result of the smuggling trade: 'James Reid, skipper, William Murray, William Reids father and son, William and William Geddes father and son and John Reid alias Lith, having been drowned at Speymouth about ten or eleven o'clock at night the 24th were all buryed this day in their own burial places. Also Charles Gordon, Postmaster at Fochabers and William Gordon, son to James Gordon, Merchant in Garmouth with them, the boat being load with prohibited goods.' Just a few days later, on 12 May, 'Marjorie Coul, spouse to the above drowned James Reid, skipper, was buried.' Maybe these prohibited goods were the product of some illicit still far away up in the hills.

Even as recently as 1820, there were no legal distilleries on Speyside or in Badenoch although the products of over 200 illicit stills in Glenlivet alone, and many more in other districts, meant that there was no shortage of high-quality spirits for the local population. The smugglers kept the taste for a good whisky alive at a time when the products of the legalised distilleries in other parts of Scotland were so inferior that they were barely worth drinking. The illicit trade forced many of these licensed distillers out of business, as their products were so damaged by taxation, but the cottage stills of Speyside and Glenlivet kept the taste for whisky alive.

The Duke of Gordon managed to encourage the passage of the Excise Act of 1823 through parliament, and it is noticeable that the lands of Strathspey and Strathavon, his own properties, were to become the sites for some of the leading distilleries in Scotland. The Excise Act

and the more reasonable duties which it imposed enabled the newly licensed distilleries to produce a spirit which was of an equal strength and taste to that of the 'home-brewed' variety and the days of the freebooters were on the wane.

The Duke of Gordon and the Lairds of Grant did all that they could to suppress the illicit distilling, a major undertaking when so many of their tenants were involved in the operation of illegal stills, and it became, according to some contemporary reports, a 'bloody affray with bands of lawless desperadoes'. The use of force was commonplace, shots were fired by both sides and people were injured and even killed. The excise officers, poorly paid as they were, were able to split the proceeds of their seizures with the government and improved their own standard of living in this way. This meant, though, that, at times, they had to lay off the pressure on the illicit stills, in order to allow them to build up enough untaxed whisky to make it worth making another seizure. The closure of the illegal stills was not a quick process. The most common complaint by the owners of the new licensed distilleries was that they could not sell their products locally due to the output of the cottage stills.

Smuggling, however, continued to flourish even after the new act had been passed and, although the traffic along the major smugglers' road over the Ladder Hills to the south gradually dried up, many thousands of gallons of the water of life were still carried south in pigs' bladders hidden under the skirts of the smugglers' women folk or were transported north to the coast in tin panniers carried on pack horses by hidden routes through the hills. The coastal fishing villages of Banffshire seem to have provided a good outlet for these smuggled goods. The excise officers in the Elgin area, which probably included much of Strathspey, reported more than 3,000 detections of illicit distilling in the year 1823–1824.

These illicit stills were to be found in the most unlikely places – it is even said that there was one in the clock tower in the centre of the main street of Dufftown, despite the fact that the local excise officer walked past the building every day on his way to and from work. Or maybe he just turned a blind eye and got his rewards in kind. But gradually the excise officers gained control of the situation and, by 1834, the smuggling trade had almost vanished. Many of the illicit stills hidden away in the Braes of Glenlivet and in the hidden tributary valleys of the River Spey and in the heather covered wilderness of Badenoch still

survived, providing a tax-free source of whisky for the local population and maybe if we search hard enough there are even to this day a few to be found – perhaps all is not lost after all.

THE COMMERCIAL DISTILLERIES

It was, though, now in the best business interests of the commercial distilleries to produce readily available products at a price the consumer could afford. The single malts remained but the development of grain whisky and the later idea of blended whiskies led to the development of an industry which many people now regard as almost synonymous with Speyside.

Some of the earliest commercial distilleries in Badenoch and Strathspey came into being following the 1823 Excise Act and 1824 was a good year for these enterprises to get off the ground. At Cromdale, the Balmenach Distillery was opened by James McGregor in that year and, although there has obviously been some reconstruction, apart from a period during the 1940s, the distillery has been in use continuously since that time.

John Cumming, a well-known whisky smuggler, had started producing whisky at Cardow or Cardhu in Knockando in 1811. Following the new act, however, in 1824 John Cumming, now described as 'a tenant farmer in Cardow, who together with his wife had for several years been distilling illegally', took out a licence for a small still which was operated as part of the farm. It remained as a small-scale operation for many years, in 'buildings of the most straggling and primitive description' (Bishop, *Lands and People of Moray: Parish of Knockando*). The original distillery was in operation until 1884 but all traces of it are now lost among the more modern farm buildings. In 1884, the new distillery, with its elegant pagoda roofline, was built on the present site.

The Macallan Distillery came into production in 1824 at Easter Elchies near to Craigellachie. Alexander Reid, a local farmer who was well known for his advanced methods of agriculture, took over the lease of a wooden building at Easter Elchies and leased eight acres of land from the Earl of Seafield to establish a distillery there. In 1847, he went into partnership with James Priest and James Davidson and the Macallan soon became known for the superior quality of its whisky.

Apart from Longmorn, near to Elgin, this is probably one of the only distilleries on Speyside to have a burial ground within its precincts. The one at Longmorn is now, sadly, lost beneath its millpond.

The Glenlivet was founded by George Smith of Drumin in 1824 and was the first legal distillery in Glenlivet. Such was the opposition to his enterprise, mainly from the local illicit distillers and smugglers, that he 'had to carry firearms for his protection for a long time till they dispersed' (Daiches, *Scotch Whisky*). The distillery moved from Upper Drumin to its present site in 1858 and the manager's house and the barley loft (now the visitor centre) still remain from that time.

The Exchequer Records, however, give us details of some of the distillers in Rothes. In one snapshot week in 1831, the distiller at the Grants' Distillery at Dandalcith, John McInnes, was making 223 gallons per week and the distiller at Macallan, Alexander Reid, some 200 gallons a week. John Cumming, the distiller at Cardow, was producing 48 gallons a week and, at the Rothes Number 1 Distillery, James Gordon was making 725 gallons per week. James Taylor, the distiller at Rothes Number 2 Distillery, was producing 126 gallons per week – a total of 1,322 gallons each week from the distilleries of the parish. John Cantlie is identified as the manager of the Dandaleith Distillery, Richard James Entwash was the District Supervisor for the Excise, the Collector of Excise was John Jackson and the Inspectors were George Pringle and Robert Hogg.

Not to be outdone, other businessmen were keen to get on board with this new commercial enterprise. James Grant and Peter Weir opened the Aberlour Distillery on the Lour Burn, now known as the Burn of Aberlour, in 1826, just above the old pack-horse bridge. After a disastrous fire, the distillery was rebuilt in 1879 but the one we see now was built, after yet another fire, in 1898. The distillery of Benrinnes also dates from 1826 but the original buildings were washed away in the Great Flood of 1829. It took six years to rebuild the operation.

The Glenfarclas Distillery at Ballindalloch was opened in 1836 by Robert Hay and, in 1865, it was sold to John Grant. This distillery has the largest stills on Speyside but, despite this, it really is quite inconspicuous on the northern slopes of Ben Rinnes, apart, of course, from its tall chimney stack. John Grant, who may have been the same person who later purchased Glenfarclas, opened his Glen Grant distillery at Rothes in 1840 in partnership with James Grant. The Glenlivet at Ballindalloch was opened by George Smith in the same

year and rapidly became a well-known name amongst those with the nose for a good whisky.

The amount of spirits being drunk by the middle of the nineteenth century was enormous. A report published in 1842 by a committee of the Church of Scotland found that, at that time, the two-and-a-half-million-strong population of Scotland consumed, on average, about two gallons of whisky a year for every man, woman and child in the country. The drink was consumed on every possible occasion – weddings, funerals and any other event at which there was a good reason to have a wee, or maybe even a not so wee, dram. In Badenoch, the shinty matches seemed to provide good reason – some may say a good excuse – for a few drinks.

Dailluaine distillery at Aberlour was built in 1851 and 1852 and, with the crow-stepped gables of its bonded stores, was founded by William McKenzie. It is suggested that this was the first distillery in Scotland to have the now ubiquitous pagoda roof. The distillery is surrounded by what McKean describes as 'a large industrial township' in what Alfred Barnard considered to be 'one of the most beautiful little glens in Scotland. Never was there such a soft bright landscape of luxuriant green, of clustering foliage, and verdant banks of wild flowers, ferns and grasses'. (Barnard, *Whisky Distilleries of the United Kingdom*)

After this, there seems to have been something of a decline in the building of new distilleries. Cragganmore was built in 1869 and Glenglassaugh, which opened in 1875, had rather a chequered career, being in production somewhat intermittently before finally closing in 1986. Glen Rothes came into being in 1878, an enterprise founded by a group of local businessmen, but it was not until the later years of the nineteenth century that the pace of expansion of the industry once more began to increase. Another Rothes distillery, the Glen Spey, was opened by James Stuart in 1885. The Glenfiddich was opened in 1886 and Balvenie, just beside the Glenfiddich, was opened just six years later.

Craigellachie Distillery came into being in 1891 and the distillery at Convalmore was opened in 1894 but is now reduced to the status of a warehouse. The Dufftown Distillery opened in 1895. This was at the same time as Drumguish near Kingussie, which is mentioned in the chapter on that area. It only survived until 1911 but a new distillery was opened on a nearby site in 1962.

Dalwhinnie opened in 1897, originally trading under the name Strathspey, but later making use of the name of the nearby village. Tamdhu opened in the same year and, although it was out of use between 1927 and 1947, it later resumed full production. The Imperial Distillery at Carron was opened by Thomas Mackenzie in 1897 but, after just two years, it was closed, not to be brought back into production until 1919. It was mothballed in 1998. The Speyburn Distillery, attractively designed by the Elgin architect Charles Doig, was also opened at this time by John Hopkins and is noted for the fact that, within the distillery complex, the use of horses and carts continued until about 1950. Caperdonich in Rothes was opened in 1897 or 1898 but this was probably just an extension of the former Rothes Number 2 Distillery although it later became an independent enterprise. The Knockando Distillery opened in the same year and was the first one on Speyside to have electric lights. It was at this point that the expansion of the whisky industry came to a halt. There was now enough distilling capacity to meet the needs of the country and no new distilleries were built for over half a century. Many of the older buildings are now lost to us, however, being replaced by new structures on the same site.

It was not until the second half of the twentieth century that more distilleries were built. Tormore, near Grantown on Spey, came online in 1958 and is often referred to as one of the most architecturally striking distilleries in Speyside. Tomintoul was opened in 1964 and Glenallachie, at Aberlour, was opened in 1967. This building, described by Charles McKean as a 'crisp white-and-black distillery in its idyllic setting by the Aberlour Burn, is the most distinguished of the modern distilleries on Speyside'. Braeval at Chapeltown in the Braes of Glenlivet was opened in 1973 and became Scotland's highest distillery, much to the disgust of Dalwhinnie which had, for many years, been able to use this fact as a part of its advertising. Braeval, however, seems to have had a relatively brief existence, being mothballed in 2002. Nearby Allt a'Bhainne in Glenrinnes was opened in 1975, as was Pittyvaich near Dufftown. This one was demolished in 2003 and so can be truly described as a 'lost' distillery. The most recent distillery to be put into use is that at Kininvie, another of the Aberlour distilleries.

THE LOST DISTILLERIES

We will, of course, never be able to find the old cottage stills but there are traces of the whisky industry all around us. The old railway lines and the distillery sidings can still be traced and, in some cases, can still be walked. Mill lades and ponds can be found in quite unexpected places and even some farm buildings still bear evidence of this lost part of our heritage. Some of the other lost distilleries, though, sometimes only receive a passing mention in the more obscure records of the area. For example, in 1845, where was the Ruichlerich Distillery, when the contract was let out for the masonry work? What was the distillery at Minimor or Minmore in the early nineteenth century? Aucherachan and Upper Drumin, the latter a predecessor of the Glenlivet, with their production rated at a few hundred gallons a week, are all long gone and we will never know what distinctive flavours are now lost to us.

CHAPTER 10
PARISH LIFE IN BADENOCH AND STRATHSPEY

It is all very well for us to think about how the wealthy lived in their castles or mansion houses or how the rich visitors from the south came up to the area for the hunting, shooting and fishing – these are the well-documented aspects of life here. But what of the life of those people who farmed the land, built the drystane dykes, made a livelihood by fishing for salmon in the Spey or floated the great rafts of logs down the river. Or of the women who tended to the children and the beasts and who kept their households running smoothly on whatever pittance of an income there was.

Their fates were decided by two major factors – the estate and the Church. The estates in this part of the country were usually quite large and, to some of the tenants, may have seemed quite impersonal as the main contact with the laird was through his estate factor or his secretary. It is probably fair to say, though, that, in Badenoch and Strathspey, the laird and the tenants knew each other better than in many other parts of the country.

The Church was the dominant feature of life for most people and the parish was the world in which they existed. Nowadays, many people do not have any idea of what parish they live in and many of the younger generation look blankly when the word 'parish' is even mentioned. To our forbears, it was everything. It was responsible for the education of their children – if they chose or could afford to give them an education. It was their pension fund when they got old and infirm and the minister looked after their spiritual well-being with his 'uplifting' sermons every Sunday. Going to church was not optional. Even if you had to walk the length of the parish, you went to church – the kirk elders saw to that. The elders of the Kirk session were also responsible for the day-to-day discipline of the parish, from recording the legitimate births and punishing the fornicators to noting marriages

and punishing the irregular ones. From organising distributions of aid to the Enrolled Poor to providing a beddall to dig the graves and a mortcloth to cover the coffin or the shroud on its way to a final resting place, it was all the responsibility of the Church.

This web of parish life bound the community together and, to most people, despite having to go to church for the often interminable sermons, it was their life, their way of living. Even when they did get a fine for hanging out the washing to dry on a Sunday or going fishing on the Lord's Day – both of these offences were most definite breaches of Sabbath – they paid their fine and then put the odd penny, when they could spare it, into the box on the mantelpiece ready to go towards the next fine.

In an area such as Badenoch and Strathspey, there were many similarities between the parishes but, owing to the geographic and cultural differences which were to be found along the course of the River Spey, there were also some noticeable variations, not least in the language spoken by the common people. For the purpose of this book, two parishes have been considered – the parish of Inveravon, or Invera'an as it is more commonly known, on the green banks of Strathspey, and the Highland parish of Laggan at the southern extremity of Badenoch.

The readily accessible records for both of these parishes start in the seventeenth century and the ministers of both were very enthusiastic in the returns which they made to the *Old* and *New Statistical Accounts*, documents which give us a really good picture of life in the late eighteenth and the mid nineteenth centuries.

THE PARISH
OF INVERAVON

In common with many of the parishes in this area, the religious persuasion of the people was split between Catholicism and Presbyterianism. This was, of course, the parish which contained the Catholic Seminary of Scalan, as mentioned elsewhere in this book.

The Kirk session minutes of the Established Church make few mentions of the Catholics but it would probably be safe to assume that, apart from the religious divide, there was little difference in the way of life of the people. The minister suggests that, in 1779, there were

some 2,244 people in his parish, of which about 850, or over one third of the population, were Catholics. This seemed to concern him more on financial than ecclesiastical grounds, though, as the Catholics did not register the baptisms of their children in the Parish Register. This denied the schoolmaster, who was also the session clerk, a considerable part of his income, which meant that sometimes the session clerk's lost earnings had to be made up from church funds. In fairness, though, the minister also goes on to complain about the number of his own flock who, although they had their children baptised, neglected to have their children's names entered into the register because they could not afford it. The tax which was imposed on such entries in the later years of the eighteenth century did little to encourage people to record these events and this can often prove to be quite a stumbling block to the family historian.

Marriages were generally recorded in the registers by couples of both faiths, as neglecting to do this would have left them open to all sorts of censures by both churches. There were a few clandestine marriages conducted by Popish priests, which never found their way into the records but the couples usually got caught out in the end, often when they wanted to leave the parish and asked for a testimonial. The testimonial, this small piece of paper, was irreplaceable and was worth its weight in gold – they would never be accepted into a new parish without it. Such was the power of the parish system.

Death was little more than a by-product of life. Before the introduction of Statutory Registration in 1855 there was no requirement to report or record a death and, as the minister of Inveravon says, with three burial grounds in the parish, it was difficult to keep track of things. Probably even more difficult than he thought as the three Catholic burial grounds in the parish, two of which were later swept away in floods, never get a mention.

Apart from the heritor of the parish, Sir James Grant of Grant, who provided much of the back-up funding for the kirk, the next most important man was probably the minister. Like almost all of the eighteenth-century ministers, Mr James Grant (a common name in this part of the world), writing in 1793, liked a good moan. He was basically pleased enough with his fairly new and recently harled manse but the stables and barns still let in the rainwater. His glebe was only about four acres and there was only enough grass for two cows but his complaints bore fruit and later he was given a bit extra on which to

graze his horse. His stipend was, in total, 860 merks and he also had 48 bolls of meal.

Next in the eighteenth-century pecking order was the schoolmaster, who also served as session clerk and precentor. In Inveravon, he had a schoolhouse built in the churchyard and a pittance of a salary of 12 bolls of meal plus the small fees he received from his students. In the winter, he may have had 30 or 40 students but when the children were needed to work on the land in the summer the school roll fell to somewhere between 12 and 20. There was also a school up in Glenlivet which was run by the Society for the Propagation of Christian Knowledge, whose master was paid between £15 and £22 sterling a year for teaching his 90-odd scholars, most of whom, of course, vanished in the summer months. How sad it is that schoolmasters and, for that matter, schoolmistresses have lost the status in society that they once held and, as a consequence of that, they have also lost the respect of the very children they struggle so hard to educate.

The larger tenant farmers of the parish were a very self-reliant group of gentlemen, several of whom were the kirk elders responsible for the discipline of the lesser mortals of the parish. Some of the larger farms grew barley, a necessity for the many whisky stills in the area, and oats, barley and pease were also productive crops not just on the larger farms but on the smaller ones as well. The farms near the hills all kept sheep, with about 3,500 of the animals in the parish by about 1800. According to the *New Statistical Account*, most of the larger farmers were, by the 1830s, 'in easy circumstances for their station in life'. The river provided a good source of salmon and trout and the two houses where the ferry boats on the Spey and the Avon were kept provided an adequate dram of whisky to the travellers who may have lodged at them while waiting to cross the river but, apparently, they seldom had ale.

It was, however, the subtenants, the cottars who made up the greater part of the people of Inveravon who give us the best picture of life there. They held their houses and kail yards in tack from the larger farmers and, although 'they are sometimes thickly set down there is no village within the parish' (*New Statistical Account*), just clusters of fermtouns. To all intents and purposes, they made their own life based around the daily ritual of waking, working, eating and sleeping, the only respite being the Sabbath. In the late eighteenth century, their cottages were at best but and bens – turf-built cottages with heather-

thatched roofs, with holes to let out the smoke. A gently sloping floor allowed the heat from the beasts to rise through the house, whilst the more obnoxious by-products of the cattle drained away down the slope. A wattle screen was usually enough, at least in the early days, to separate man from beast.

The cottage garden, not the chocolate-box cottage garden we may think of but a very functional kitchen garden growing kale, herbs, onions and the newly arrived potatoes, would have provided sustenance for the family but meat was a rarity. Fish could be caught in the rivers and the burns if there was time and fishing on the Sabbath was quite a common offence. The ubiquitous chickens, maybe even a goose, would have added to the scene and the general cacophony. The older children would take the beasts to the hills to graze in the summer but there was no way the animals could be overwintered and, if they were fit enough, they were sent off with the drovers to the markets in the south. If not, the family had a source of salt meat for the winter months. The relatively short growing season meant that they had to be careful what they grew as the winter frosts came early and the snow lay long in the high crofts.

The tenants ploughed their lands with fairly simple ploughs usually drawn by oxen or by two cattle led by two horses and this idea continued even after the enclosures of the late eighteenth and early nineteenth centuries. There were no large plough horses here but the cattle and the oxen served their purpose well. Almost every farm, except the smallest croft, had its own lime kiln and a lot of time was spent digging peat to fuel the kilns, until eventually the peat supplies ran low and it was more convenient to buy the lime for the fields from the large lime works in nearby Mortlach or Dufftown as it later became known.

Before the passing of an act of parliament in 1823 to encourage legal distilleries, the inhabitants of Glenlivet and many other people in the area were actively engaged in either manufacturing whisky or smuggling the finished product to market. It was a sad croft or farm which did not have its own whisky still or a couple of family members who were not carrying barrels over the lost byways in the hills to the markets of Elgin and Keith or to the fishermen smugglers of Buckie to be taken even further afield. The minister in 1836, one William Asher, seemed to approve of the new act of parliament, writing that 'the energetic measures taken by government for the suppression of smuggling have proved eminently successful here, the male population,

instead of prowling over the country in search of a market for their whisky, and being constantly on the watch to elude the eye of officers of excise, are now happily employed in the cultivation of farms, or in prosecuting handicrafts'. The women who were apparently 'in the habit of spending no small portion of their time, by night as well as day, in the bothie, a prey to the licentious and immoral, are now more safely and suitably employed in domestic occupations, or in performing such portions of field labour as fall to the lot of their sex'.

What a change of culture the licensing acts must have brought about in just a few short years, and giving such pleasure to the minister in the process, but no doubt he also enjoyed his wee dram in the evenings. It also led to a lost way of life for many of the people, as one of the few freedoms they had was now taken from them.

The old whisky stills and smuggling houses which were to be found along almost every stream in the parish were replaced by the two legal distilleries in Glenlivet. The very name Glenlivet is in the heart of every whisky connoisseur. The old distilleries at Aucherachan, which made about 300 gallons a week, and the smaller one at Upper Drumin

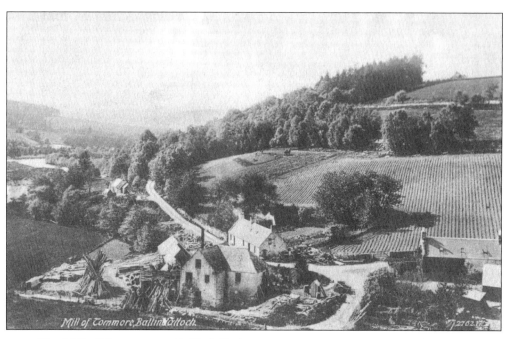

The Mill of Tomore, near Ballindalloch

Ballindalloch Post Office and shop, a typical winter scene

have now vanished under the more commercial modern businesses but the name remains, and the flavour.

The patterns of agriculture in Inveravon were also changing. The enclosures which had proved so successful in the lowland parts of Moray and Banffshire were creeping up the hills, the old runrig system of strip farming was becoming lost and fields with dykes or hedges were changing the landscape for ever. Even in the highest parts of the parish land was being brought into cultivation. Even so, only one son could inherit the lands and maybe one lucky one would be granted the land on the periphery of the farm, the so-called 'Newlands'. Inveravon was fortunate in a way as the loss of agricultural employment during the 'improvements' did not lead to such a great wave of emigration as was experienced in so many nearby parishes – maybe the minister had persuaded them all to 'prosecute handicrafts'. Nevertheless, many young men and young families did leave Inveravon in search of a different, if not better, life elsewhere, sometimes in the Industrial Revolution factories of Central Scotland, sometimes overseas.

The middle of the nineteenth century saw the use of two-horse ploughs and improved agricultural implements and the area around

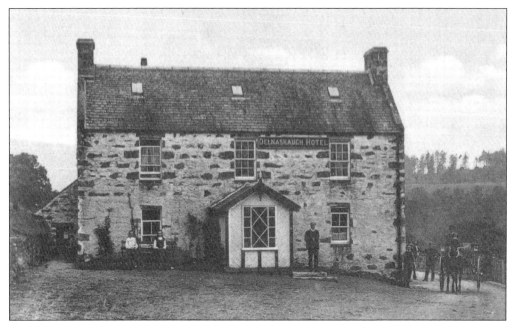

Delnashauh Inn, Ballindalloch

Glenlivet was rapidly becoming home to some of the largest farms in the parish. Sheep farming, unusually, was not found to be very profitable especially in the upland areas and most farmers concentrated on the small black cattle which could easily be driven to market. The parish had four fairs and, in fact, there is still a farm named Peter Fair, not too far from the kirk, where the fairs were held each year. These fairs were for the sale of horses, cattle, grain and other foodstuffs and also no doubt for the products of the local artisans. Two of them were also feeing fairs, where workers could be hired by the farmers for the coming half year or, indeed, just for the period of the harvest. The labourer of the day couldn't even get on is bike to find work – he just had to walk. And, if he didn't find employment at Inveravon, he would have walked on to Aberlour or Rothes or Dufftown, until he found some farmer willing to give him six months' hard but paid labour and a roof over his head.

The new toll road through the lower end of the parish, although thought by many to be too steep, proved a useful addition to the life of the people, bringing Aberlour and even Grantown on Spey within easy reach, but the coach service which ran from Dufftown to Grantown

was a short-lived enterprise. The ferries at Blacksboat, as already mentioned, and another ferry at Balnellan, proved invaluable for filling the gap between the bridges at Craigellachie and Grantown on Spey.

By the middle of the nineteenth century, the demand for education was booming. In addition to the parish school, there were also four Protestant and three Catholic schools in Glenlivet. The parish schoolmaster, with his salary and his fees as session clerk, was now on a salary of over £28 a year.

Even the language was changing and had been for a long time. The old Gaelic tongue had been in decline for many years and the intruder, the English language, was now being taught in the schools. The all-important Bible was in English and this was the language of the tenant farmers, the minister and the laird. The last link with Highland Scotland and the old cultures of the clans was being eroded, new connections were being cultivated downriver, the Spey Valley led trade and commerce to Elgin and the coastal ports and English was their language.

Were these links and developments just a geographical thing or were there wider cultural and economic forces at work? Let us now follow the Spey upriver to another place, if not another time.

THE PARISH OF LAGGAN

Deep in the Highlands, many miles upstream near to the source of the River Spey, lay the parish of Laggan. Different people, a different culture, another way of life – but was it really so different to the life enjoyed, if we may use that word rather loosely, by the people of Inveravon?

Laggan is quite a large parish but the main area of habitation occupies a strip of, at the most, about three miles wide along the valley of the Spey. According to one early minister, this was bounded, especially to the north, by 'a prodigious ridge of inaccessible rocks', the Monadhliath Mountains. What would he had said if three centuries later he could have seen what a Mecca the mountains of the Highlands had become for the more adventurous members of society? Hopefully the peace and quiet of the hills is not just another 'lost' aspect of Badenoch and Strathspey.

Just like the farmers of Inveravon, those in Badenoch grew black and

white oats, and also barley, although in this area that crop required large amounts of compost manure. The farmers kept the small black cattle so typical of the Highlands and sent them away with the drovers to the markets in the south to avoid the expense of over wintering them. Unlike their downstream neighbours, though, they found sheep farming very productive and, in the late eighteenth century, the four or five sheep farms in the parish supported about 12,000 beasts. This was ultimately to prove part of the downfall of the parish. The best wedders would fetch up to 16 shillings a head, whilst the smaller kind preferred by the 'general run of tenancy' (*Old Statistical Account*) were often valued at only half that figure but, by the end of the century, that price was declining, as was the value of the wool.

The parish was not able to grow enough vegetables to support its own population but, at last, some attempt was being made to enclose some of the fields in the valley. What agriculture there was could be carried out using two-horse ploughs – there is never any mention in the old records of cattle or oxen being used.

The minister, Mr James Grant (yes, another one of the same name), described his parishioners in three classes. There were the gentlemen farmers, mainly consisting of half-pay officers, there were the graziers, 'chiefly those who are professedly shepherds' and then there were 'the lower class of people, which are the more numerous class'. He was able to break the distinctions down even further – the gentlemen farmers paid annual rents for their farms of between £30 and £100, the graziers between £60 and £90 a year, whilst the lower class of people had land which was valued at just £3 to £6 a year. So much for social equality. Maybe this is one of the aspects of life which, if not lost, is at least not made quite so obvious nowadays. One thing that does become obvious, though, is that the economy of the parish of Laggan was founded on the little white woolly beasts. Sheep farmers were coming from as far away as Ayrshire to take up tenancies but mostly on Colonel Macpherson of Cluny's lands, as the other, more dominant proprietor of the parish, the Duke of Gordon, had 'not yet shewn any great disposition to let his lands to shepherds, that nobleman is attached to his people, and fond of nourishing and rearing them'.

The schoolhouse, one room for the students and two for the schoolmaster, lay near the centre of the parish and the master received an annual salary of 2,500 merks for teaching his school of 50 to 80 students, sometimes more. There is no evidence of the seasonal

variation in numbers found in Inveravon – no doubt a reflection of the agriculture of the parish. Almost everyone in the parish seemed to have a servant of some kind, whether it was an unmarried family member or an outsider. If the servant was an outsider, he was almost always a married man with a family. Quoting again from the writings of the minister in 1793, the servant 'receives from his master a hut to live in, grass for a cow, ground to sow a boll or two of corn, and a small plot for planting 3 or 4 pecks of potatoes, with a pay of two pecks of meal a week to feed his family. Sometimes, if he is better than the ordinary run of servants, he will in addition receive £1 Sterling in the year.'

The parish had its own mason, weavers, house carpenters, tailors and a blacksmith, but no shoemaker as the common people made their own shoes. There were, though, three or four brogue makers in the parish.

By the middle of the nineteenth century, things were changing. Lands had been sold off in the early years of the century by the Duke of Gordon and there were now four main landowners, the principal one of which was now James Evan Baillie of Kingussie.

Gone now is the old church of St Kenneth at the east end of Loch Laggan. Even in the nineteenth century, this was a roofless ruin and time has continued the decay. But building work was going on as well at this time – Cluny Castle was rebuilt from the ruins, as mentioned in an earlier chapter, and Glentruim House also came into being. The Shooting Lodge at Ardveirge was built by the Marquess of Abercorn on the shores of Loch Laggan, and Mr Baillie of Kingussie, not to be outdone, built another lodge at Glenchirra. So the wealthy prospered but not so the poorer classes.

Unlike Inveravon, the sheep were now taking over. Several of the smaller farms and crofts, with their short leases and unproductive lands, had been turned into sheep walks and, in the first three decades of the nineteenth century, the population of Laggan fell by over 300, a fifth of the population being forced off their lands. At one time, the rent of the land was decided by the number of sheep it could support. Writing in 1839 the minister, Mr Donald Cameron, commented, 'In some parts of the parish, where about eighty years ago there was a dense population, there are to be found now only a few scattered shepherds' huts.' And a lot of the evidence of these is now also becoming a part of the lost heritage of Badenoch. The families emigrated to America and Australia. The glens were silent now, no longer echoing to the lilt

Marypark ploughmen, c. 1930

of the Gaelic tongue which was the language of this land. Even the language was becoming lost now, though, as the English taught by the parish schoolmaster to the new generations who lived here gradually supplanted the old ancestral tones.

Even in the nineteenth century, the parish could not support itself – it had no industry, wages were low and the price of wool governed almost every aspect of life. If the wool did not sell well, everything suffered. By now, there were over 40,000 black-faced sheep grazing the slopes of the hills above Laggan and Kingussie.

The parish of Laggan had one thing that Inveravon never had – shinty! The matches are also known as camac. A game of the land of Badenoch and the Highlanders, a hard game to match the hard character of the men, it never reached the more genteel parts of lower Strathspey.

A good description of shinty is found in a document from this period. 'A gentleman announces that he is to give a shinty play, on a certain day, in a certain place. The meaning of this announcement is that a certain

quantity of whisky is to be distributed, at the place, to the players and spectators. The quantity of whisky provided on these occasions varies, according to the wealth, the liberality, or the vanity of the donors, from four to ten, or perhaps fourteen imperial gallons. Hundreds of people, old and young, gather together on these occasions, and the scene is closed, in many instances, by drunkenness, fighting and bloodshed. This practice is most injurious to the morals of the people, and ought certainly to be discontinued by the gentry.' Such a biased description could only have been written by one person – the minister – but maybe he is writing from his own experience of going to a shinty match; at least he would have got a good dram. Shinty is, needless to say, now a well-regulated and accepted sport but still, to the outsider, quite an aggressive one – the character of the men of Badenoch has not been lost. And the local pubs still do a roaring trade in drams after each game!

CHAPTER 11
ABERLOUR

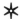

THE KIRKTOUN
OF SKIRDUSTAN

Skirdustan – it sounds like some exotic country somewhere near Afghanistan or Uzbekistan but, no, it is just a wee rural parish on the grassy banks of the River Spey.

The parish of Aberlour originally went under the name Skirdustan, after its patron St Drostan. Some sources suggest that the word *skir* is Gaelic for 'a division' or 'a parish' but it is more likely that it is from the Gaelic *sgear*, 'a cliff' or 'a rock'. This may indicate to us that the

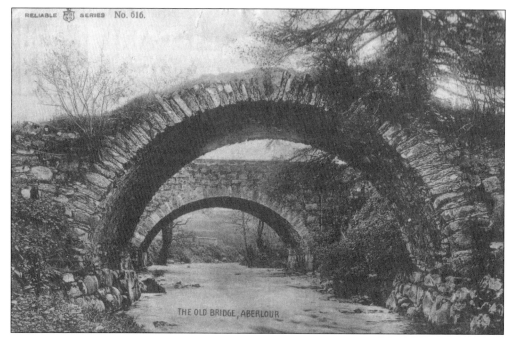

The bridges at Aberlour, the old pack-horse bridge with the new road bridge beyond

Christian missionary St Drostan originally set up his place of worship in a long-lost cave in one of the many rock faces overlooking the valley of the Spey.

A church was built near to the site and the Kirktoun of Skirdustan came into being, a scattering of black, turf-built houses surrounding the heather-thatched kirk. There are charters and other records which show that the church was in existence in 1226 but there is now no evidence of this first church.

The track along the Spey crossed the Lour Burn, now called the Burn of Aberlour, by a ford near to the kirk and met up with the track from Glen Rinnes which came into the valley over the shoulder of Meikle Conval. In these early times, a track is all it would have been, probably a grass-covered trackway closely following the riverbank. Another trackway may have come down the hill from the lands of the Dowans, probably from Kinermony, where there are suggestions that there was a religious house, now long vanished, occupied by the Knights Templar. There was also possibly a Roman Catholic monastery on the site of the present-day distillery and some sources have suggested that the alder trees along the nearby banks of the burn were planted and used by the monks for making shoes and clogs.

THE OLD VILLAGE

By the sixteenth century, life was changing, albeit very gradually. The track along the bank of the Spey was becoming much busier and travellers needed a place to stop for the night. The village was expanding northeastwards from the old churchyard and, in fact, a new church had been built by this time – not, like the old one, a structure made of boulders from the riverbank held together with mud but a church of worked stones, with a bell-tower in the gable end although still the heather-thacked roof remained.

The Reformation had wiped away the Popery and idolatry of the Roman Catholic Church and Presbyterianism had taken hold across Scotland. Ordained in 1569, William Peterkin was the first Presbyterian minister of Aberlour but what sort of a welcome he would have received in these largely still pro-Catholic Gordon lands we will never know.

The Gordons of Aberlour lived for many generations at the old house of Aberlour, which lay just to the northeast of the present Aberlour

Aberlour Village, the main road into Aberlour

House. Being staunch Roman Catholics, despite the many edicts against Popery, they were actively engaged in the Jacobite Rebellion of 1715 and also gave their tacit support to the events of 30 years later.

The village lay between the kirk and the ferry across the Spey. The black turf-built cottages had changed little over the past few centuries, but some stonework was now being introduced into the buildings, often in the form of a chimney to replace the old hole in the roof, or as frames for the door. The cottages had their garden ground to grow vegetables and to support their chickens and a pig and maybe a cow to give milk for the family. The cottages would have had strips of land in the runrig to grow their crops and other beasts would have been taken to the outfield by the children of the village. The middens outside each cottage would have added to the general malodour of the place and the muddy track which served as a street would have done little to enhance the overall appearance of the village. Maybe some things are better to be 'lost'.

There would also, of course, have been the tradesmen and the artisans. The seventeenth- and eighteenth-century records of Aberlour mention smiths, squarewrights, masons and shoemakers and the parish even had its own midwife, who the Kirk session had sent to the Infirmary in Aberdeen to be trained, partly at their expense. There was, of course, also a village school and, in 1720, Patrick Gordon is recorded as being the schoolmaster there. The old pack-horse bridge still remains, repaired by a local mason John Duff in 1729, just below the modern road bridge.

Aberlour, strangely, had its 'Fishertown'. This title was usually reserved for the coastal villages which lay way to the north along the coast of the Moray Firth, as the settlements occupied by the sea fishers of the villages. But Aberlour too had its fishing industry, the plentiful salmon providing a livelihood for the indwellers of Fishertown. Like today, though, the fishing was owned by the laird – the fishermen were merely tenants who probably paid their rents to the laird in terms of the number of fish they supplied and by other services. The southeast fishings were the property of the Gordons but, on the opposite bank, the Laird of Elchies ruled supreme. We will never know precisely what this 'Fishertown' was like as, although the documentary sources mention it, it is now only remembered in the farm of Fisherton, standing well back from the banks of the Spey at the northern end of the village.

Life in the old village can best be described by some entries from the Kirk session records of the time, which reveal a way of life now lost in three centuries of Aberlour dust. In 1706, the kirk became vacant on the death of the minister, Robert Stephen. His son, also Robert, was called by the heritors on 8 October 1706 and was eventually ordained as Minister of Aberlour on 18 September 1707. Robert Grant was named as the beddall and one of the kirk elders, and Robert Wright was appointed as collector for the poor, a vital position in those times when the Church was the only source of money for the fourteen elderly or infirm people in the parish. William Anderson, sometime schoolmaster in Bellie, was appointed as schoolmaster of Aberlour on 7 January 1708. He was also appointed as session clerk and later entries show that his salary was £4/13/4d for each half year. The beddall, Robert Grant, received a half-yearly allowance of 10/0d to buy shoes, reflecting obviously the amount of walking around the parish he was obliged to undertake in addition to his grave-digging duties.

On 1 August 1708, the minister complained to the Justices of the

Peace about all of the breaches of Sabbath and profanations of the Lord's Day which the Kirk session at this time seemed unable to control. The complaint seemed to make very little difference to the number of cases being brought forward but the punishments were becoming more severe.

Medical attention was, to put it mildly, quite primitive and the people had to resort to the attention of one James Brown from Glenlivet, who seems to have been quite successful in curing many of the local people or at least keeping the grim reaper from the door for another year or two.

The meal from the minister's farm at the Dowans was distributed to the poor of the parish every year and became part of an annual ritual at the village church, probably a very welcome one in times of hardship.

In September 1709, it is recorded that 'the Bridge of Fiddich is falling'. The loss of this bridge would have meant that many parishioners from across the river and also the ones who came from Boharm parish would not have been able to get to the kirk in Aberlour. All of the affected parishioners, both from Aberlour and Boharm, were asked to contribute to the repair bill. Some two years earlier William Hutcheon had been fined for fornication with Marjorie Cumming but had still not paid his fine. He now offered the Kirk session a dozen deals (planks) to use to repair the bridge, as a part payment of the fine but the Kirk session actually accepted the wood in full payment and he was absolved.

George Donaldson was appointed as the new kirk treasurer in 1710 and one of his first tasks was to give Robert Grant the beddall two groats to 'buy a new spade for the use of the public'. This was maybe not one of his better ideas as, about six months later, people were digging graves in the churchyard without asking the session or the beddall. Eventually the minister was obliged to announce from the pulpit that 'no person or persons should presume to open any grave in this Church or Churchyard or bury any corpse without first acquainting the Beddall under the fault of five pounds Scots toties quoties.' The beddall was obviously losing out on his grave-digging fees.

The Gaelic language – or Irish as it was then known – was still common in the old village of Aberlour in the early 1700s and many miscreants appearing before the Kirk session needed the services of an interpreter.

Drunkenness was a common problem in all of the parishes at this time and the numerous whisky stills along Strathspey provided an

inexpensive source of the water of life. 'Intimation was made from the pulpit that those who should be found to frequent the change house [inn] on the Lord's Day and drink in time of divine worship or on the Lord's Day afternoon, shall be staged before the Session as Drunkards and Sabbath Breakers and fined according to law.' (Aberlour Kirk Session Minutes, in National Archives of Scotland). There was at least one alehouse in the village and many more in the surrounding area – these were basically just a room in the cottage of some person who had ready access to a supply of whisky or beer.

The churchyard in the old village of Aberlour was, as in many other parishes, the site of the local market. Despite many earlier acts forbidding this, the table-stones commemorating those long gone made ideal places for the merchants to lay out their wares. Eventually another act was read from the pulpit 'against the buying and selling of feeing servants on the Lord's Day, other bargainings, drinking, idle, unprofitable and sinful discourses, resorting together, etc.' (Aberlour Kirk Session Minutes).

Repairs to the kirk were under way in 1724. James McKondachie, mason, did work on the new loft in the kirk and made new feet for the pillars at a cost of £9 and Alexander Douglas made the pews for the new loft.

The appearance of the old church must have been changed considerably in 1736. The heritors having earlier agreed to the purchase of a new kirk bell, the session agreed to their requests for the building of a steeple on the kirk and the next year a thane (a weather vane) was fitted to the top of the new steeple.

The weather during the 1730s and the 1740s had shown a noticeable decline and there are frequent references in the session minutes to the fact that 'the day was exceedingly stormy', often so bad as to lead to the cancellation of church services.

At one meeting of the heritors, it was noted that 'the number of the poor in this parish depends much on the Seasons. In the years of plenty the poor are not many, but as the country in generall is not rich a bad year or two add greatly to the number of our Poor. Thus was remarkably the case in the years 1740 and 1741, then out of about 1000 souls upwards of 100 received meal or money out of our public funds.'

In 1755, '[i]t being observed in Session that several stones are come out of the foundations of the bridge at Kirktoun, that whole of the bulwark is failing, that the pinnings of the revelings are shaking and

the tabling loose, and that the complete bridge may be in danger if not quickly repaired which will be a very great public loss'. It was agreed with John McKondachie, mason, that he should do the work at a cost of £4/7/od Scots. And so the old pack-horse bridge was saved for future generations.

The weather continued to be bad right through into the 1750s and the harvests were poor and food was frequently in short supply but Aberlour actually came off better than many of the nearby upland villages.

The fashion for the setting up of new 'planned villages' was not lost on Aberlour. One of the Grant lairds commented in about 1760, 'It is in the interest of every gentleman possessed of ane estate in the Highlands to collect a number of Mechanicks and other industrious people into some centricall spot.' Aberlour was one such 'centricall spot' but, as the century wore on, the other nearby planned settlements of Grantown on Spey, Rothes, Archiestown, Dufftown and Tomintoul also competed to attract these tradesmen and merchants. As a consequence of this, it was to be another half a century before Aberlour was to join the ranks of the 'planned villages'.

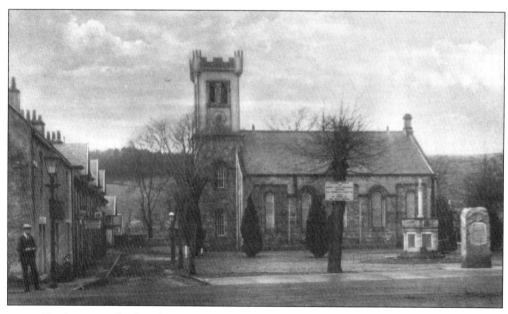

Aberlour Parish Church

The Great Flood of September 1768, in which the Spey rose some 18 feet above its usual level, caused considerable damage to the fields bordering the river and left salmon high and dry 100 yards from the riverbank but it seems that the village itself escaped quite lightly.

By the last decade of the eighteenth century Aberlour, as a parish, was home to about 920 people, of which probably only about two or three hundred actually lived in the old village itself. According to the minister, the people seemed quite satisfied with their way of life and were generally very industrious, with wages having nearly doubled over the past 20 years. The church, by this time, was in a poor state and repairs were made in 1786.

But changes were coming as the landowners had already been implementing the 'agricultural improvements' in the surrounding area. The old runrig way of farming was rapidly becoming a thing of the past and the enterprising landlords and farmers were now enclosing their fields with hedges and dykes so fewer people were needed to work the new fields along the banks of the Spey and on the slopes of the hills above the village. The old farm cottages were being knocked down to make way for the improvements, farm workers were living in the new cottages or even in the village itself. The dispossessed were leaving Aberlour for pastures new.

CHARLESTOWN
OF ABERLOUR

By the early nineteenth century, the lands around the village were in the ownership of the Grants of Elchies and eventually, in 1812, Charles Grant of Wester Elchies laid out the new planned village of Aberlour, named 'Charlestown', either after himself, which is more likely, or, as some sources suggest, after his son. A feature of all of the new villages was the square and the focus of the new town was the road which led from the square down to the old church and churchyard. The new village was erected into a Burgh of Barony, with all the privileges which that status endowed on the inhabitants. The walk along the new road through the village was not a great distance in modern terms but it was enough to form a focus on which the village could begin to expand. Another road led away from the square to the ferry on the Spey.

It was a typical wide village street, not cobbled, just packed earth and

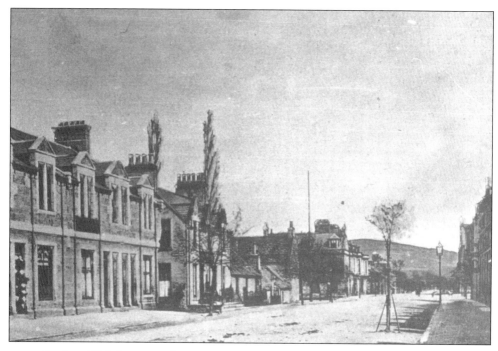

Aberlour High Street, early twentieth century

Aberlour, the east end of the High Street

Aberlour High Street, early twentieth century

grass where the traffic was not too heavy, with the odd tree to break up the scene. Feus were granted along the street and, in addition to each house having its own garden, all of the feu holders were granted four acres of land near to the village to grow their own produce. Houses and workshops were now being built of stone. Some of the better ones were of quarried stone, neatly worked, but the poorer type being of stones brought up from the riverbanks, smooth stones bonded with a mixture of mud and dung. Some of the houses had a slated roof but the majority were still thatched. The village pump was in the square but the river provided a useful wash house for the women of the village. The land between the kirk and the river was known locally as 'The Isle', as a result of the channels which the Spey had cut through this area.

The dates for the fishing season had by now been formalised – the fishing starting on 1 February and closing on 14 September. A small bird called a water-cock was numerous in the Spey and, being a diving bird, it did great damage by eating the spawn. It is said that, in earlier times, anyone who managed to kill one of these birds would be allowed to fish in the close season but this reward soon died out as the need for conservation became more apparent, even in the nineteenth century.

The early years of the nineteenth century were a time of great change – men returning from the Napoleonic Wars seeking employment, improvements in the roads and emigration not only overseas but to the new factories in the Central Belt of Scotland and even further afield. The old kirk in the churchyard had been falling into disrepair and was eventually closed, apparently, according to local legend, when one lady fell through the floor of the gallery. The new church, seating a congregation of 700, was built at the end of the square nearest to the river and was opened in 1812 but the stone tower was added over 20 years later.

In 1813, subscriptions were taken from the more prosperous gentlemen, and one lady, in the parish of Aberlour, for the building of the new Mortlach and Aberlour Turnpike Road. These included:

James Gordon of Aberlour	£250
Charles Grant of Elchies	£200
Archibald Young in Kininvie	£62/10/od
Captain Leslie of Kininvie	£125
James Shearer of Buchomb	£65
Mrs Grant of Elchies	£20
George Grant in Drumfurrich	£15
James Falconer in Kinermony	£10/10/od
William Green in Rinnachat	£10/10/od
Peter Stewart in Easter Kirktown	£5/5/od
James Donaldson in Sauchenbush	£5/5/od
James McDonald in Rutherie	£5/5/od
Daniel Grant in Balinteen	£5/5/od
George Daun in Lyntian	£5/5/od
James McQuiban in Sheandow	£5/5/od
John Donaldson in Mains of Allachie	£5/5/od
James Shanks in Bog of Kininvie	£5/5/od
William Gordon in Upper Mains of Kininvie	£5

Although the road was not fully completed, William Anderson won the contract to build the toll house and toll gate at Fishertown of Aberlour at a cost of £55. In its first few months to May 1813, the tolls collected there by George Symon, the toll keeper, amounted to £11/10/4d. In that same month, the Toll Bar was let to Archibald Watt at £21 for the year.

The building of the toll road seems to have been a slow process.

Duncan Davidson did not complete the road building on time and was relieved of the contract and, following this, Malcolm McBain took over the contract to complete the road as far as the bridge at Kininvie and John Guthry and William McGrigor agreed to complete the road as far as the Brae of Broomhead of Tulloch.

All of this was, of course, done in conjunction with the building of Telford's new bridge at Craigellachie, which was finished in 1815. With the final opening of the completed toll road between Craigellachie and the Hill of Carron in 1817, Aberlour was really put on the map, on the main route to another new planned village, Grantown on Spey. There were two inns along the road, one on the road out to Craigellachie and the other on the Burnside. Some 20 years later, Charlestown of Aberlour was home to about 250 souls and held four markets each year, in April, May, July and November. How sad it is that all of these old market days, not only in Aberlour but in most villages and towns, are now lost.

The Great Flood of 1829, both of the Spey and the Burn of Aberlour, 'was terrible at the village of Charlestown of Aberlour. On 3rd of August Charles Cruickshanks, the innkeeper, had a party of friends in his house. [The Cruickshank family commonly having their surname spelt as Cruikshank, without the letter 'c', were reputed to be one of the oldest families in Aberlour.] There was no inebriety, but there was a fiddle, and what Scotsman is he who does not know that the well jerked strains of a lively Strathspey have a potent spell in them that goes beyond even the witchery of the bowl?' So wrote Sir Thomas Dick Lauder in his account of the Great Moray Floods of 1829.

He goes on to report that '[w]hen the river began to rise rapidly in the evening, Cruickshanks, who had a quantity of wood lying near the mouth of the burn, asked two of his neighbours, James Spence and James McKerran, to go and assist him in dragging it out of the water. They readily complied, and Cruickshanks, getting on the loose raft of wood, they followed him and did what they could in pushing and hauling the pieces of timber ashore, till the stream increased so much that, with one voice, they declared they would stay no longer. Making a desperate effort, they plunged over head, and reached the land with the greatest difficulty.' All except poor Charles Cruickshanks. He was described as a 'bold and experienced floater' but at last even he was overcome by the rapidly increasing flood and the frail raft of timber he was standing on was carried away down the burn towards the Spey.

He managed to cling on to a tree and his friends and the villagers launched a boat into the burn in the hope of getting a rope to him. And the rescue attempts went on all evening to no avail but, as darkness fell, they abandoned their futile attempts to rescue him.

Sometime during the night, the tree to which he had clung for so long succumbed to the force of the torrent and he was swept away down the river. His body was recovered the next day some four or five miles downstream on the Haugh of Dandaleith. There are still descendants of Charles Cruickshanks, on the female line, alive in Aberlour to this day.

The manse was flooded and much of the contents of the cellar were swept away – maybe not entirely by the river but more likely by a few enterprising local men. A part of the glebe was swept away but the village of Charlestown itself seems to have escaped any major damage.

By 1836, the old church in the churchyard had been reduced to a roofless ruin, open to the elements and mouldering away as the rainwater formed puddles in the sightless eyes of the skulls whose fading carvings adorned the surrounding tombstones, now green with the moss of ages.

The use of Gaelic had all but died out in Aberlour by now. Only a few of the older people were still able to speak and understand the language and these were probably families whose ancestors had come into Aberlour from further up the Spey in Badenoch. At the parochial school in Charlestown, the students were able to learn Latin, geography, arithmetic and elementary mathematics, writing, reading, grammar and, of course, the Principles of Christian Knowledge. All was, as always, taught by one dedicated schoolmaster aided and abetted by some of his more senior pupils. There was also a female school in the village, where the girls could learn sewing, knitting and reading, for which the schoolmistress was given a free house, garden and a croft of land and was also able to earn additional money from dress-making.

The two principal inns in Aberlour were the New Inn, in Charlestown itself, and the Cottage Inn, which was just across the bridge of the Burn of Aberlour. The New Inn was, no doubt, the main coaching inn on the Speyside road, being a convenient distance from both Grantown on Spey and from Elgin. There were also two or three 'houses of entertainment' for which spirit licences were granted every year.

The building of the Aberlour Church tower is mentioned in a letter on 10 April 1839 from John McInnes, addressed to Edward Wagstaff Esq., the secretary to the Duke of Richmond and Gordon.

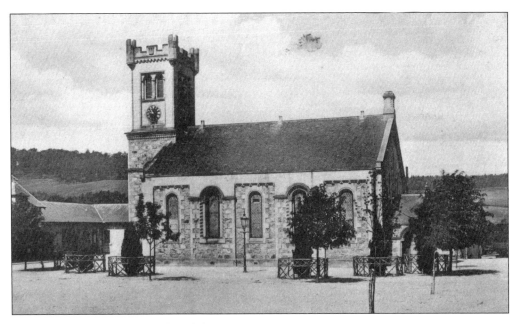

Aberlour Parish Church and the Square

The foundation stone of the Tower to be added to the church of
Charlestown by Mr Grant of Aberlour is to be laid with Masonic
honours on the 22nd inst by the Trinity Lodge of Elgin. The
arrangements, I understand, are nearly completed with the exception
of a Band of Music which it appears cannot be mustered nearer
than Inverness or Aberdeen, and I am requested (being connected
with Mr Grant's business) to write to you if you could ascertain if
you could grant permission for the Castle Grant Band to give their
attendance at Charlestown on that day. I am aware that most of the
Musicians are retainers of the Duke of Richmond and consequently
from his private Band, and that it is perhaps taking too much liberty
to make this request but if it is one that could be complied with it
would be esteemed a great favour, but if otherwise do not hesitate
to say so. Be so good as let me know as soon as possible that I may
report accordingly to those gentlemen who are taking the active
management.

Permission was granted and the band met at Charlestown at 12 o'clock
on Monday 22 April, ready to march off along the main street of
Aberlour at 1 p.m., much to the delight of the local people.

Following the Disruption of 1843, when the Free Church separated from the Established Church of Scotland, the new congregation needed a place of their own in which to worship and the Free Church, a fine Gothic building, was erected just four years later at a cost of £290/3/od.

The body of the church that was built in 1812 is no more. Early in 1861, it was almost completely destroyed by a disastrous fire and only the tower and the belfry remained. All of the kirk's documents were stored in the church tower and the minister, Dr James Sellar, instructed the beadle, George James McWilliam, 'Up you go and save what you can.' The beadle retorted, 'Up you go yersel! – for years ye hae been prayin for a wall of fire round yer Zion, and ye have gotten in this nicht'. The minister had spent so much time preaching 'hell-fire and damnation' it would, seemingly, have been more appropriate for him to go himself. The church was rebuilt to a plan by George Petrie but evidence of the fire can still be found in some of the stones of the building, in spite of a later rebuild when an apse and vestry were added in 1933.

There was a backwater of the River Spey, known locally as the 'Broomie', and this was one of the places where the local children were able to skate in the winter. Due to the flooding, the square would often become a lagoon and, after a spate on the river, the people were often able to go and pick up the salmon which had become stranded there. The building of the railway in 1862, despite the minister's objections that the railway line ran too close to the church, eventually put an end to this flooding.

The railway not only brought passengers into Aberlour. There were also as many as six freight trains each day, most of them bringing coal into the area, and taking away the products of the local distilleries and farms. The trains also carried cattle from the area to the larger markets such as Smithfield. The annual Sunday School picnic must have been a sight to behold. The children were brought to the station from all the outlying areas of the parish and from the town itself in carts fitted out with hay bales as seats. The anticipation and the excitement of the train ride to the beaches at Lossiemouth can only be imagined and, as always in the recollections of these days, the sun shone from a clear blue sky and everyone came home brown and happy. The station still survives, albeit in a different guise, but the freight yards and the cattle loading docks, which once employed half a dozen workmen, are now all lost to us beneath the appropriately named housing development, 'The Sidings'.

Aberlour, the hotels on the Square

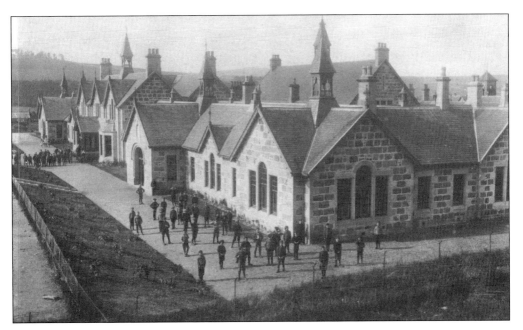

Aberlour Orphanage

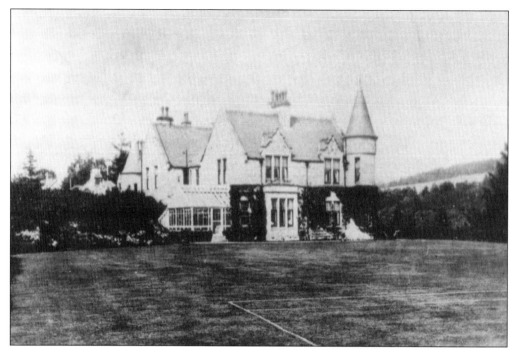

Aberlour, The Dowans

The village of Charlestown of Aberlour never seems to have had markets in the way that other settlements had, despite having been erected into a Burgh of Barony and almost certainly at that time being given the right to hold markets on specific days. It did, however, have a feeing market, where the local landowners and farmers would choose their labourers and servants for the next six months or the next year. There was little security for the common agricultural labourer in those days. And these were days which lasted up until the 1930s. The 'deil's acre', the patch of land outside the bank on the square, was the site for these feeing markets, with the pubs and the inns waiting invitingly nearby to welcome those men who had found employment and had a little bit of spare money in their pockets.

The idea of the now-famous Aberlour orphanage was instigated by the Reverend Charles Jupp in 1875 at the west side of the village. He had been invited to Aberlour by Miss McPherson Grant of Aberlour House to be her personal chaplain in 1874 but, as part of the agreement, he stipulated that a new church should be built in Craigellachie and the work was in progress when Miss McPherson Grant died the

following year. Dr James Sellar, the parish minister, died in 1886 and an anonymous poem 'Elegy on a Late Departed Lady', thought by many to have been penned by Dr Sellar following the death of Miss McPherson Grant, shows that he had little regard for the activities of Charles Jupp.

The more recent orphanage near to St Margaret's Church was opened in 1889 and it included not only the orphanage but a school, farm buildings and a clock tower. By 1967, with all the new developments in childcare, the old buildings fell out of use and the site was sold off. All that now remains is the clock tower which dates back to the opening of the new orphanage.

GRANTOWN ON SPEY

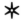

The town of Grantown on Spey is, relatively speaking, a new town. There was, however, an old village of Castletown of Freuchie, the old name for the castle. This village was about half a mile southwest of Castle Grant, near to the edge of the castle policies, and was certainly in existence before 1553. In 1694, King William and Queen Mary ordained that 'the town formerly called Casteltown of Frequhie, now and in all time to come to be called the Town and Burgh of Grant, and to be the principal Burgh of Regality, a market cross to be erected therein, and proclamations to be made thereat'. The village was the focus of parish life, being authorised to hold weekly markets at its own market cross and also cattle and sheep fairs. It was still, however, a fairly random collection of cottages, crofts, barns and byres, with a few merchants' dwellings which were probably not much grander than those of the ordinary folk. As a burgh, it never really got off the ground and it was nearly a century later that the town did begin to develop.

The family of Grant, like their neighbours the Gordons, were amongst the great 'improving' landowners and, in parallel with their enthusiasm for the 'agricultural improvements', they also wanted to improve the way of life of their tenants and to generally 'tidy up' their estate. In 1766, Sir James Grant of Grant replaced the old village with the new 'planned town' of Grantown, which was laid out 'in the midst of an extensive uncultivated moor' a few hundred yards from the old settlement. (*Old* and *New Statistical Accounts*).

The first indication of these plans had been a notice in the *Aberdeen Journal* of Monday 15 April 1765:

Sir Ludovick Grant and Mr Grant of Grant propose a TOWN should be erected and will give feus of long Leases, and all proper Encouragement to Manufacturers, Tradesmen, or others sufficiently recommended and attested to as to Character and Ability, who incline

to settle there. – The Place proposed for the town is called Feavoit, to which the Fair and Markets in the neighbourhood can be collected. It will be the more convenient, as it lies near to Spey Bridge, has public roads branching off from it to Inverness, Nairn, Forres, Elgin, Keith, Braemar, Perth, and to the West Highlands, being eighteen miles from Inverness and twelve miles distant from Forres.

Those who incline to settle, on Enquiry will find that it is a good, pleasant country, and well accommodated with all materials for building, lies near plenty of Moss and other Firing, has the woods of Abernethie and Glenchernick near it, and a fine Limestone Quarry easily wrought. It is particularly well situated for all Manufacturers of Wool or Linen, being a great sheep country; the Linen Manufactory already introduced, the soil good, having fine water and every conveniency for Bleachfields. The situation is also well adapted for Wood Merchants, Carpenters, Cart Wrights, etc, the Woods lying near, and to be had at low prices, and at a very moderate Charge floated down Spey to Garmouth, where shipping may be easily had. Beside what is to be feued or let in long Leases those settling at the above place may have, in tack, cultivated or Improveable Grounds, for their further Accommodation.

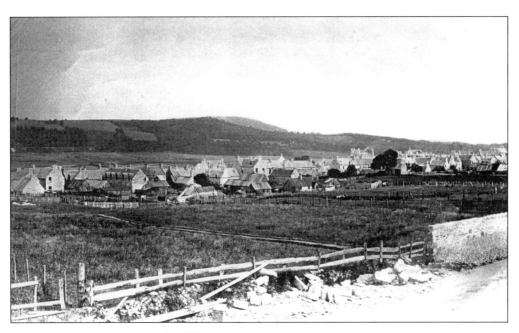

Grantown on Spey, early 20th century

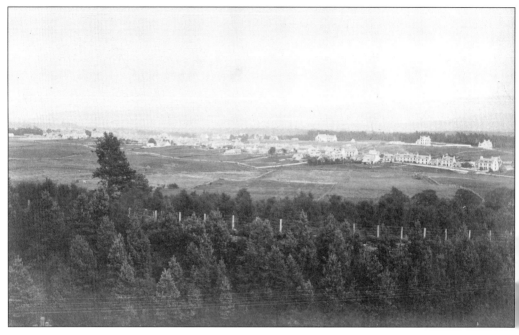

Grantown on Spey from the hills above

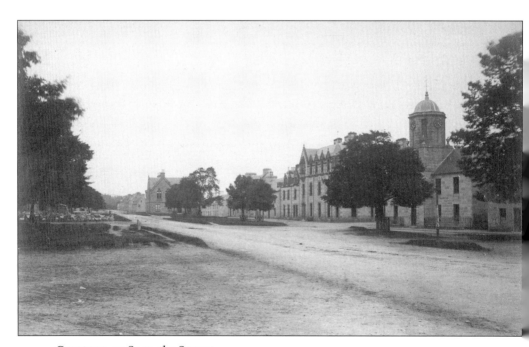

Grantown on Spey, the Square

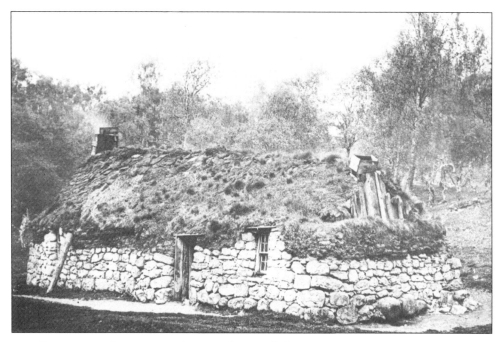

Cottage near Grantown on Spey, early twentieth century

And so it goes on – a really good sales pitch for the new town.

The three span, rubble-built 'Old' Spey Bridge had been completed as a Military Bridge just 12 years earlier. A nearby stone slab reads, 'AD 1754 the companies of the 3rd Regement the Right Honourabl Lord Charles Hay, Colonel, ended'. Whether this plaque records the completion of the bridge or the completion of the length of military road leading to it, we will never know. But the bridge certainly put Grantown on Spey on the map.

The 'agricultural improvements' which were coming into fashion at this time amongst the major landowners led to the demise of the runrig system and the larger tenant farmers, with the encouragement of the landowner, were beginning to enclose their land into fields, with dykes or fences surrounding them. In the surrounding areas, the farmhouses were being improved and some of the principal tenant farmers in the parish were soon enjoying a way of life which would have been the envy of a previous generation, in many ways almost matching that of the laird.

The problem with the 'improvements' was that this new style of agriculture deprived many of the smaller tenants of their runrig lands

and they were not able to survive on what they were able to grow in their small cottage gardens. Whilst a proportion of the cottars found employment and generally better housing on the new farms, there were many who were unable to find work and this led to an exodus of the poorer and less skilled workers. Many of them moved south to find employment in the new industries of the Central Belt of Scotland, whilst others chose to make a new life overseas – not quite the 'Moray Clearances' but the effect was the same for many families.

By the 1780s, the new town of Grantown on Spey had become, under the watchful eye of the laird, Sir James Grant, the main market town for a large part of the Spey Valley and a major player in the Highland linen industry. It also produced fine woollen cloths, a good proportion of which went for export. Although the linen industry failed towards the end of the eighteenth century, not only in Grantown but across the whole country, the economic foundations of the town were strong enough to resist this decline and the town continued to expand.

The minister, in his submission to the *Old Statistical Account* in 1793, gives us one of the earliest pictures of life in the village. 'Grantown is a village erected under the influence of the Grant family, it being little more than 20 years since the place where it stands was a poor rugged piece of heath. It now contains some 300 to 400 inhabitants, some of whom are as good tradesmen as any in the kingdom. Shoemakers, taylors, weavers of wool, linen and stockings, blacksmiths, wrights, masons and 12 merchants keep regular shops in it.' The minister goes on to record that there were two established schools in the village of Grantown, one of the teachers receiving a salary of £30 sterling with an excellent dwelling house at Sir James Grant's expense. This school was partly funded by the Scottish Society for the Propagation of Christian Knowledge. The other school, taught by a woman, was attended by 30 or 40 young people who were not only initiated by her in the first principles of letters but the young girls 'receive under her, a foundation of the various branches of female education'.

A brewery was established in the village right from the start, 'on purpose to keep the people from drinking spirituous liquors'. There were two bakers and a butcher in the town and two or three public houses. The elegant town house was built above the prison where 'yet few have been confined within its walls'. 'Stone bridges have been erected over almost every rivulet, and of course the roads are in the highest order.' There were two taverns or public houses on the turnpike road, for the

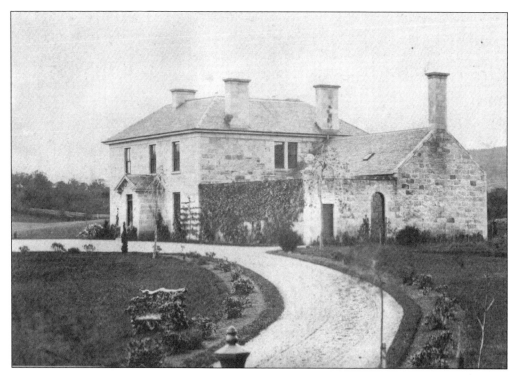

Inverallan Manse near Grantown on Spey

benefit of travellers, in addition to those in Grantown. Many of the turf houses had, by now, been replaced by ones built of stone, with a slate roof, and the new village seems to have been an almost idyllic place to live and, in comparison with what had gone before, it probably was.

In 1795, there is recorded a nineteen-page 'Trust and Deed of Covenant for carrying into effect the Speyside Charity School 1795', a school which was to become very sought-after by parents from the local parishes who wanted to give their children a good education but were not able to afford it. The charity school is now long gone, replaced by the crisp granite lines of Speyside House, with the clock under the cupola being paid for out of funds collected for soldiers in the Napoleonic Wars, which, with the ending of hostilities, were no longer needed for their original purpose.

The Square was the original market place for the new town, and in fact the market cross from the old village was moved to the new planned village on 13 June 1776, implying that the rights of the Burgh of Regality, or more likely by now a Burgh of Barony, were conferred on

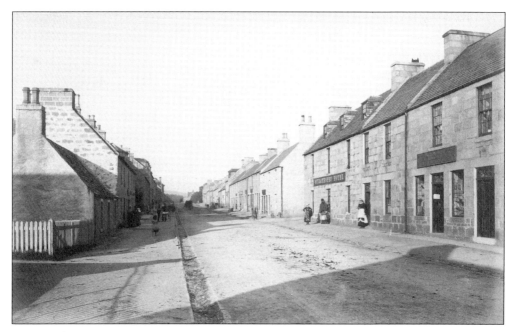

High Street, Grantown on Spey

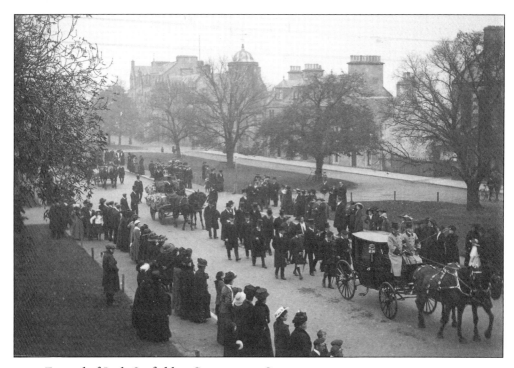

Funeral of Lady Seafield at Grantown on Spey

the new town. We will never know where the old market cross stood, or whether, indeed, it was ever properly put up, as there are no further mentions of it after that date.

The nineteenth century brought many changes to Grantown on Spey. The improvements to the roads during the first two decades of the century meant that the village was now an even more important staging post on the road north from Perth to Nairn, Forres and Elgin, and the first stage of the Victorian expansion began.

The old cottages began to disappear by the middle of the century and the original planned village of 1766 was overwhelmed by new buildings. The Grant Arms Hotel had been opened by Robert Glass in 1851 – maybe he foresaw the coming popularity of the Highlands thanks to the influence of Queen Victoria. The Queen and Prince Albert actually came to Grantown on Spey in 1860 and visited that very hotel. The new Grantown Grammar School came into existence in 1851, with Peter Carder its first schoolmaster. The school was modernised in 1910 but eventually closed in 1968. The new Masonic Hall opened just three years later on the site of the old lodge and tenement on the north side of the Square.

It was, though, the coming of the railways in 1863 which brought Grantown its popularity as a Highland holiday resort. Not content with having one railway station, it had two. One station was near to the town, on the Highland Railway's route northwards over the Dava to Forres, which was for many years the main line between Perth and Inverness. The other station was on the other side of the river, on the Great North of Scotland line to Elgin. The railways of Badenoch and Strathspey will be discussed in more detail in a later chapter.

Perhaps it was the railways which prompted the opening of the gas works in the town in 1864 – coal could now be brought in cheaply and easily – and it was not long until the main streets of Grantown were ablaze with light from the new gas lights along their also quite new pavements. The old town house with its jail was by now looking rather unfashionable and a new courthouse was opened in 1867. Maybe its new 'modern' cells were able to attract a few more inmates than the old place.

The visitors came, many of them from the smoky, grimy cities of the south, to experience the clean Highland air and the freedom, albeit somewhat limited by the local landowners, to walk the hills and glens. Some of them may have stopped off for a while on their way to the

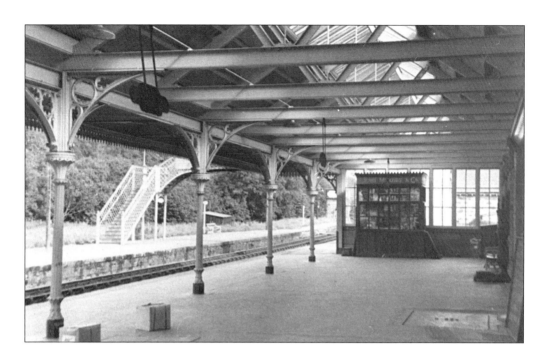

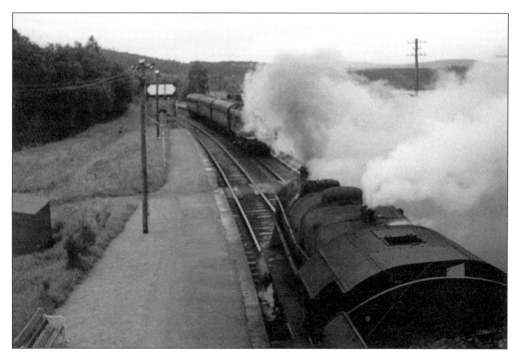

Two views of West Station, Grantown on Spey, in the 1950s

Grantown on Spey, 19th-century view of the square

health-giving sea air of Nairn, the 'Brighton of the North', just a few
stops up the line. John Ross Fraser opened the Strathspey Hotel in
1895 and, by 1904, he was obliged to extend both the hotel and the
stables. Despite the coming of the railways, the horse was still the only
real way of getting around the countryside, whether seated astride it or
in a gig being pulled by it.

More and more shops appeared along the High Street. Miss Sim's
shop opened in 1885 at 27–29 High Street but the records don't tell us
what she sold there. The larger houses which had been built over the
past 20 years were being extended – some as hotels, some as guest
houses, all to take advantage of the village's increasing popularity. By
the end of the nineteenth century, the High Street and the Square
would have looked very much as seen by the modern visitor.

The Temperance Hotel was opened in 1901 and the Christian Institute
in 1912. With the prospect of war looming, the Drill Hall was opened
in 1912 and, in more recent and more peaceful times, it was taken over
by the RAF as an outdoor activity centre.

The building of comfortable houses by wealthy merchants and
businessmen from the south, some of them smaller versions of the

lairds' Highland mansion houses, continued into the twentieth century. Some, such as Blantyre Villa and Comely Bank, were extensions to earlier houses while others, such as Rosehall and Heathfield, were later developments. Grantown even had its own picture house but, like so many of them all around the country, it closed in 1970 and the building was later bought by the Royal British Legion.

If we look closely enough, there are still a very few traces of the original village but they become fewer by the day as land becomes more and more valuable. The nineteenth-century buildings are still there – in fact, much of the High Street dates from that time – and the tree-lined Square still presents us with a sense of the peaceful Highland village so admired by its Victorian visitors. So don't just think of Grantown on Spey as a convenient place to stop off for a coffee or for fish and chips, park the car and, as they say in these parts, 'have a wander' and explore the village.

CHAPTER 13
AVIEMORE

Now the winter sports capital of Scotland, Aviemore was originally just an inn on a bleak moor. Even by the end of the 1950s, the population was only about 300 people. How it has changed!

As with many other similar places, such as Pitmain, people's impressions of the early inn at Aviemore seem to vary widely. One writer refers to it as a dirty ill-kept inn with little to attract the traveller whilst another, maybe from the more recent perspective of the 1850s, comments, 'There was no such inn upon the road; fully furnished, neatly kept, excellent cooking, the most attentive of landlords, all combine to raise the fame of Aviemore. Travellers pushed on from the one side, stopped short at the other, to sleep in this comfortable inn.' In early days, they probably didn't have a lot of choice – inns were few and far between on the road north – but this would no doubt have changed with the increasing popularity of the Highlands in Victorian times.

The coming of the railways, the opening of the line between Perth and Forres and the later building of the direct line to Carrbridge and Inverness, led to the demise of the old inn and, as the coaching traffic disappeared, it did not take long for custom to decline and the building fell into disuse. Other businesses did prosper, though, and the Aviemore Station Hotel was one of these – although, sadly, it burnt down in the late 1950s.

The railways had opened up the area not only to the wealthy Victorian merchants and traders from the south who, following Queen Victoria's enthusiasm for the Highlands, wanted to have a slice of the action but also to the hunting, shooting and fishing fraternity. Before the First World War, it was really only the wealthy who ventured to these wild and inhospitable parts, some even spurning the railway to test their new-fangled motor cars against the climb up Drumochter and the perils of that new road which was later to be called the A9.

The original railway station had been opened in 1863 on the

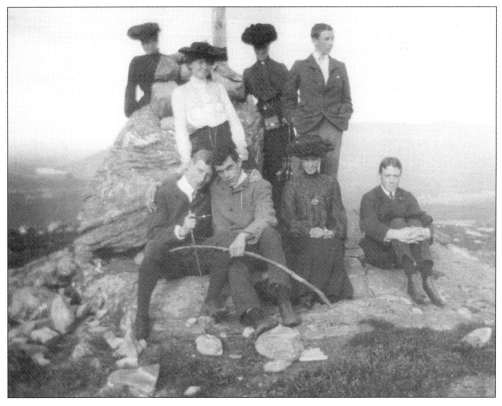

The summit at last: hillwalkers in Badenoch and Strathspey

Highland line from Perth to Forres and then on to Inverness. When the direct line over the Slochd was opened in 1898, Aviemore became an important junction station and, right through until 1965, it continued to have trains from Inverness and Forres bringing travellers from the north across the Dava Moor. This was also where the holidaymakers bound for the beautiful beaches of the Moray Firth would change trains to go to the seaside via Strathspey or over the hills to the north.

The years between the wars saw little decline in the number of wealthy visitors to the Highlands but they were now being joined by a new and hardier breed. Hillwalkers, mountaineers and climbers of all kinds, not so rich – in fact, many of them downright impoverished – were determined to have their fair share of the pleasures of the countryside. They haunted the youth hostel at Aviemore and the numerous Highland bothies in the hills and the summer campsites along Strathspey.

The end of the Second World War brought a new age of prosperity and easier travel to many ordinary people. In the late 1950s, the nearby village of Carrbridge had pioneered the marketing of this area as a centre for winter sports. The hoteliers and guest house owners of Aviemore were very keen to extend their relatively short tourist season and formed a company called Cairngorm Sports Development Ltd. It was this organisation which built the White Lady Chairlift in 1963 and also developed later lifts to open up the mountains. The winter scene in the Highlands was transformed, hotels and guest houses not just in Aviemore but in other nearby villages soon found that there was a demand for rooms all year round and the local cafes and restaurants similarly prospered.

These changes did not go unnoticed further south. The body then known as the Scottish Development Department were not slow in thinking that, with a massive injection of capital, much more could be achieved. This led to fears amongst the local landowners and the fledgling conservation movement that as much could be lost as would be gained. The whole fragile fabric of this part of Badenoch and Strathspey could be under threat from the developer.

As always, money spoke and the powerful interests of both business and government saw Aviemore as a potential gold mine. A holiday complex based in Aviemore would satisfy several of the aims of the entrepreneurs. They could create a tourist magnet in the Highlands, they could boost Scotland's tourist industry by building a new Aviemore Centre which would attract visitors from both home and overseas and they could encourage the growth of jobs and business developments which would go a long way to stemming the southward drift of the local population. Many, though, thought that they were going about the matter with undue haste and with no consideration for the local environment and, in fact, that they were trying, to a large extent, to impose urban planning developments right in the middle of a small Highland village.

The old village of Aviemore, really, is no more. It is doubtful whether many visitors even realise that the place had any history at all. True, it wasn't much of a history but what bit there was is now long gone under concrete buildings, roads and car parks. So the concept of the Aviemore Centre was born and the development went ahead on a 75-acre site at the foot of the Monadhliath Mountains. A complex of roads, hotels, chalets, a caravan site, theatre and cinema, ice-rinks, shops,

restaurant and all the other features formed what was almost a self-contained community in the centre of the old village.

Built at a cost of, officially, some £2* million and unofficially at a cost of probably twice that, the Aviemore Centre did attract tourists and did provide employment for about 600 people in its early days but it never gave the investors a realistic return on their money. It trebled the local population and no doubt raised the profile of not only the village but of the whole of the Spey Valley, from Dalwhinnie right down to Grantown on Spey. But many of the smaller hotels, guest houses and shops suffered badly as a result of the pulling power of the new centre.

The centre was opened by Lady Fraser of Allander, the widow of Sir Hugh Fraser of Allander, one of the great supporters of the project, in 1966. The Centre rapidly developed into a major tourist venue – even Prince Charles and Princes Anne attended the Royal Hunt Balls in the Osprey Rooms. TV programmes were often hosted from the centre and the skating and curling rinks, built to international competition standards, the swimming pool and the presence of a 365-days-a-year Santa also boosted its popularity. The dry ski slope, shops, nightclubs and discos all added to the attraction and, for the more energetic, Mr Sandy Caird brought the first ski school, with its associated shop, to Aviemore.

For a while, Aviemore had not one but two railway stations. After the cuts of the 1960s, the main station was no longer a junction and the main Perth to Inverness line halted only briefly at what was becoming quite a dilapidated station despite all the new tourist facilities. It is thanks to the restored Strathspey Railway that Aviemore became a Mecca for railway enthusiasts. This railway, not being a part of British Rail, was denied the use of the main line station and was obliged to build its own wee station, known as Aviemore (Speyside), further up the line in the railway yard. Opened in 1978, this station was built from materials salvaged from the old Dalnaspidal station, which had been yet another one to fall victim to the Beeching cuts.

With the ongoing development of the Aviemore Centre, an effort was made to bring the Strathspey Railway's terminus closer to the town centre and the declining fortunes of British Rail soon led to the two companies coming to an agreement and the redevelopment of Aviemore Station and the Strathspey Railway being allowed access to the island platform at the main station. The old Aviemore (Speyside) station is

now no longer in use, having closed in July 1998. The buildings on the island platform of the main-line station, having been derelict for many years, were all sensitively restored and it is a tribute to the work put in by volunteers and professionals alike that the station now looks much as it did when it was first built in 1898. Relationships between the two companies improved to such an extent that the old junction spur to the south of the station was refurbished and, one day, trains from the south may run all the way to Grantown on Spey again over the Strathspey Railway metals.

The optimism of the developers was short-lived, however, as the anticipated boom for the centre soon faded. The lack of reliable snow, the outdated 1960s architecture of John Poulson's buildings and the general downmarket approach and a lack of investment soon led to a general state of decay. One writer has suggested it was trying to be the 'Blackpool of the Scottish Highlands', sadly at a time when Blackpool itself was on the slide. The new shopping parade in the village did little to improve the 'concrete block' appearance of the place and, gradually, the tourists drifted away. As air travel became cheaper, they could find more attractive destinations overseas.

The Centre struggled on but, one by one, the facilities closed down, the shopkeepers gave up trying to make a living and, by the middle of the 1990s, Aviemore was virtually a ghost town. In 1998, many of the original buildings were demolished as part of a proposed £50-million overhaul. Only the railway survived as a major tourist attraction. Not only was the old village lost, the dinosaur which had swallowed it up was also consigned to history.

It was too late and, although some of the visitor buildings were replaced, many of the leisure facilities proved to be too expensive to reinstate. There was little to attract the visitor and the market continued to decline. Maybe, though, with increasing numbers of people participating in winter sports and the enthusiasm for the steam trains, there is yet to be a third phase or, if we include the old inn, a fourth phase, in 'Lost Aviemore'.

KINGUSSIE

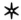

Kingussie, standing at 750 feet above sea level, is often thought of as the capital of Badenoch. Its fresh, bracing air has, for the past two centuries or more, been an attraction to visitors. The village stands on a historic site, the area is filled with the remains of stone circles and cairns, ruined chapels and a monastery and the origins of the parish church date back to the early days of the parish structure in the thirteenth century.

In 1451, King James II supposedly granted charters of the lands for building crofts and Kingussie was then erected into a Burgh of Barony. In the aftermath of the '45, the nearby village of Ruthven began to decline in importance and Kingussie, just a mile away on the opposite bank of the River Spey, soon became the main settlement.

In 1548, William McIntosh of Dunachton sold the lands of Keppoch in Lochaber to Alexander McRanald McConnel Glass, the payment of 400 merks to be made 'within the Friar Kirk of Kyngusy upon the high altar there'. It is evident from a charter dated 18 December 1572 to Lachlan McIntosh of Dunachton that the lands of Pitmain, Kingussie and Ruthven were all considered as one entity, when they and 'all pertinents within the Lordship of Badenoch, which formerly belonged to George, sometime Earl of Huntly, but had been forfeited by him to the Crown by treason', were now granted to him. Lachlan McIntosh was to hold these lands on behalf of the Crown.

In 1597, Mr William Carnegie, then minister of Kingussie, granted a tack (lease) to Lachlan McIntosh of Dunachton. This was the lease of the vicarage teinds and small teinds, 'sic as lamb, kid, guis, greib, woll, lint, hemp, calf, foill and utheris of the parish of Kingussye'. This gives us a good idea of the produce of just a small part of the village of Kingussie at the end of the sixteenth century, with lambs, kids, geese, waterfowl, wool, lint and hemp, calves and fowl, and other items. It was certainly a self-sufficient wee village. The lease was for the lifetime

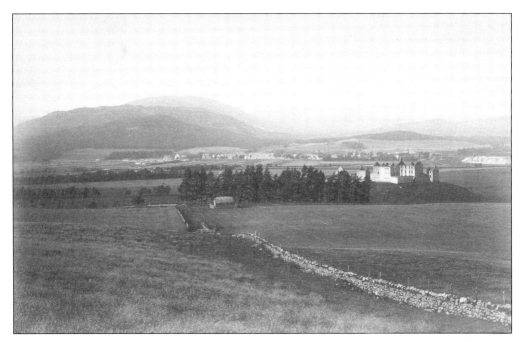

Ruthven Barracks with Kingussie beyond

of Lachlan McIntosh and the lifetime of his heir and nineteen years thereafter, 'for payment to the granter of £20 Scots yearly'.

This shows us something of the status this small Highland village held at that time due, in no small way, to the presence of the monastery, the 'Friar Kirk', and also the various chapels, now sadly lost for ever among the heather. Kingussie, although it may be difficult to imagine now, would, at one time, have been a major centre of learning and culture in these remote parts of the Highlands.

In the 150 years from then until the Jacobite Rebellion of 1745, little more is recorded of life in the village but, as the soldiers eventually left the barracks and the nearby village of Ruthven diminished in importance, Kingussie was able to expand to fill the needs of both travellers and local people alike.

With such a large number of Highland gentlemen's country houses in Badenoch and Strathspey, the shooting season was the main event in the calendar. One of the most noted visitors was probably Colonel Thornton of Thornville Royal in the county of York. He was the son of William Thornton of Knaresborough, who had himself fought on the government side against Bonnie Prince Charlie and had come to love

the Highlands. Maybe, as a consequence of his father's expeditions into these northern parts, Colonel Thornton had been sent to university in Scotland and had made friends with the sons and heirs of several of the more important Scottish landowners.

Colonel Thornton had once visited Badenoch and Strathspey and had spent the holiday under canvas but, having made his fortune as a consequence of his military activities, he decided that his next visit north should be made in a little more style. He was probably one of the first Englishmen to anticipate the Glorious Twelfth in anything approaching an organised manner. For the autumn months of 1784, he rented the house of Raitts, the predecessor of Belleville or Balavil, which was at that time owned by Mrs Mackintosh of Borlum.

Now comes a real 'lost' event. We will never see the likes of it again! Just for a start, the proprietor of Raitts was required to provide and provision 20 horses for a period of three months. But Thornton himself 'assembled a camping equipage suitable for four or five gentlemen with their attendants, and added two small boats, the Ville de Paris and the Gibraltar'. A large selection of culinary delicacies was also packed, as the expedition thought they may need to add to the 'rude fare' of the far north (Thornton, *Sporting Tour through the Highlands of Scotland*). An artist was employed to paint the landscape and the birds and animals, including those who were so unfortunate as to come within range of a fowling piece or a fishing rod.

The party came north and the baggage had been taken by sea from Hull to the then thriving port of Findhorn, from where it was all to be carried in 49 country carts to Kingussie. They were maybe thankful for the military roads which had been built by Wade and Caulfield only half a century earlier but think what a traffic jam they would have caused on the A9 nowadays. By the middle of July, however, Colonel Thornton had got all of his possessions sorted out and was ready for his expeditions. What expeditions they were – visits to Loch an Eilein, Loch Ennich, Loch Laggan and the beautiful Loch Vaa. Not mere fishing trips but adventures worthy of a wealthy country gentleman. The menu for one of the 'accidental dinners' which they ate on these expeditions has survived and the one thing that was obviously not lost was any weight! The first course was 'A Hodge-Podge, Remove, a Roast Pike of seven pounds, Sauces, Greens, Reindeer's tongues, Potatoes and Chickens' and that was just to whet the appetite. The second course of 'Loin of Mutton, Black Game, Partridges, Currant Jelly, Capsicum, and

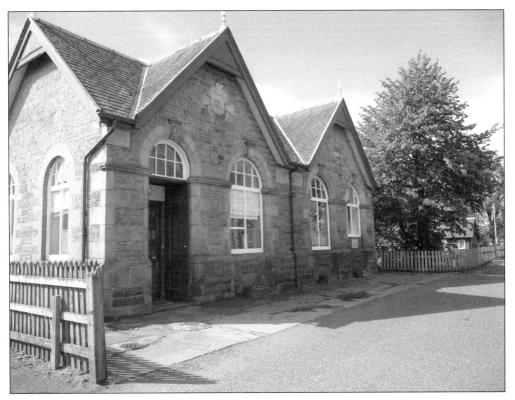

Kingussie, the old Post Office

a Carving' was followed by 'Biscuits, Stilton Cheese, Cheshire Butter and Goat's Milk' (Thornton, *Sporting Tour through the Highlands of Scotland*). How the other half lived!

Just to the south of Kingussie was the Inn of Pitmain, a place which has already been mentioned briefly as a stance for the drovers. One traveller described the Inn of Pitmain, which dated back to 1752, as 'the dirtiest inn in Scotland' but maybe he was just there at a bad time, as others took a different view. In what had now become one of the principal staging posts on the long road north, another writer found his stay there very comfortable indeed. 'The Inn of Pitmain is on one of the richest and most extensive farms, and is therefore plentifully supplied with every article desirable to travellers, and is fitted up with the best accommodations; and being in a situation of singular importance to Highland journeys, it is much frequented in the summer season.'

It was at the Inn of Pitmain that Colonel Thornton was invited to dinner with Colonel Duncan MacPherson, known as 'Duncan of the

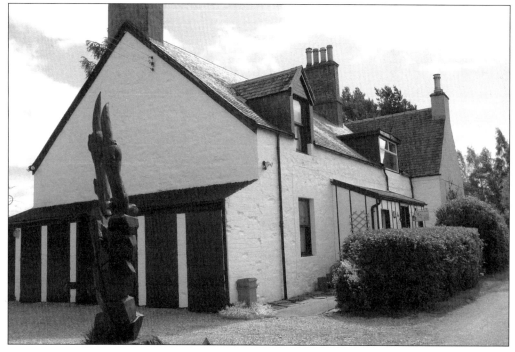

Old Poorhouse at Kingussie

Kiln'. Duncan was no less than the son of Ewen MacPherson, the chief of the clan who had been so ruthlessly burnt out of Cluny Castle by the Redcoats in 1746. The reason for this gathering of the clan was for a celebration that the lands had now been restored to the family by the government, thanks in no small part to the activities of the poet James 'Ossian' MacPherson, the man who was later to demolish Raitt and build the new house of Belleville. Following the celebrations, the beacons blazed from the summits of the hills surrounding Kingussie. 'On the instant the pipers lifted a salute and played till all the darkened meadowland of Spey, rich with the scent of wild flowers and heather and drifting peat reek, throbbed to the power and majesty of the mighty music. Old folk in Ruthven and children and lonely cottars on the hillside came to the door to listen . . . Many a throat was tight, many an eye was dim; for the Chief had come into his own again.' (Thornton, *Sporting Tour through the Highlands of Scotland*)

Whatever its advantages or disadvantages to the traveller, however, the old Inn of Pitmain is no more, having closed in the 1850s when the nearby town of Kingussie proved to be a more popular attraction

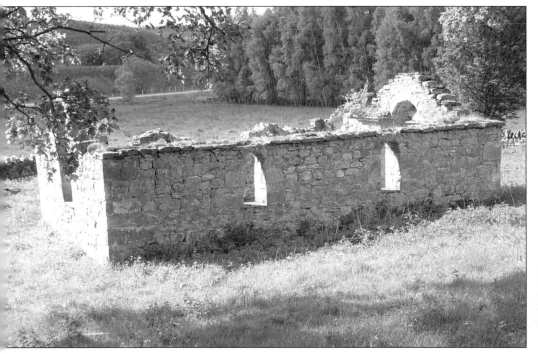

The ruins of Dunachton Kirk, near Kingussie

for the nineteenth-century tourist, especially with the arrival of the railways a decade later.

Just 15 years after Colonel Thornton's visit, the Duke of Gordon, following the fashion of the times, designed a 'planned village' to take the place of the few cottages which had clustered around the old parish church of Kingussie. Unlike many of the villages which had been planned during the past 30 years or so, Kingussie did not have a town square as such, the focus of the settlement being near the church, at the bridge over the burn of Allt Mor, where the road to Ruthven ran away to the south to the ford across the Spey, which was to be replaced with a bridge some nine years later. Two other streets, parallel to the High Street, were built but it was left to the later developers to expand the village to its present-day layout.

With the arrival of the railways, Kingussie took on even greater importance. Kingussie was an attraction; it could be reached in a few hours on the train and the professional classes and the merchants from Central Scotland and from even further south participated in the building boom of the 1880s and the 1890s. It is said that some £200,000

Log Footbridge near Kingussie

of private capital went into the building of these holiday villas, many of which were probably only in use for a few months of each year. At that time, this was a very large sum of money indeed for one small Highland village and the property boom continued right up to the start of the First World War.

The Speyside Distillery was opened about two miles to the east of Kingussie at Drumguish in Glen Tromie in 1895 but was not a great success and went out of business in 1911. The industry was revived, however, in 1962 by George Christie, a Scottish entrepreneur and whisky enthusiast, on a site opposite the old distillery and has continued in production since that date. The appropriately named Duke of Gordon Hotel dates from 1906 but much of the original building is now lost in amongst all the later additions which, it must be said, have at least been kept in a style appropriate to the old hotel.

NEWTONMORE

The history of this village is rather obscure, some sources suggesting that it evolved from a small settlement at a place where the cattle were collected, having travelled over the Corrieyairack Pass, before being taken to the tryst at Pitmain. Although the old farm of Banchor dates from about 1645, before the early nineteenth century there is no record of a village at Newtonmore.

The road to the north met with the old drove routes from the west here and the village was at the junction of the main routes into Badenoch from Perth, Fort William and Inverness. By the middle of the eighteenth century, there was a small settlement of four or five houses along the northern side of the road, between the River Calder and the burn of Allt Laraidh, and it was originally known as 'Strone-muir', a name which now survives in the name of Strone Road, at the northern end of the village. From the early years of the nineteenth century, this settlement began to be boosted by the crofters moving down from the glens, especially from Glen Banchor. These new residents were able to build their own houses and bring their own crafts and skills, and so the village of Newtown-more came into existence.

In 1808, the new bridge over the Spey was to prove a boon to both Kingussie and the village now known as Newtonmore. Things improved even further when, in 1817, the Parliamentary road was built through Newtonmore by Thomas Telford and, by 1828, Newtonmore was beginning to expand to rival nearby Kingussie.

The village, like Kingussie and Aviemore to the north, was to benefit from the coming of the Inverness and Perth Railway in 1863. Newtonmore, at the junction of these important road routes, was already well established as a centre of commerce in the Highlands and, seeing the opportunities which the railways created, the businessmen of Badenoch started to build hotels with the same enthusiasm as had happened elsewhere in the Highlands. The trains were bringing tourists

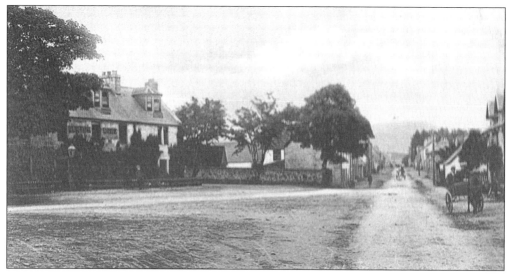

Newtonmore Main Street, c. 1900, the main road north from Perth to Inverness

and with them came prosperity. One only has to look at the hotels and guest houses along the main street, almost all of them dating from the nineteenth century, to see how the old settlement is now forever lost. As Newtonmore continued to grow in popularity, both as a venue for the holidaymaker and also as a centre for the hunting fraternity, more and more large houses were built in the village. It was never a planned village – by this time, the craze for such things was past – but Church Terrace, running parallel to the main street, shows that the idea of uniformity was not lost on the developers.

Queen Victoria made frequent visits to the area. Having been put off Cluny Castle by the bad weather, she also visited Ardverikie, which on one visit she painted. On later visits, she was put off by the midges and she eventually decided on Balmoral. What a difference it would have made to the economy of the area if we now had a 'Royal Speyside' instead of a 'Royal Deeside'.

Right at the end of the nineteenth century and into the early years of the twentieth century, a stagecoach service operated between Kingussie and Spean Bridge, no doubt linking with the main coach from Perth at Kingussie and with the Fort William coach at the other end. The service stopped in Newtonmore at 'The Hotel', which was later to be renamed Main's Hotel. The hotel is now lost to us as a hostelry but it still survives into the twenty-first century in the form of a care home.

The two World Wars of the twentieth century had a devastating effect on the economy of Newtonmore, as they did on many other communities. The Highlander has always had a reputation of going away to be a soldier and the loss of such a large proportion of the men depleted the workforce so much that many of the traditional industries fell into an almost terminal decline. Farms and crofts stood empty or were occupied by the womenfolk who were unable to cultivate them to the same extent, the Highland estates were short of workers and times became very hard – so much so that, for the post-war generation, there was little chance of finding meaningful employment and the drift away to the cities continued. Cottages lay empty and, even in villages like Newtonmore, the ageing population had little to look forward to, a whole way of life was slowly disintegrating, becoming lost for ever.

Changes were afoot, though, and, although one way of life was vanishing, another was appearing over the mountains from the south. With the improving economic situation in the 1960s, even those who considered themselves to be merely 'comfortably off' rather than wealthy could take advantage of the very low property prices in the north and could afford to buy themselves a 'wee Highland home', ideal for holidays in the clean fresh air of the mountains. The cottages needed renovation, in some cases almost a total rebuild, but the DIY scene was expanding and, although the visits to the Highlands may have been a working holiday for many, the end result was, in Newtonmore and in many other villages, to bring a new lease of life.

The tourists enjoyed it too. They had money to stay in the hotels and bed-and-breakfast establishments and to go pony-trekking and hillwalking. Business, once more, was booming and Newtonmore was undergoing something of a renaissance. The new A9 road, the main road to the north, was diverted to bypass both Newtonmore and Kingussie and there were fears for the future of both villages. But it was not to be. The tourists enjoyed the relative peace and quiet – they could wander down the main street in safety and relax in what to many city dwellers served as a reminder of an almost lost world.

DALWHINNIE

What can we say about Dalwhinnie? Originally there was just an inn and a few small crofts with their turf-built cottages thatched with heather but the settlement owes its origins, as has been said earlier, to the fact that it was a meeting place for the cattle drovers. There is always some argument as to whether Dalwhinnie is the highest village in the Highlands, at 1,160 feet above sea level, or whether this honour goes to Tomintoul – there are only a few feet of altitude separating the two and, anyway, it must all depend on where in the villages the measurement is taken. Dalwhinnie is high, there is no question about it, and, for the weather observer there, it holds the dubious status of officially being, according to the Meteorological Office, a 'mountain weather station'.

The teams of soldiers constructing the military roads met at Dalwhinnie in 1729, one team working southwards from Inverness, the other working northwards from Dunkeld. The road from Fort Augustus across the Corrieyairack came into Dalwhinnie through Laggan but this was a road which was to have a useful life of less than a century. It all meant more business for the inn at Dalwhinnie, though, and it is strange to note that there seem to be no contemporary reports of what the earliest inn was like.

The Inverness and Perth Railway came to the village in 1863 but, unlike its neighbours further down the Spey, Dalwhinnie never seems to have capitalised on this new form of transport, apart from the once grand Dalwhinnie Hotel, which was almost certainly built when the railways came but is now suffering the ravages of time.

This isolated village in the middle of its barren moor is, like its neighbours, now bypassed by motorists on the 'new' 1970s A9 and still retains the character of such a Highland community. The purity of the water led James Buchanan to set up a distillery here in 1897 and this is, without argument, the highest distillery in Scotland. Although

Dalwhinnie is in Badenoch and several miles to the south of the major whisky area, James Buchanan stretched a point and somewhat misleadingly called his whisky 'Strathspey'. Eventually, of course, the name was change to the 'Dalwhinnie', one of the classic malts so beloved of whisky connoisseurs. The distillery was put out of action by a major fire in 1934 but was back in production just four years later.

The twin pagodas of the distillery are now purely ornamental as all malting has been done elsewhere for more than 40 years. The company made quite a considerable investment in the visitor centre and, to enhance the visual aspect of the distillery and make it more obvious from the nearby main road, the kiln pagodas were covered with lacquered copper. The very remoteness of the distillery, however, has also meant that the owners have had to invest in more than just tourist facilities and they have built a special hostel to cater for the members of staff who are cut off there when the winter blizzards rage. It may be quite nice to be cut off in a distillery on a wild winter's night!

LOST ROADS
AND RAILWAYS

THE TRACKS AND ROADS OF
BADENOCH AND STRATHSPEY

The main A9 from Perth to Inverness, the A95 from Aviemore to Elgin and the Moray coast and the A86 coming into Badenoch from Glen Spean and the west are the routes now taken by most people travelling through Badenoch and Strathspey. There were many earlier 'roads' through these mountains and across the moorland; some of them are almost totally lost, others are reduced to the status of trackways and footpaths and yet more are now given a minor road designation. Even if the visitor does not want to get out of the car and wander far from the beaten track, there are still numerous byways which can reveal more of the past of this beautiful part of the country. Just looking out on either side of the road, there are many indications of the earlier roads, some ancient, some much more recent.

From earliest times, there have been trackways across the mountains, following the river valleys, making their way up to the easiest pass across the hills or winding through the many bogs and mosses which present a constant hazard to the unwary. Although the earliest inhabitants were few and probably barely left an echo of their footsteps along the grassy banks of the Spey, by Pictish times, there must have been well-used paths between the settlements and these would have formed the foundations of almost all of the later routes.

Coming into Badenoch from the south, there is really only one way – the mountains see to that. From the valley of the River Tay and journeying northward past Blair Castle, Glen Garry takes us up through the wild lands of Atholl to the Pass of Drumochter. On the western side of the pass are two peaks – the Sow of Atholl and the Boar

of Badenoch – these two porcine features surely marking an imaginary boundary line between these great names in Scottish history.

We can also come into Badenoch by road from the west, two old routes joining each other at Laggan. The road along the banks of Loch Laggan comes in from Spean Bridge and Fort William but the more adventurous route, over the Corrieyairack Pass, from Fort Augustus, follows the fledgling River Spey more closely.

Strathspey is reached from here by roads and tracks following the river but there is also another way into the strath from the south. The high road from Perth and Blairgowrie leaves Strathardle and ventures northwards through Glenshee to Braemar, Balmoral, Ballater and eventually to Aberdeen. It is at Crathie that the traveller can decide to head for Strathspey, making for Gairnshiel by one of two routes, equally scenic but one a little easier on the engine and the brakes. Over the River Gairn and climbing towards Cock Bridge and Corgarff Castle, the Lecht Road takes us to the planned village of Tomintoul. This is not strictly Speyside yet but, from this point onwards, we are coming into the whisky country for which Speyside is so famous. A choice of equally attractive routes lets the traveller make for Grantown on Spey, down Strath Avon along the back of the Hills of Cromdale or down the valley of the River Livet towards Aberlour.

From the softer and more gentle lands of the north there are many routes into Badenoch and Strathspey but, even so, the road from Inverness had to face the long climb up to the Slochd summit and the roads from the Moray Firth coast ventured south across the bleak and reputedly haunted Dava Moor. Only by following the river itself was there easy access from here into Badenoch and Strathspey.

So how old are these roads? The ones along the riverbanks, as already suggested, were probably the most ancient routes in this part of the country. The early traveller was not going to venture far from a well-kent pathway – the thought of facing wolf, bear and other unsociable beasts in the wilds of the Highlands kept their feet firmly on the beaten track. But men, women, children and their beasts did cross the mountains by all of these routes. In the twelfth and thirteenth centuries, the landed gentry would have come north as part of the king's plan to pacify the Highlands by installing his favourites in the castles of Inverness, Nairn, Forres, Elgin and many more. Their retinue would have travelled with them, including their servants, their soldiers and, of course, the ubiquitous camp followers.

Clergymen, bishops, priests and monks would have trodden these ways, on their way north to found the abbeys and priories of Kinloss, Pluscarden, Urquhart and Elgin. Holy men who were, like the new landed gentry, on a mission to 'civilise' the Province of Moray, that almost independent 'kingdom' so hated by the kings beyond the mountains, a kingdom which stretched from Lochaber to the Spey and from the bounds of Badenoch right up to the lands of the Earls of Ross.

The 'roads' were not empty and, in fact, were becoming well-trodden ways through the countryside. 'Spidals' or inns were springing up along these ways – think of Dalnaspidal or the Spittal of Glenshee. This early word provides the origins of our modern name for a place of sanctuary, the hospital.

The Highland clansmen also used these routes – they gave easy access when they fancied the idea of a battle with a neighbouring clan or a bit of cattle thieving. This is where the even older and even more 'lost' byways came in handy – they could take the stolen beasts home by ways which were hopefully unknown to the chasing clan.

THE MILITARY ROADS OF
THE EIGHTEENTH CENTURY

The feet of humans, of horses, of cattle being driven – these are what made the early roads of Badenoch and Strathspey. Later road builders had little choice but to follow them – their predecessors had already chosen the easiest way through the hills and valleys. In the aftermath of the Jacobite Rebellion of 1715, the government, just like the kings of some five centuries earlier, decided that the Highlands again needed to be tamed. No more would the Highlands be beyond the control of an English parliament in London – communications needed to be improved and General Wade was the man entrusted with the planning and building of the new military roads.

Some writers have commented that nothing has contributed more to the peace and prosperity of the Highlands than the roads which were constructed by General Wade and his successors. From the military roads of the eighteenth century to the new turnpike roads of the early nineteenth century, the area was gradually being opened up to merchants and visitors from the south. The remit given to Wade was to construct roads between the existing barracks at Perth, Ruthven,

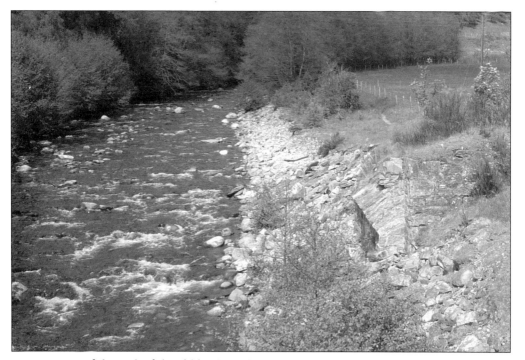

Traces of the arch of the old bridge, Glen Banchor

Fort George, Fort Augustus and Fort William. All of these roads, to a greater or lesser extent, passed through the lands of Badenoch and Strathspey.

Conceived, as they were, as military roads, 16 feet wide and following as straight a line as possible to shorten the journey, they had some difficult gradients. They were maybe very suitable for marching soldiers but, for the normal traveller, they were probably only a marginal improvement on what was there before. Lord Lovat, travelling south via Drumochter after the '45, commented:

> I brought my wheelwright with me as far as Aviemore in case of accidents, and there I parted with him because he declared that my chariot would go safe enough to London, but I was not eight miles from the place when on the plain road the axle-tree of the hind wheel broke in two, so that my girls were forced to go on bare horses behind footmen, and I was obliged to ride myself. I came with that equipage to Ruthven late at night, and my chariot was pulled there by force of men, where I got a wheelwright and a smith, who wrought

two days mending my chariot, and after paying very dear for their work and for my quarters two nights, I was not gone four miles from Ruthven when it broke again, so that I was in a miserable condition till I came to Dalnacardach.

This was not to be his last breakdown on the road to Perth and, if it was like this for a wealthy gentleman such as Lord Lovat, with all of his entourage, how must it have been for the less well-off traveller in a cart? Think of this next time you complain about the state of the A9 and offer a prayer of thanks for the efficiency of our modern vehicles.

In 1728, Wade reported that he was pressing on with the building of the road from Dunkeld to Inverness and 300 men were employed on its construction. In 1729, the road from the south had reached Dalnacardoch and, by September of that same year, it had reached Inverness.

So where in Badenoch and Strathspey can we find traces of this old road? Much of the evidence is lost for ever under the railway line or under the modern roads. The present road from Ralia through Newtonmore and Kingussie almost certainly follows much of Wade's route but, as far as evidence of the original road structure goes, it is not until we get north of Ruthven Barracks and Kingussie that it reveals itself to us in a brief stretch along the hillside above the Insh Marshes, just northeast of Balavil House. The road along the Spey from here to Aviemore, the old road past Loch Alvie, is also almost certainly along Wade's route.

The road climbed away from Aviemore and then divided somewhere near Kinveachy, the Inverness route making for the Wade bridge at Sluggan, a very typical steeply arched bridge not unlike the old bridge at Carrbridge. This bridge was demolished in the Great Flood of 1829 and was replaced shortly afterwards. From here, it took the only way northward, over the Slochd and onwards to Inverness and Fort George. From Kinveachy, another route, constructed by Wade's successor Major William Caulfeild, ran northwards over the Dava to Dulsie Bridge, again making for Fort George.

Almost parallel to this across the Dava ran another of Caulfield's roads. This, though, had come to Strathspey by an entirely different route. As we have already said, there is also another way into Strathspey from the south. The high road from Cock Bridge and Corgarff Castle over the Lecht takes us to the planned village of Tomintoul and, from here, it is an easy descent into the valleys of the Spey and the Avon. A

stone about five miles from Tomintoul on the Lecht Road records the progress of the soldiers employed in its construction: 'AD 1754. Five companes the 33 Regmnet Right Honbl Lord Chas Hay Colonel made the road from here to the Spey'. The Old Military Road crossed the Bridge of Brown and went on past Castle Grant, where the nearby village must have been an inviting port of call for the road builders on their way to Fort George. The soldiers again recorded the end of their labours with a stone near to the old Spey Bridge which has already been mentioned in the chapter about Grantown on Spey.

Somewhere about the top of the Dava the military road divided, the western branch going across to meet the road from Kinveachy at Dulsie Bridge, the other heading down towards Forres. The focus of all of these roads on Fort George just shows how important the pacification and control of the Highlands was to the military planners of the day. Although the threat from the Jacobites had receded into history, there were still others whose thoughts may turn to invasion or insurrection.

From Tomintoul other roads, the older roads, allowed access for the soldiers into the strongly Catholic Braes of Upper Banffshire and down to the Gordon lands around Fochabers, not important enough for the expense of building military roads to be considered but probably worth an upgrade to the existing routes.

Fort George, of course, was not the only fort. Fort William and Fort Augustus could also be reached through Badenoch. From Dalwhinnie a branch of Wade's road had continued northwestwards to Laggan, where the road to Spean Bridge went on in the direction of Fort William and the other road went away to Garva Bridge, mentioned earlier, and on out of Badenoch over the Corrieyairack Pass towards Fort Augustus.

THE TURNPIKE ROADS OF
THE NINETEENTH CENTURY

Useful as these earlier roads by Wade and Caulfield were, they could not handle the increasing traffic of the nineteenth century. In the decades before the coming of the railways, the stagecoach and the post coach reigned supreme. They needed to get passengers and mail quickly and safely from one town to another. The old military roads were useful but they had to be widened, the gradients eased and the hostelries along the way had to come up to the standards expected

of the traveller. Other travellers in their own private carriages also needed to get places both on business and for pleasure as the country's economy expanded.

The Commission for Highland Roads and Bridges was established in 1803 by an act of parliament 'for the purpose of building land communications'. Haldane, writing his *New Ways through the Glens* in 1962, described the story of the three gentlemen who were appointed to manage the new Commission. The engineer was the famous Thomas Telford, James Hope was the legal agent in Edinburgh and John Rickman was the secretary, based in London, to liaise with the government. John Mitchell, a mason from Forres, and his son Joseph were appointed as the chief inspectors to the project. Surely, in this present day and age, such a vast undertaking could never be left under the control of just five men – there would probably be more than that just to look after the health and safety side of things.

Half of the cost of the 'parliamentary roads', as they came to be known, was borne by the government, the other half by local interests such as landowners, local parochial councils and other such bodies and over 1,000 miles of road and 1,117 bridges were built. Apart from being regularly resurfaced and, in some cases, widened, many of these parliamentary roads are little changed and still in use, forming the basis of our modern road network. It was only with the coming of the railways that the work of the Commission was eventually finished.

Telford specified a road width of 16 feet, much as his predecessors had done, as this allowed two wagons or coaches to pass in safety. Gradients were always kept to a maximum of 1 in 30 unless local conditions would not allow this. The traveller was now beginning to experience speed and comfort unknown to their ancestors, although we would nowadays no doubt think it quite a rough ride. There were also milestones, many of which have survived in places along both the old military roads and the new parliamentary roads – well worth looking out for on your travels. The numerous bridges must have been a real problem, though, being built to a width of just 12 feet, but at least the relatively light traffic of the day did not need traffic lights on either side of the bridge. Some of these bridges can be seen off to the sides of the modern road, especially where it has been rerouted over a wider bridge.

Where can we see these old parliamentary roads? The A9 is a prime example as, in many places, the new route runs almost parallel to the

nineteenth-century road. Turn off the new A9 to visit the café at Ralia and, as soon as you leave the modern tarmac, you are on the original road leading down to the Spey Bridge and Newtonmore. The road along Speyside from Grantown on Spey to Aberlour and Craigellachie, although much modified now, is another good example of one of Telford's original roads, leading, as it does, to his beautiful bridge at Craigellachie.

<div align="center">

TWENTIETH-CENTURY
MOTOR ROADS

</div>

The parliamentary roads served us well but, by the 1920s, with the increasing popularity of the motor car and the heavier lorries, something had to be done and so a whole new 'great north road' running all the way from Blair Atholl to Inverness was planned by the fledgling Ministry of Transport, to be built entirely at the government's expense. Work started early in 1925 and the whole route was completed by the end of 1928. The road was designed for the motor car, with gentle gradients

The main road north: winter on the Slochd

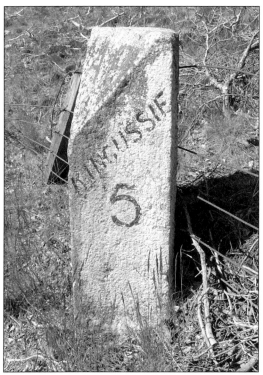

Milestones on the old A9 between Kincraig and Kingussie

and well-designed bends, apart from at the various railway bridges which were eventually to become quite notorious bottlenecks. For about half of its length, the 1920s road followed the old parliamentary road and, for the rest of the way, it was built on a new alignment but never, due to the nature of the countryside, veering far away from the old routes. Various new bridges had to be erected, now being made of reinforced concrete such as the bridge over the Spey at Newtonmore. Unfortunately this led to the demise of some older structures and it was commented at the time that 'it was a matter of sincere regret that the beautiful stone arch bridges, which harmonised so well with their surroundings, had been ruthlessly destroyed and replaced by others of concrete which disfigured the landscape. That was nothing short of calamity. It was to be hoped that no engineer or government authority would ever again be responsible for such a disgraceful massacre of charming stone bridges.' Even more of the character of Badenoch and Strathspey was being lost.

The message was heeded, though, and, although the improvements of the 1970s and 1980s resulted in the loss of several of the concrete bridges, not one of the few surviving stone bridges was destroyed as a result of this work.

To the observant and inquisitive student of roads and communications, the journey north along the A9 and the A95 could take weeks! All along the route through Badenoch and Strathspey, there are survivals of each stage of the road. The very early trackways have, of course, vanished but there are a few places where a track along the riverside may evoke echoes of centuries-old footsteps or of holy men and warriors about their business on horseback. Traces of the military roads built by Wade and Caulfield can be found and the routes of the parliamentary roads, now resurfaced and widened, are still followed for a large part of the way.

The 1920s motor road, the government's 'great north road', is not lost although, in some places, it is hidden beneath the modern surface. Venture off into Newtonmore and Kingussie and follow the old road to Aviemore and Carrbridge – this, in its day, was a 'new' road. Despite what the agitated present-day motorist may think, when stuck behind a group of Tesco and Morrisons articulated units, it is no faster to follow the old road than to stay on the new but it is certainly a lot more interesting. The days, only 40 years ago, of allowing six or seven hours to drive from Perth to Elgin on a good day are long gone. The latest version of the A9

and all the improvements to the A95 and other roads have brought the Moray coast within easy reach of the Central Belt of Scotland. How those early travellers would have envied us our comfort but they saw and knew a lot more of the countryside than we ever will.

THE RAILWAYS OF BADENOCH AND STRATHSPEY

Railways came late to Badenoch and Strathspey – not because of any lack of will but due to the nature of the terrain. It was not really railway country but, thanks to the enthusiasm and drive of the early entrepreneurs, the settlements along the Spey Valley were linked with the south and with the major towns in Moray, Nairn and Inverness to the north.

The Highland Railway drove their line northward from Perth through Atholl and over Drumochter, following the route of the road all the way to Dalwhinnie and then onwards. The long climb over the mountains was a battle for the early locomotives, which needed to be banked by another engine all the way up the long climb from Struan, which, despite its isolated setting, became home to the 'Struan Bankers' and their hardy breed of drivers and firemen. Cresting Drumochter, the line ran down through Newtonmore and Kingussie to Aviemore, offering a brief respite for the fireman. Then it was on to Grantown on Spey and again the climb commenced up to the summit of the Dava Moor and on to Forres where it joined the line which ran between Keith and Inverness. At last the Highland capital was connected directly by rail to the south – by what may seem a rather circuitous route but the high ground of the Slochd was still to be conquered.

Strathspey was the territory of the Great North of Scotland Railway. This line, which connected Dufftown with Nethy Bridge, was later connected to the Highland Railway line near Boat of Garten. The detailed history of the small companies involved with these early lines is beyond the scope of a book such as this but, for the enthusiast, a wealth of information is available.

The first train to run on the Speyside Railway was on 18 June 1863 and, a week later, a train carried, of course, the directors and officials of the company to a 'sumptuous lunch' in the new engine house at Nethy Bridge, then called Abernethy. Within a couple of weeks, the

line was opened for a regular service. A journey which could have
taken several days on foot and not been much easier in the wagons and
carts of the day was now done in a matter of hours. The connection to
the Highland Railway was finally opened in August 1866.

The Inverness and Perth Junction Railway and the Inverness and
Aberdeen Junction Railways had merged in 1865 to form the Highland
Railway. As was usual with such things, though, although both the
Highland Railway and the Great North of Scotland Railway were in
the business of transporting passengers and freight, there was little
co-operation and, at several times, outright antagonism between them,
until about the end of the nineteenth century.

The Speyside line, the Highland Railway, coming down into Speyside
from Forres across the Dava Moor through Grantown on Spey, and, in
later years, the direct line crossing the Slochd from Inverness through
Carrbridge were all focussed on the old village of Aviemore and the
traffic going south. It was not only passengers of course – almost all
of the numerous distilleries along Speyside had their own sidings from
which their products could be conveyed to the markets of the south.

Each of these lines has its own catalogue of features which are now
lost. It is not only the thundering or, in many cases, wheezing steam
trains which have faded into history but the buildings and the way of
life which they brought to the area. It seems more convenient to deal
with each line in turn.

THE HIGHLAND RAILWAY
FROM FORRES TO AVIEMORE

There were not a lot of stations on this line once you got south of
Dunphail – just Dava, the Castle Grant Platform, Grantown on Spey
and Broomhill. As might be expected on this desolate line, there was
also a ghost train high in the sky above the Dava. William Herbert, in
his *Railway Ghosts and Phantoms*, records that:

> In December 1917, when the ground was covered by a thick hard crust
> of snow, John MacDonald was returning home on the path beside
> the railway at about 8 p.m. when there appeared high in the sky
> beside the Plough stars an engine and four trucks containing cattle.
> He could see the trucks moving and smoke coming from the engine.

Dava Station in pre-Beeching days

> Mr Calder (the foreman) and John's Uncle Angus . . . also saw the
> ghostly train and could give no explanation, apart from the fact that
> a train of forty cattle-filled trucks had burned at Dava Station about
> 30 years earlier and all the cattle had died.

This was not the last apparition that John MacDonald was to see on
the Dava line. Maybe, though, this was just an updated version of
the old story of the carriage drawn by four headless horses which
frequented the road across the Dava. There is just something about
that moor that makes you glad to be off it, especially on a dark and
foggy winter's night.

Back to reality. The Inverness and Perth Junction Railway had finally
opened on 9 September 1863, just a few weeks after the other line to
the north. Climbing southwards from Forres the line crossed the River
Divie on the 477-foot-long Divie Viaduct with its seven arches. At the
summit on Dava Moor, the line had reached 1,050 feet above sea level
and was totally exposed to the worst the Scottish winter could throw
at it, with howling winds and massive snow drifts.

The main part of the traffic on the line was trains transporting cattle and sheep from the fertile lowlands of the Laich of Moray. Just four years after the opening of the railway line, the traffic had increased so much that, during one week in 1867, some 21,000 sheep were carried on the line.

Some of the livestock never made their destination. During the severe winter of 1880–1881, 17 December was a particularly disastrous day. A northbound train became stuck in the snow just south of Dava Station and had to be abandoned, the driver, the fireman and the passengers all making their way safely to the relative shelter of Dava Station. A train going in the opposite direction also became stranded on the other side of the station and, again, the passengers and crew were able to make it to safety. Not so the cattle which stubbornly refused to leave the warmth and comfort of their cattle trucks and suffocated to death beneath the 60-foot-deep snow drifts which soon covered both trains. This was, of course, not the only winter which disrupted travel on this line but was probably the most severe in its century-long life.

No more do the trains pass through Dava Station and what remains of it lies hidden in the woods. The old trackbed wends its way towards Grantown on Spey and to another lost 'station' which was the Castle Grant Platform. Just where the main road from Forres to Grantown, the old military road, passes under the railway line at the west lodge of the castle, the laird had his own railway platform. It was just for the use of himself, his family and their guests, of course – no common passenger ever alighted here. He was allowed to build it 'in acknowledgement of the great facilities given by the Earl of Seafield in the formation of the railway through his estates'. Little remains apart from a few concrete platform stumps now themselves becoming lost amongst the vegetation.

Then it's onwards to Grantown on Spey, originally just designated as 'Grantown' by the railway company, despite the confusion this was liable to cause with the other Grantown station on the other side of the River Spey. By the time of British Rail, however, it had achieved the title 'Grantown on Spey West' but even this did not guarantee its survival. The station was at the end of what is now Woodlands Terrace in Grantown and, although the old station building has been demolished and the rubble used, apparently, to fill the gap between the platforms, the station master's house still remains.

The last station on this line before it joined the GNSR was at

West Station, Grantown on Spey in the 1950s: a real train!

Broomhill, on the banks of the Spey. This station, as with the others on the line, went out of use on 18 October 1963, as part of the cuts instigated by Dr Beeching. Broomhill, though, now has a new lease of life under the ownership of the Strathspey Railway. The volunteers from this organisation have rebuilt a facsimile of the station on the surviving foundations, and it now serves as the temporary northern terminus of the railway, until its final northwards extension to a restored Grantown on Spey West station.

Broomhill may be one of the few stations which has two sets of name boards – one giving the real name of the station, the other the name of its television persona, 'Glenbogle', the station which appeared in the series *Monarch of the Glen*. So at least this is not a lost station, maybe just a little schizophrenic.

Then it's southwards to Aviemore from where the line heads along the valley of the Spey into Badenoch.

THE STRATHSPEY LINE, THE GREAT NORTH OF SCOTLAND RAILWAY FROM CRAIGELLACHIE TO BOAT OF GARTEN

This was based on a vastly different type of traffic from the Highland Railway's line from the north. It is true to say that it did carry sheep and cattle and, of course, it also carried passengers but one of the most profitable cargoes on this route was the product of Speyside's largest industry – whisky. Despite some early commentators suggesting that it would be impossible to build a railway line along this route, it was built and, by 1863, the line was opened for traffic.

It was also a very scenic line through glorious countryside. The river is often hidden to the motorist travelling down the main road from Craigellachie in the north to the other Craigellachie near Aviemore but this was not so for the railway traveller. The line followed the river very closely for most of its route – 'indeed there were places where the track seemed almost to hang above the water' ('The Strathspey Railway', unpublished material in Moray Archives).

During the early years of the twentieth century, the idea of 'railway excursions' was promoted by the Great North of Scotland Railway and became very popular. On Saturdays and on Wednesday afternoons – the Aberdeen half holiday – in the summer, the company put on excursions to Dufftown, Craigellachie, to Boat of Garten and even as far as Kingussie. The return excursion fare of 4 shillings, or 20p in modern terms, was within reach of many Aberdonians' pockets and the excursions became so popular in the years before the First World War that the station staff in Aberdeen had to resort to assembling the passengers on the platform in front of the locked carriages, which were then filled one at a time. How many people from the Granite City would have been introduced to the pleasures of Speyside on these excursions and how profitable must these visitors must have been to the tea shops and public houses in the places they visited we will never know but they were certainly profitable to the railway company. The concept of an excursion like that and the social interactivity it must have produced are surely now part of a very lost way of life to modern holidaymakers.

The line from Keith and Dufftown met the line from Lossiemouth and Elgin at Craigellachie, the station being built in the angle between the lines. The railway almost immediately curved away on to a ledge above the river and passed through a short tunnel on its way towards

Aberlour. The existence of this tunnel is still preserved in the name 'Tunnel Brae' where the road climbs over the hill before descending down towards the village. In Aberlour itself, the station is not lost but has a second life as the tea rooms in the park, just at the back of the church whose minister objected so strongly to the coming of the railways. Aberlour was the most populous centre on the line, which gives a good idea of how light the passenger traffic must have been in normal times, but the distillery in the village no doubt made up for that in terms of revenue.

The line carried on along the river to Dailuanie Halt, which was opened in 1933 for the workers at the distillery there. Traces of the old halt can still be found, cut into the bank near the distillery, which also had its own private siding adding more traffic to the line. The railway, for a short time, then crossed to the northwestern side of the Spey, the cast-iron arch bridge stretching some 150 feet across the river, sharing the crossing with a roadway which was built originally for the private use of Mr Grant of Carron. Only the roadway now, of course, still survives. The Imperial Distillery lay between the railway station and the river and the old maps suggest that there was a sawmill and a timber yard on the other side of the station alongside the siding leading to the goods yard. After the closure of the line, the site was purchased by the distillery and landscaped but the distillery itself then closed.

There were three small halts before reaching the next 'real' station at Knockando. Imperial Cottages and Gilbeys Cottages were two small stops without even a platform, being opened following the introduction by British Railways of the diesel railbuses with their retractable steps. The other halt was a private platform at Knockando House which was reserved for the use of the owner of Knockando House and his factor 'only during the pleasure of the Directors' ('The Strathspey Railway', unpublished material in Moray Archives). It never appeared in any railway timetables.

Knockando Station – or should it be called Tamdhu or even maybe by its original name of Dalbeallie? – was adjacent to the private siding to the Tamdhu Distillery. From here, the line continued onwards to Blacksboat, which has been mentioned earlier in the chapter on 'Boats and Bridges'. Here the company had a lattice girder bridge built across the Spey by the firm of C. McFarlane, engineers in Dundee. From this point, the line ran for the rest of its length on the southeastern bank of the Spey.

Carron village in the early twentieth century

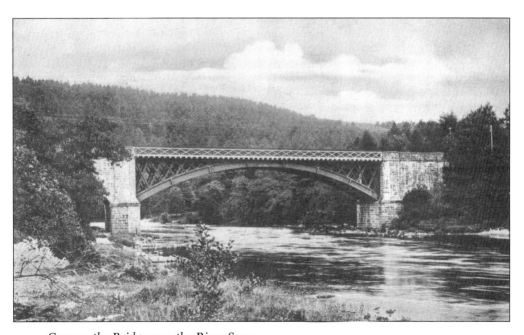

Carron, the Bridge over the River Spey

Ballindalloch was an important stop on the route of the Strathspey line. Due to its accessibility from the Tomintoul road, it acted as a station for much of the traffic from Glenlivet, both passenger and freight. The opening of the Cragganmore Distillery in 1869 near to the station provided another boost to trade and, from the maps of the time, the goods yard at Ballindalloch station appears to be relatively large and was no doubt a scene of great activity.

The valley of the Spey widens here and the line passed through more gentle country until it reached the small station of Advie. Starting life as a small wooden station building on the single platform, it was rebuilt in 1896 as a much more ornate structure. One may ask why the company went to such trouble for a small rural settlement but the clue to this lies with nearby Tulchan Lodge, the property of Lady Seafield. The lodge was used as a shooting box and was well known to members of the royal family, particularly King George V when he was Prince of Wales. It was also used by King Edward VII when he visited the lodge. It is sad that the old station building, with these royal connections, is now another of the lost buildings of Badenoch and Strathspey.

In the early days of the railway, there had been a small station at Dalvey but, as nearby Advie was rebuilt, this was closed, only to reopen briefly as a halt for the benefit of the local farmers.

The next station was Grantown on the opposite side of the river from the town itself, which was about a mile away. This was not too much of a disadvantage, though, as the Highland Railway line, which had its station in the town itself, was not of much use to the farmers of Strathspey as it climbed away northwards over the wastes of the Dava Moor. It was the GNSR's Strathspey line which was of use to them. The station in the town was good for the tourist trade but the line along the riverbank was of much more benefit to local trade and industry. So the two lines were able to coexist, if not always happily, and, in some ways, to complement one another. The station was later renamed Grantown on Spey East to avoid confusion but the idea of building a hotel next door to the station, to take advantage of any tourist trade using this line, was soon abandoned.

The line then passed the halt at Balliefurth Farm before reaching Nethy Bridge, which was the highest station on the Great North of Scotland Railway at 690 feet above sea level. Many of the stations actually had the altitude displayed on the station name board. For three years after the line was opened, Nethy Bridge, originally named

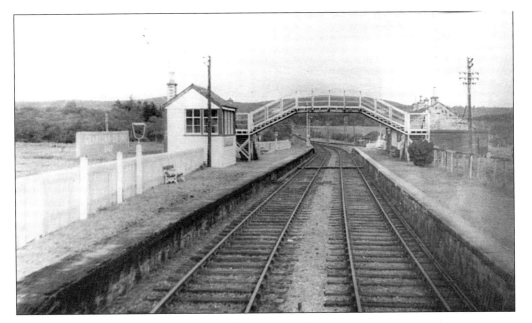

East Station, the Speyside line at Grantown on Spey

Abernethy, was the terminus of the line and had an engine shed and a turntable. This station also boasted the only public level crossing on the Speyside line.

In August 1866, the railway was finally completed, crossing the Spey on a six-span wooden viaduct. This was eventually replaced by a five-span steel girder bridge, the piers of which still remain near Tullochgorum. The line then ran parallel to the Highland Railway until they reached Boat of Garten and these two parallel lines were often the scene of some quite enthusiastic racing by the train crews. The station at Boat of Garten was owned by the Highland Railway and, until the 1950s, the trains which had arrived there from Speyside had to use the eastern side of the station, which meant that their passengers had a long walk to reach the main station building. The Great North of Scotland Railway did, however, have its own engine and carriage sheds at Boat of Garten but all traces of these buildings have now vanished.

Boat of Garten does still exist as a station. The preserved Strathspey Railway now have a station and a museum there and many older locomotives, steam and diesel, and period rolling stock can now be seen there. So maybe all is not lost.

AVIEMORE SOUTHWARDS TO DRUMOCHTER

This was certainly the territory of the Highland Railway and the main station on this part of the railway system was Aviemore. It may be difficult to decide what is lost on this part of the railway. The stations along this route, Aviemore, Kincraig, Kingussie, Newtonmore and Dalwhinnie, have already been referred to in the chapters on each settlement and perhaps all that has now vanished are the smells and the sounds of the steam trains. It is now diesel trains which take the traveller away southwards. Maybe for some it is a last view of the Highlands as they cross Drumochter but the spectacular scenery of Badenoch and Strathspey is always there in its many changing moods, waiting to welcome the visitor back to these historic lands.

BIBLIOGRAPHY
AND SOURCES

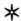

Barr, D. and B., *The Spey, from Source to Sea* (Edinburgh, 2009)

Bartlam W.A.B, Mining at the Lecht (unpublished in Moray Archives)

Daiches D., *Scotch Whisky* (London, 1969)

Devine T.M., *Clearance and Improvement* (Edinburgh, 2006)

Dunbar-Dunbar, E., *Social Life in Former Days* (Edinburgh, 1865)

Dunbar-Dunbar. E., *Documents Relating to the Province of Moray* (Edinburgh, 1895)

Dunnet, H., *Invera'an, a Speyside Parish* (Paisley, 1919)

Gaffney, V., *The Lordship of Strathavon* (Aberdeen, 1960)

Goldie, F.A., *A Short History of the Episcopal Church in Scotland* (Edinburgh, 1976)

Graham, H.G., *Social Life in Scotland in the 18th Century* (London, 1909)

Grant, E., *Memoirs of a Highland Lady* (Edinburgh, 1988)

Haldane, A.R.B., *The Drove Roads of Scotland* (Edinburgh, 2008)

Haldane, A.R.B., *New Ways through the Glens* (1962)

Herbert, W.B., *Railway Ghosts and Phantoms* (Newton Abbot, 1989)

Lauder, T.D., *The Great Moray Flood 1829* (various editions)

Leslie, W., *Survey of the Province of Moray* (Elgin, 1793)

Leslie, W.A., *General View of the Agriculture of Moray and Nairn* (Elgin, 1838)

A List of those concerned in The Rebellion of 1715 (Moray District Archives)

A List of those concerned in The Rebellion of 1745 (Scottish Historical Society, Edinburgh)

Livingstone A., Aikman C.W.H. and Hart, B.S., *No Quarter Given* (Glasgow, 1984)

Magnusson, M., *Scotland, The Story of a Nation* (London, 2000)

McDonnell, F., *Sasines for Banff, Elgin etc.* (St Andrews, 1996)

McFarlane, W., *Geographical Collections*, Vols 1–3 (reprinted 1906, Scottish Historical Society

McKean, C.M., *The District of Moray, An Illustrated Architectural Guide* (Edinburgh, 1987)

The New Statistical Account 1843

The Old Statistical Account 1793

Pocock, *Tours of Scotland* 1760 (NLS)

Rampini, C., *History of Moray and Nairn* (Edinburgh, 1897)

Sellar, W.D.H., *Moray Province and People* (Edinburgh, 1993)

Shaw L. (ed. Gordon) *The History of the Province of Moray* (3 Volumes) (Glasgow, 1882)

Simpson, E., *Discovering Moray, Banff and Nairn* (Edinburgh, 1992)

Skelton, J., Speybuilt, *The Story of a Forgotten Industry* (1994)

Smout, T.C., *A Century of the Scottish People 1830–1950* (London, 1986)

Smout, T.C., *A History of the Scottish People 1560–1830* (London, 1960)

Stevenson, D., *Revolution and Counter Revolution* (London, 1977)

Watson, J. & W., *Morayshire Described* (Elgin, 1868)

NEWSPAPERS AND MAGAZINES

The Aberdeen Journal
The Banffshire Herald
The Banffshire Journal
The Elgin Courant
The Northern Scot

OTHER SOURCES

NAS Seafield Muniments GD248 various documents
NAS Gordon Castle Muniments GD44 various documents
NAS Other Gifts and Deposits GD series
NAS Gifts and Deposits GD331
NAS Exchequer Records, E326 series
NAS Records of Privy Council
NAS Kirk Session Minutes for all of the parishes of
Badenoch and Strathspey

INDEX

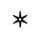